Nik Software Captured

The Complete Guide to
Using Nik Software's Photographic Tools

Tony Corbell

Josh Haftel

WILEY

John Wiley & Sons, Inc.

Tony dedicates this book to his daughter Leslie, whose love and support is never-ending and who is by far the best writer in the family.

Josh dedicates this book to Natasha for her love and understanding during these weeks of hard work and time spent apart leading up to their wedding day.

Nik Software Captured

The Complete Guide to Using Nik Software's Photographic Tools

Nik Software Captured
The Complete Guide to Using Nik Software's Photographic Tools

Published by
John Wiley & Sons, Inc.
10475 Crosspoint Boulevard
Indianapolis, IN 46256
www.wiley.com

ISBN: 978-1-118-02222-1

Manufactured in the United States of America

10 9 8 7 6 5 4 3 2 1

Acknowledgments

We both acknowledge the folks whose efforts day in and day out create and perfect these great software tools with which we are privileged to work and represent. The Nik Software Engineering team, R&D team, QA team, and of course, the Plug-in team. Under the direction of Manuel Wille and CTO and founder Nils Kokemohr, these folks make the best imaging tools and technology in the world.

We also acknowledge and thank CEO Michael Slater and Executive VP Ed Sanchez for their support, guidance, and leadership.

A special thanks goes out to the folks who helped pull this all together from the publishing side: Stephanie McComb, Carol Person, and Galen Gruman. You could not ask for a more professional or more talented group of people to work with.

Credits

Senior Acquisitions Editor
Stephanie McComb

Editorial Director
Robyn Siesky

Business Manager
Amy Knies

Senior Marketing Manager
Sandy Smith

Vice President and
Executive Group Publisher
Richard Swadley

Vice President and
Executive Publisher
Barry Pruett

Editor
Carol Person, The Zango Group

Layout
Galen Gruman, The Zango Group

Cover Designer
Michael E. Trent

Copy Editing, Proofreading, and Indexing
The Zango Group

About the Authors

Tony Corbell

Tony has worked as a professional photographer since 1979, when he began in West Texas. Since 1990, Tony has taught more than 500 seminars and workshops throughout the world on studio and location lighting techniques and theory. Tony *loves* old John Wayne movies and is consumed with anything Beatles-related (he has been known to shoot Fab Four haunts in Liverpool, England).

Josh Haftel

Josh graduated from Rochester Institute of Technology with a Bachelor of Fine Arts in Visual Media from the School of Photographic Arts and Sciences. Since 2001, Josh has worked at Nik Software and currently oversees the product management department. When not in the office at Nik, Josh is an avid hiker, mountain biker, and traveler. Josh lives to eat and travel, and loves taking pictures of both.

What's in Our Bags

Both of us use an extensive array of cameras, lenses, and technologies to create our imagery. Here is a list of our equipment:

Tony Corbell

Camera: Nikon D700 and D3s
Lenses: Nikkor 12-24 2.8, Nikkor 24-70 2.8, Nikkor 85mm 1.4, Nikkor 70-200 2.8
Memory cards: Delkin CF cards 16GB
Tripod: Enduro
Lighting: Profoto D1 500W.S. (6 heads), Pocket Wizard Wireless transmitters, Sekonic L758DR flash meter
Bag: Think Tank International 2 (roll-aboard), Domke F2 (shoulder bag)
Computer: MacBook Pro 2.3GHz Core i7 with 8GB of RAM, Photoshop CS5.1,

Lightroom 3.4, Aperture 3.2, Nik Software Complete Collection

Josh Haftel

Camera: Nikon D700 and D3s

Lenses: Nikkor 24-70 2.8, Nikkor 24mm 1.4

Memory cards: Lexar 600X CF cards

Tripod: Gitzo GT3154L, Markins TB-30 tripod base, Really Right Stuff BH-55 ball head, Really Right Stuff Omni-Pivot pano package

Filters: B+W Kaesemann Circular Polarizer, B+W ND110 10-stop ND, Lee Big Stopper 10-stop ND, Lee .9 ND, Lee .9 Hard graduated ND

Bag: Lowepro CompuRover AW

Computer: MacBook Pro 2.3GHz Core i7 with 8GB of RAM and OWC SSD drive, Photoshop CS5.1, Lightroom 3.4, Aperture 3.2, OnOne Software Perfect Resize, PTGui Pro, Nik Software Complete Collection Ultimate Edition

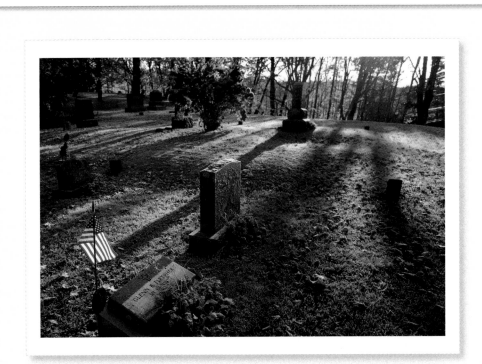

Contents

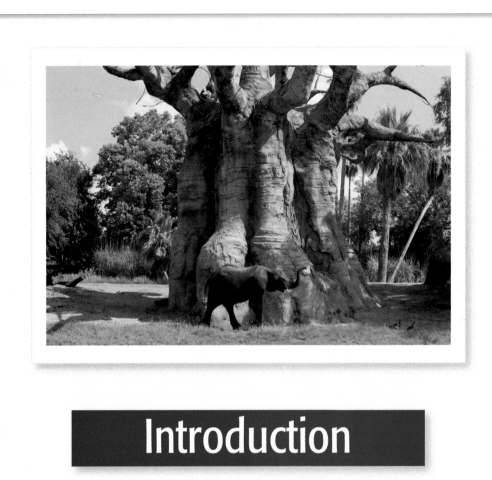

Introduction

Welcome to the world of Nik Software and our in-depth look at one of the most talked-about and successful line-up of tools for digital photographers. Over the past 12 years, Nik has changed the way photographers not only work but also think. Visualization has always been important to photographers as they would often expose the film based on techniques they would later use in the darkroom. Now, as you learn more and more about the things that you can do with these plug-in tools, you can once again visualize your postproduction at the time of capture, often changing how you shoot.

About This Book

We wrote this book for people who are new to image editing and enhancement, as well as for those who are completely comfortable with it. We have tried to ensure there are bits of important information for the seasoned professional and at the same time hit on elements that are key for those just starting. You will find general information on each Nik Software product as well as a step-by-step process for editing different types of images.

As you go through the process of editing, you will discover there are times you will want to spend extra effort on one aspect of your image and less effort on another. No two photographers can ever agree on how this time drain is organized — nor should they. The key is to be organized and understand the best tools available for the task at hand.

When we took on the task of writing this book, we found ourselves in a unique position. On one hand, we know the products and their use really well. On the other hand, we don't really know what people want or need to know about the topic. Then there was the decision on how to best present the information: from a technical standpoint or a more visual one? In this case, we have tried to offer a little of both. We have included as much technical data as is necessary to understand the software's functionality and enough aesthetic influence to show why the tools should be used.

Two Points of View

We come from two different worlds. Tony learned strictly on the job, having taken his first picture for a paying client. His style and desire to always learn more has helped to shape his work. Tony's story is unlike most who enjoyed photography as a hobby before making it a career. On the other hand, Josh learned his craft and honed his skills at one of the world's leading technology school, where he excelled at all things scientific and technical yet possessed a remarkable talent for the aesthetic as well.

Our approaches and techniques are quite different. Yet after coming together on this

project, we found that the final result, and ultimate goal, is precisely the same. We simply want to help people make better pictures. One of us takes a structured, engineer-like precision. The other is a fly-by-the-seat-of-the-pants kind of guy. Collectively, we have come up with what we believe is a good mix of technical and aesthetic and a good mix of how to do something and why you might want to.

We hope that as you go through this book, you will take the time to try the examples we present and recognize how much your work can improve by using these fabulous products.

Why This Book and Why Now

The digital revolution — certainly the transition from film — is complete. Today, more and more people are buying and using digital cameras, so there is an explosive need for information: purchasing the right camera, understanding how to make an image look better, and rescuing an important picture that was not taken under ideal conditions.

Photography is a wonder to us all, and we hope that as you go through these pages, the information helps you understand what is possible and how easily you can accomplish it.

Conventions Used in This Book

Although this book is chock full of how-to advice and examples, it is not full of arcane computer instructions. But occasionally, you will see a few computer conventions:

⌘: This symbol represents the Mac's Command key, which is equivalent to Window's Ctrl key. Where we do refer to keyboard shortcuts and keys, we list the Macintosh shortcut or key first, then the Windows shortcut or key. For example, if we say, "press and hold Option or Alt," that means to press and hold Option on a Mac or to press and hold Alt on a PC.

⇨: This symbol represents the use of a menu option, so File ⇨ Save means to choose the File menu, then choose the Save option, and Type ⇨ Format ⇨ Bold means to choose the Type menu, then choose Format from the menu, and then choose Bold from the submenu.

Finally, we use the `code font` to indicate URLs and other text you type in literally, such as in text fields.

Chapter 1

Editing Basics

By understanding the foundations of postprocessing, you will find that your editing not only improves but so will the speed at which you can process your images. In this chapter, we cover some of the basics of image editing as well as general terminology that you might encounter in this book or when discussing postprocessing with others.

Fundamental Editing Techniques

Far too often, we are approached by photographers who feel completely overwhelmed by the idea of editing their photos. These photographers range from folks with many years of experience shooting film to folks whose first camera was digital. When we talk with these photographers, we find that their biggest problem is knowing what to do — and why they should do it. Although the theory and reasons why you should edit in certain ways, along with all the different approaches, could fill volumes, there are a few basics that once you learn them help the process tremendously.

Evaluating an image before editing

The first thing you should do before making any edits is evaluate your image. Evaluating doesn't mean just to determine if the image is too dark or too bright or needs to be rotated or cropped, but to really identify what is wrong with the image and what you would like to do to it. There are different ways of keeping track of the things you want to do to your image, and although over time you will get good at identifying and then resolving the edits you identified, we recommend that you start off with a pad of paper at your desk and take notes as you edit your images.

Some photographers actually have a plan at the time of shooting. They visualize the final image even before the shutter opens. This takes lots of practice, because you will need to know what the image will look like once it has been captured. You then need plenty of knowledge of what you like as well as what tools are available and what those tools are capable of doing. This is a great goal, as it makes you a better shooter, and the act of evaluating your image once you have transferred to your computer is a good first step to being able to visualize your images.

Before starting to evaluate your picture, make sure your image has potential. You can spend a lot of time editing a picture just to find out that, no matter what you do, you cannot make it a great image. By being able to quickly determine if a picture has potential or not, you will prevent wasting time editing an image that you will never use.

Basically, an image with potential will have a clear subject and at least one of the three

following elements (the more elements the better): an interesting subject, interesting light, and good composition. Put another way, you can do something with a moderately interesting subject with mediocre composition but amazing light. Obviously, an interesting subject with awesome light and superb composition makes the best image, but you would be surprised what you can do when you have only one of the three elements to work with. Figure 1-1 shows an example.

Now that you have an image with potential, look at your picture as a whole and note where your eyes go first. Is that where you want the viewer's eyes to go to? Sometimes it is helpful to sit back from your picture a bit, or even allow your eyes to defocus if you are having a hard time figuring out the focal point. We often squint to see where our eyes go first.

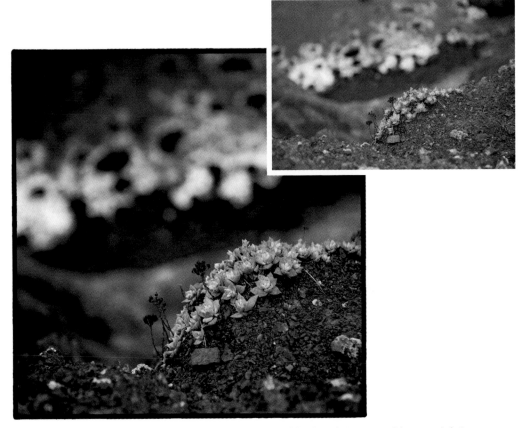

■ **FIGURE 1-1.** When evaluating your images, you can quickly identify images with potential. As an example, this image as shot in the camera (the inset) isn't very interesting, but with some editing it becomes memorable.

The first place you want your viewer's eyes to go should be the image's main subject. If your eyes don't go to the main subject, note where your focal point is and try to determine why. (We cover some of the possible reasons later in this chapter.)

You should next note the overall color and tonality of the image. Is the image too bright or too dark? Are the colors too bright or too subtle? Is the image too green or too warm?

What about the objects that are based on the four typical memory colors: sky blue, plant green, skin color, and neutrals? These colors are called *memory colors* because people see them so often and have an amazing ability to perceive the trueness of the colors. These are the most important colors in your image and if these colors are off, your viewers will immediately notice. Keep in mind though, it is perfectly fine for these colors to not be exactly as they are in nature. If these colors are different, just make sure they are significantly different and there seems to be a reason for a difference.

Next, look around the borders of your image. Are there things that could be considered distractions begging for the viewer's attention? Is there a curb cutting into the lower-left corner? Is there a telephone wire clipping the top-right corner? These are things that can be easily cropped and in most cases will need to be cloned if the cropping and composition are just right.

After closely scrutinizing the edges, look through the rest of the image for other elements that might become a distraction. Is there someone in the background looking right into the lens? Perhaps there's some noise, hot pixels, or dust on the sensor or lens? Note these to be fixed as well.

Finally, think about how you want the image to look. Is there an image or painting you are striving to emulate? Is there an emotion you want to impart? Knowing what you want to enhance before you start editing will help you make informed decisions as you begin to edit your image. For example, if you know that you want the image to end up with very warm, friendly tones, it doesn't make much sense to cool the image down even if it starts off a bit too warm.

Planning your edits based on the human visual system

In addition to developing your editing plans, it is a good idea to keep in mind a few things about the human visual system. Because we all make images for other people to enjoy, knowing how people look at images is very helpful when you plan your edits. Without simplifying things too much, think about the perception of a scene as a series of elements that will draw the viewer's eye. Those are, in order:

1. Faces and text. The first and strongest attractor to our eyes is the human face. This

FIGURE 1-2. Any picture with a face draws the viewer's attention right to the face, and usually to the eyes.

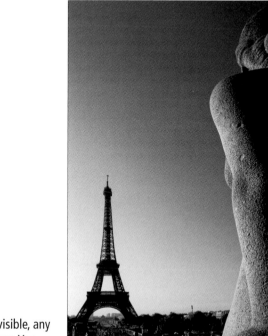

FIGURE 1-3. Although the eyes of the statue are not visible, any viewer can tell that the statue is looking at the Eiffel tower. You can use explicit and obvious leading lines, or implied leading lines such as in this photograph.

FIGURE 1-4. The use of blur to separate the subject from the background helps direct the focus of the viewer.

includes both actual faces and objects that look like faces, as Figure 1-2 shows. After human faces are the faces of animals. Text is also one of the first attractors.

2. **Leading lines.** Think about how easy it is to stop people by just pointing somewhere. You don't even need to point at anything in particular, you just need to point and people will look in the direction you are pointing. Leading lines act the same way, by pointing the way to people. You can use leading lines either to keep the viewer looking within your photo or to point to a subject in your image that you want someone to notice. Leading lines can also be implied, either by someone pointing in the image or through the gaze of a person in the photograph, as in Figure 1-3. The viewer will likely look at whatever the person in the photograph is pointing to or looking at, if they are not looking into the lens.

3. **Objects in focus.** Assuming that the image has a shallow depth of field, the viewer will certainly pay attention to the objects in focus first and foremost, as Figure 1-4 shows.

4. **Bright objects.** Just as when you are driving down a street at night and a car passes you but you can't stop looking at the headlights, we are attracted to bright lights. Any image with a very bright area will attract the viewer's attention to that spot, as Figure 1-5 shows.

5. **Colorful objects.** The more colorful, the more attention we give to that object, as Figure 1-6 shows. There is even a whole science to the way different colors attract our attention, but perhaps that is something for a book on advertising.

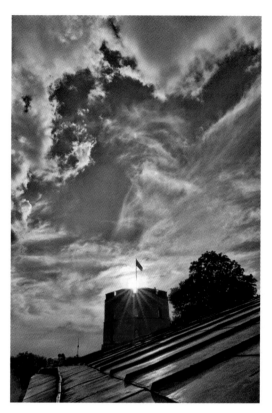

■ **FIGURE 1-5.** The sun in this picture is the brightest object and thus draws your attention directly into it and the castle in front of the sun.

6. **Objects with high contrast.** The higher the contrast of an object, the more attention we pay to it, as Figure 1-7 shows.
7. **Objects with more detail, compared to others.** If you have objects that are sharper than others, the viewer will look at the sharper objects first, as Figure 1-8 shows.

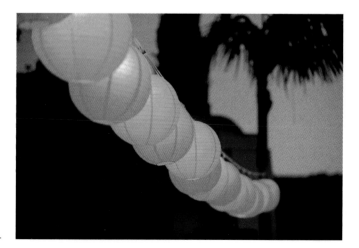

■ **FIGURE 1-6.** The colorful lanterns immediately draw the eye in this photograph.

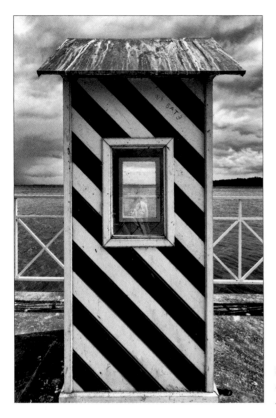

■ **FIGURE 1-7**. The high contrast building in this photo draws and captures the eye.

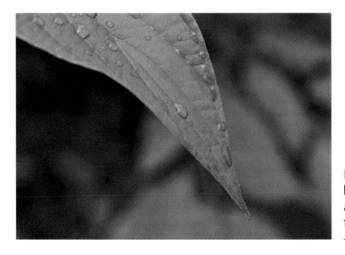

■ **FIGURE 1-8**. The combination of the out-of-focus background, the varying levels of focus on the leaf, and the leading lines of the leaf itself draw the eye to the tip of the leaf almost magically.

To put all these points into perspective, you want your subject to be in focus and normally be the brightest, most colorful, highest contrast object in the image that is also sharper than the rest of the image. Alternatively, you want to avoid areas outside your subject having these attributes, as they will be distractions.

Editing Terminology

With any new technology, concept, or practical science comes a new language. There are new words and phrases that become part of the daily work of people engaged in the same activity. Photographic editing is no different.

The following list contains the terms used in this book as well as terms generally used by photographers and digital artists. Although the list is in no way complete, it represents the most important terms photographers use on a daily basis.

Artifacts. Artifacts take on many shapes and sizes but are all unwanted details in your photo. Common types of artifacts are noise, hot pixels, JPEG artifacts, and chromatic aberrations.

Bit depth. Also known as *color depth*, this term describes the resolution of color information as well as dynamic range. Normal images have a bit depth of either 8 or 16

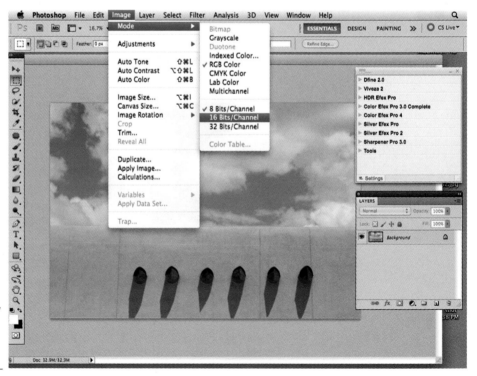

FIGURE 1-9. In Photoshop, you can change the bit depth for your images by choosing Image ⇨ Modes. Note that to get the true benefit of a higher bit depth, you need an image that originated with that bit depth.

bits per channel, although high-dynamic-range (HDR) images have 32 bits per channel. Each bit represents an increase in the number of hue (tonal) values based on a base 2 system. That is, an 8-bits-per-channel image has 2^8 (256) hues per channel. A 16-bits-per-channel image has 2^{16} (65,536) hues per channel. A 32-bits-per-channel image has 2^{32} (4,294,967,296) hues per channel.

RGB images have three channels total, yielding the total number of colors as the number of values per channel to the power of 3. For example, an 8-bit image can display 16,777,216 total colors, a 16-bit image can display 281,474,977,000,000 colors, and a 32-bit image can display 79,228,162,500,000,000,000,000,000,000 (!) colors.

The biggest benefit of larger bit depth is the ability to do a more extreme editing. When working with a low-bit-depth image, adjusting brightness or contrast too far may result in an artifact commonly referred to *posterization* or *banding,* as shown later in this chapter.

One drawback of higher bit depth images is larger file sizes. But you can start with a high bit depth and then reduce it in a tool such as Photoshop, as Figure 1-9 shows, to one that works both for the image and your file-size concerns.

Chromatic aberration. Also known as *color fringes*, these artifacts show up due to the way that different wavelengths of light bend at different angles when refracted through a medium such as a lens. Some lenses have stronger chromatic aberrations than others, but aberrations always appear as purple or blue fringes around fine objects that grow more pronounced the farther from the center of the image, as Figure 1-10 shows.

Color channel. To represent a large range of colors, digital images use three or four channels of color data per pixel. This makes it possible to cover a wide range of colors with less data, because the interaction between the different channels creates different colors.

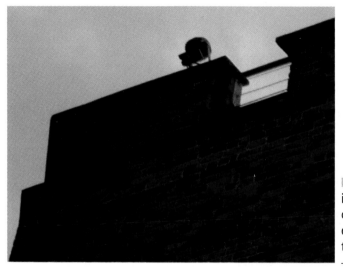

FIGURE 1-10. Chromatic aberrations are common in nearly any image from any lens. In this image, the chromatic aberrations are easily seen as cyan fringes on the top of the building and as red fringes below the light fixture.

It is possible, in some applications, to review or even affect a channel separately from the others.

Color space. A color space, also known as a *color profile*, is a model of colors that objectively defines the range of colors possible either as a working color space (which is a theoretical range of colors) or as an output color space (which is based off a device and that device's actual range of reproducible colors). Color spaces are used in one of two ways: to set up the relationship between colors while editing an image, or to understand the limitations of a specific output device and thereby work within those limits.

Common working color spaces are sRGB, Adobe RGB 1998, and ProPhoto RGB; each has its own pros and cons. Output color spaces are sometimes provided by a printer or paper manufacturer, and you can create them through the use of a color profiling system such as the X-Rite i1Photo Pro.

Color mode. A color mode is a way to describe a color based on a set of channels, or color attributes. Common color modes are RGB, where a color is made up of its red, green, and blue components; HSB, where a color is made up of its hue, saturation, and brightness components; CMYK, where a color is made up of its cyan, magenta, yellow, and black components; and Lab, where a color is made up of its luminance (L*), and two color-specific channels called a* and b*.

Modes such as RGB, HSB, and Lab are interchangeable. You also often interact with them directly, such as through a color picker or a control point.

The CMYK color mode is used only for printing, so we recommend only switching to this color mode as close as possible to the point in which the image will be rendered to the printing plates.

Color temperature. Even though color temperature is commonly selected at the point of image capture, color temperature also has an effect on the image as it is being edited, where you can use it to elicit a specific response.

FIGURE 1-11. The Photoshop color picker does a great job of showing the three main photographic color modes (RGB, HSB, and Lab) next to one another.

Color temperature traces its origin back to the CIE, the *Commission Internationale de l'Éclairage*, the international organization based in Vienna that led the way in creating the first color models and color spaces, from which the Lab color space is derived. To create that first color model, the CIE's scientists heated a piece of metal to different temperatures and then had individuals note their perception of the color of that object at the different temperatures. At lower temperatures, the metal radiated a reddish hue, and at higher temperatures it radiated a white-blue hue.

Today, we often refer to the color of light as either warm or cool, *warm* meaning that the image has more reds in it and *cool* meaning that the image has more blues in it. Figure 1-12 shows an example.

Halos. Halos are both an old and a new problem. They are mostly introduced by various postprocessing methods. Halos appear most often as light rings around objects, although depending on the object and the cause, they can also be visible as dark rings as well.

▦ **FIGURE 1-12.** We processed the same image three times to show what a photograph looks like processed cool (upper left), neutral (upper right), and warm (at immediate left).

FIGURE 1-13. We have purposefully introduced halos using the Unsharp Mask filter in Photoshop.

In the darkroom, halos could be created when dodging or burning an object, because most photographers used roughly shaped objects to block the light being added or subtracted from their image. In digital postprocessing, halos can be added either due to poor selection techniques or as a by-product of a image-processing algorithms, as Figure 1-13 shows.

FIGURE 1-14. Some hot pixels (here, the very bright red pixels here among the contrast and color noise) in an eight-minute exposure.

HDR. HDR is an acronym for *high dynamic range* and can refer to an image that was captured with an HDR process or the HDR process. A true HDR image has 32 bits per channel of color data and cannot be accurately viewed on a typical monitor (there are very few HDR monitors available). Normally, when someone refers to an HDR image, it is due to a specific look that the image has due to the current trends of HDR processing, which leans toward high contrast, high texture, high saturation, and often a large number of halos.

Hot pixels. Hot pixels are one type of noise, often created by very long exposures. Hot pixels appear as very bright and often colorful pixels in an otherwise dark and muted area. Hot pixels often need to be retouched by hand, one at a time, though Dfine 2.0's color noise reduction can often tame some of the less-intense ones.

LDR. LDR is an acronym for *low dynamic range* and refers to non-HDR images, such as nearly every image captured by current cameras.

Noise. Noise is an artifact of digital cameras due to many factors. Noise appears as different colors and shades in areas that should otherwise be smooth and is often a telltale sign of a digital image.

Pixel. A pixel is a portmanteau word combined of *picture* and *element*; it refers to the smallest element of an image.

Posterization. Also known as *banding*, posterization is most commonly caused by trying to adjust brightness, contrast, or saturation to extreme levels when working with a low-bit-depth image. Posterization occurs when a region with a gradient is edited such that the remaining colors in that region after being enhanced cannot create a smooth

■ **FIGURE 1-15.** In this 8-bits-per-channel image, too much contrast was added to the sky, resulting in the bands of detail.

transition from tone to tone. When posterization happens, bands of different tones appear, as Figure 1-15 shows.

To avoid posterization, you need to work with a higher-bit-depth image or reduce the degree of enhancement applied to the image.

RAW. A RAW image is the file format of a captured digital image. A RAW file contains all the data captured from the camera, which allows for maximum fidelity and processing flexibility at a later stage. A RAW file typically has the highest balance of quality efficiency because it contains more color information than the JPEG format and its file size is significantly smaller than the TIFF format.

Resolution. For most photographers, *resolution* refers to the spatial resolution of an object. The spatial resolution indicates the amount of information used to describe an object over a set length. Spatial resolution is only relevant for output (print), as digital display devices have a fixed resolution based on the size of the pixels in the display device.

Common forms of spatial resolutions are dpi (dots per inch, used with printers) and ppi (pixels or points per inch), both of which are used with digital files.

Other types of resolution common with digital cameras are color resolution (also known as bit depth) and temporal resolution (used in motion pictures only, and describes the number of frames per second).

Tone mapping. Tone mapping is the process of adapting an image's details from one medium to another. When shooting film, tone mapping is the process of identifying and assigning a tonal value from the real world to a portion of the film's reproducible range, and then from the film to the paper the image is printed on. In digital photography and editing, tone mapping refers to the transition from multiple LDR images into a single HDR image and then back to a single LDR image.

Chapter 2

The Digital Workflow

With digital photography, just as with any complex process, there are as many ways of creating pictures as there are people taking pictures. All too often, photographers — especially those new to digital — seek out the Holy Grail of image editing: the perfect workflow. This perfect workflow is a fallacy; it doesn't exist.

A Basic Workflow

There are certain steps that happen to fall naturally into certain parts of the flow of image creation, either because they must be done first (such as transferring an image to a computer) or because the benefits far outweigh the negatives (such as performing noise reduction early on). We give you the most basic parts of the workflow, along with reasons they should be done in this particular order.

We always recommend shooting in RAW format, therefore the following steps are based on images captured in RAW. If you are not shooting RAW, go out and buy a larger memory card for your camera and an extra hard drive — you need to start shooting in RAW.

Use the correct settings

We assume that you have a camera and have either set it correctly or are shooting RAW and are willing to change the settings later. The common adage "garbage in, garbage out" means you cannot fix something that is completely broken just as you cannot fix an image that is completely out of focus, poorly composed, or entirely too dark or too light. In all these cases, there isn't much you can do after the image is captured to fix it.

Another thing to keep in mind is that it is often a lot faster to set the image correctly in the camera than to fix it in postproduction. Sure, you can batch-process enhancements, but resetting the white balance on all your images or having to perform excessive noise reduction on images in which a high ISO wasn't necessary adds unnecessary steps to your workflow.

Organize your images

Organizing your images is an obvious workflow step, but it's not always done. It needs to be. Often, when life beckons, you might be tempted to throw the files into one big folder, a digital shoebox if you will — just like a pile of tax receipts. But the truth is that it is far easier to organize the images as they come in than to go back later and sort through hundreds (or thousands) of images when you need to find something quickly.

It is amazing how a simple organizational structure can save you heaps of time down

the line. Of course, you can go completely bonkers on the organization (there are entire books dedicated to digital asset management, or DAM), but unless you are a stock photographer, you can probably get by with a few simple rules:

Rule 1: Dedicate a place to store all your images, and keep all the images in that one place

Both the Windows and Macintosh operating systems have a folder called My Pictures and Pictures, respectively, that is often a good place to start. If you don't want to store all your images on your hard drive, you can set up a My Pictures or Pictures folder on a different disk.

Rule 2: Set up a folder hierarchy

We've found the easiest hierarchy is year, followed by the specific photographic event, starting with the month it was taken. Make sure to use four digits for the year and two digits for the month to keep things organized neatly, as well as easily identifiable. A slightly reduced example of one of our picture folders is:

```
Pictures
2010
04 - Berlin
06 - Maine
06 - Tokyo
08 - Lithuania & Russia
12 - San Francisco
2011
01 - Mono Lake
03 - Hong Kong
04 - Muir Beach
04 - Portland
05 - Joshua Tree
```

Rule 3: Transfer the images to your system using your application of choice

We both use a photographic library application, such as Lightroom or Aperture, to transfer and catalog our images. Most photographers use one of these two tools, and we highly recommend picking one and getting it into your workflow. Figure 2-1 shows an example of one of our Lightroom libraries.

Depending on the tool you use, we recommend adding labels, ratings, and even tags to your images. We don't tag every single image, but tags can help you find your best shots later. Consider adding a rating to your favorite images, or creating portfolio tags based on

subject matter. Using tags, you can create intelligent collections of your photos that are automatically updated as soon as you add a specific tag to a photo.

Identify images to edit

Selecting only the images to edit may sound like common sense, but we have seen wedding photographers, with *thousands* of images from a single shoot, go through batch processes on all their images. In the end, their clients see maybe 100 images, so editing those other thousands of images was a waste of time. Going through and identifying only the images that need to be edited will save you heaps of time, and in the end, that is what a good workflow is about: saving time while getting the best possible results.

Many photographers use an iterative approach, such as:

- **Step 1:** Go through and reject all the images that are out of focus, contain blinks, are too dark or too light, or whose subject matter just didn't work out like you thought it might before pressing the shutter button. Hide all the rejected images.
- **Step 2:** Go through the remaining images and identify the "hero" shots. These are the images that are obviously the keepers. Some photographers do this step as they go through their rejects; it all depends on how you like to work. Hide all the hero shots.

FIGURE 2-1. Josh's Lightroom organization structure (its libraries)

■ **Step 3:** Go through the remaining shots and look for images that could be keepers with the help of a few tweaks. This step takes a bit more practice to be able to quickly identify images that could be turned into a keeper with a crop, tonality adjustment, or filter. Figure 2-2 shows images tagged as rejects as well as keepers.

During this process, you may also want to label or tag images for specific types of enhancements. For example, we use the label function in Lightroom to identify the major types of images that we shoot: single shots to be edited, panoramas, HDRs, and HDR panoramas. For series of images, we also group the series into a stack, making it easier to keep track of the images.

These steps all rely on a photographic management tool such as Lightroom or Aperture, but you can do some of these steps without an application.

Apply any RAW-based adjustments

Now that you have narrowed down the images that should be edited, it is time to work on refining the attributes that affect the entire image. This can include tweaking the white balance, adjusting the exposure, and recovering highlights or shadows. We don't recommend adjusting the contrast and saturation or applying too much sharpening, as

■ **FIGURE 2-2.** Using Lightroom to mark rejected images (the flag with an X), selected images (the white flag), and other images.

these adjustments greatly (and adversely) affect the noise in the image, making it hard to apply noise reduction later. You may even want to adjust only the white balance and highlight recovery, as these two adjustments can be done only on a RAW file. Figure 2-3 shows adjustments being made to a RAW file in Lightroom.

Apply lens-based enhancements

In this optional step, you can fix any potential artifacts caused by the lens. Even the most expensive lenses can suffer from distortion, chromatic aberrations, or vignetting, and many enhancements applied later in the workflow can even exaggerate these artifacts. Photoshop, Lightroom, and Aperture all have tools to help you fix these issues, either automatically or manually (see Figure 2-4).

Crop the image

Many photographers argue that cropping can be done at any time in the workflow. But we recommend cropping early in the workflow, because if you are like us at all, an area of the image that just should not be there might distract you. Getting rid of distractions

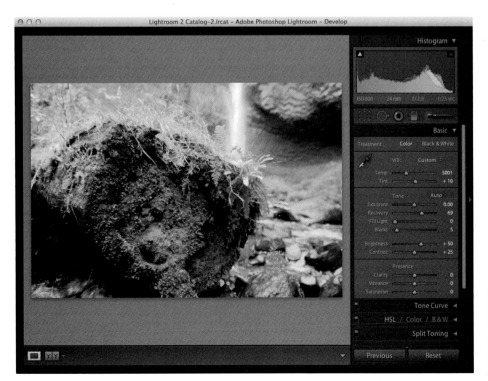

FIGURE 2-3. Using Lightroom's Develop module, the white balance and highlight recovery are adjusted.

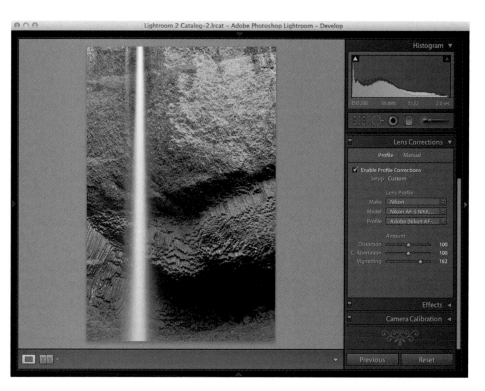

FIGURE 2-4. The lens corrections in Lightroom's Develop module are just one of the tools available to apply lens-based enhancements.

is good for you, as you will spend less time worrying about distractions. It's also good for your viewer as well, because your subject will stand out more.

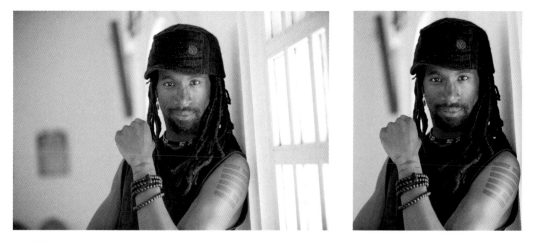

FIGURE 2-5. Left: The original image as captured. Right: Cropping can help remove distractions or sections of the image not relevant to the subject.

Keep in mind that cropping reduces the amount of information in your image, so cropping in camera (by composing the image correctly) is always a good idea but not always possible. Figure 2-5 shows how an image can be improved by cropping.

Apply noise reduction

Even though we love Dfine 2.0 and believe it is the best noise-reduction tool available, we don't recommend using it on every image. We cover noise reduction in Chapter 5, but to keep it short: Apply noise reduction *only* to images in which you think the noise will interfere with the viewer's appreciation of the image.

When applying noise reduction, apply it only to the areas in the photo that need it, such as with Dfine's control points or the Brush tool, available in the Photoshop version of the filter.

Do panorama stitching or HDR merging and tone mapping

If you're making a panorama, stitch the images together with your preferred stitching tool. If you are making an HDR image, now is the time to merge and tone-map the image. For an HDR panorama, first make the panoramas for each exposure and then make the HDR with the different stitched panoramas. Chapter 7 explains how to create HDR panoramas.

If you're working with a single photo, skip to the next step.

Retouch dust or other imperfections

Retouching is also often done as a later step, but retouching earlier means you will be less distracted by the dust that appears on your image. Figure 2-6 shows an image before and after dust has been removed.

Use Viveza 2 to balance light and color

Viveza 2 makes it possible to control light and color both globally and selectively in your photos using Nik Software's patented U Point technology.

Make sure to start adjusting the tonality and color problems that affect the entire image equally (such as the entire image having a colorcast or being too dark) and then work your way down to the local level, adjusting specific areas using control points.

If you are creating a black-and-white image, skip this step. Figure 2-7 shows the Viveza 2 interface.

▨ **FIGURE 2-6.** The Spot Healing tool in Photoshop is useful for getting rid of dust and other distractions. The top image is the original, and the bottom image is the touched-up version.

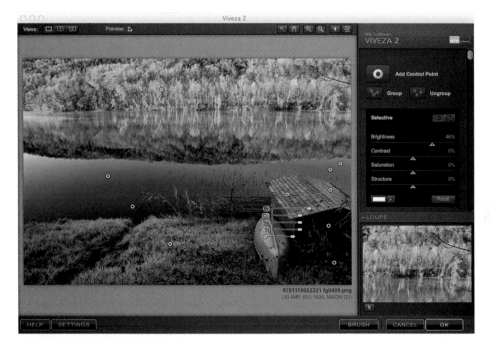

FIGURE 2-7. Viveza 2 lets you make powerful selective adjustments with just a few clicks.

Stylize with Color Efex Pro or Silver Efex Pro

Both Color Efex Pro 4 and Silver Efex Pro 2 provide a wide range of possibilities for stylizing and enhancing your image. Color Efex Pro provides 55 filters that you can use to create a unique look or feeling in your image. Silver Efex Pro provides all the controls you need to get the highest possible quality black-and-white images. You can even use both tools on the same photo.

Make a final round of clean-up

Now that your image is enhanced and about ready for output, it never hurts to go through and do a final once-over to look for any errant pixels, dust, artifacts, and other unwanted elements you may have missed earlier. Use the retouch brushes in Photoshop, Lightroom, or Aperture to make sure the final result is all about the subject, not about a small hair or piece of dust that got on the sensor and was blown up to two feet across.

For Photoshop only: Save a master version

If you're working in Photoshop, make sure to save a master version of your file. This master version contains everything you've done to your image so far and often will be the only file in addition to the RAW file that you should keep.

For Photoshop only: Resize based on output

You should resize as late in the process as possible. When you resize your image, the image size increases, which requires additional time and processing to apply any enhancements. Thus, if you resize early, each edit will take longer. Additionally, the resizing process works with interpolated (computer-created) image information, but some image processing algorithms (like noise reduction) work better with the original details.

Resizing at the end makes quite a few things possible. First, it ensures that you are working with the optimal (native) resolution throughout all your enhancements. Second, it ensures that you are not processing unnecessary pixels at each step: Resizing last means that there are only one or two steps done on the large file size, instead of all the steps. Resize either using Photoshop's Image Size function or, as we prefer, using OnOne Software's Perfect Resize. Figure 2-8 shows the Perfect Resize interface.

This step isn't necessary if you are working in Lightroom or Aperture, because both applications keep the image at the native resolution until you output the image in print, upload to the Internet, save to disk, and so on.

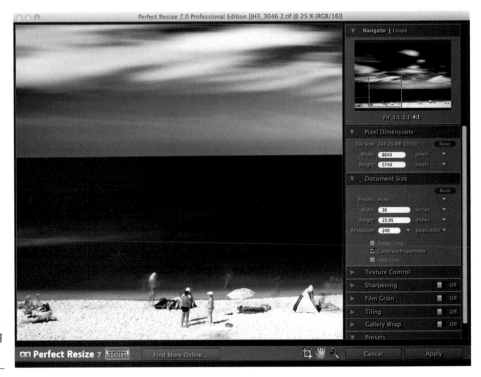

FIGURE 2-8. Perfect Resize can produce better results when making enlargements.

Sharpen based on output

Sharpen the image appropriately for the type of print device you will be using for output. Chapter 10 shows techniques to use when working with Sharpener Pro in Photoshop, Lightroom, or Aperture. Sharpener Pro's interface is shown in Figure 2-9.

For Photoshop only: Save your sharpened working file

To avoid resizing and sharpening a file you know you are going to print again, save the file, but in the filename, clearly identify that it is the resized and sharpened version. Also include the file size and output method you've sharpened for, as shown in Figure 2-10.

Note that this step isn't necessary if you're working in Lightroom or Aperture.

Print or upload your masterpiece

Finally, you're ready to share your image, as Figure 2-11 shows. This is definitely the most important step in the entire workflow. After all, why else do we capture an image than to share it with the world?

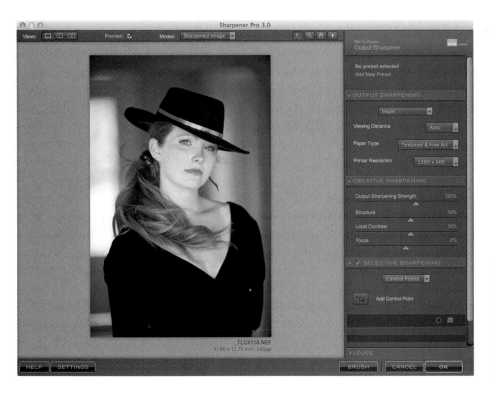

FIGURE 2-9. Sharpener Pro provides powerful control for optimal sharpening without the guesswork normally involved in image sharpening.

■ **FIGURE 2-10.** Finding and using naming convention consistently makes it easier for you to find a specific file.

■ **FIGURE 2-11.** There is no better feeling than seeing your masterpiece coming off a printer.

Creating a Custom Workflow

As with any technical process, there are certain compromises that you need to understand and accept.

Noise reduction

Noise is usually manifested as a small difference in colors and shades in an area that should otherwise be all the same. Anything that increases the difference of tones (such as sharpening, contrast, shadow correction, or saturation) will exaggerate noise. If you plan to do any of these enhancements later (especially at extreme levels), consider doing noise reduction to the image, even if the image doesn't seem to need it. It is much easier to apply noise reduction earlier in the process than later.

Noise reduction, in its basest form, is a type of blurring. Each noise-reduction tool tries to focus and limit blurring to only nondetail areas, and although the technologies that allow this are getting better and better, expect detail loss when applying noise reduction.

Thus, it is important to apply noise reduction only to areas that need it, and to not apply noise reduction to areas that don't need it. The inclusion of U Point technology in Dfine 2.0 greatly helps with noise reduction, as Figure 2-12 shows.

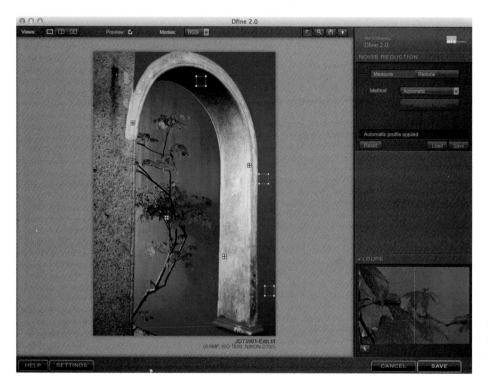

FIGURE 2-12. Applying noise reduction in Dfine 2.0

Additionally, excessive noise reduction in areas of subtle tonality shifts, such as the sky, can result in posterization (also known as *banding*). You need to strike a fine balance for skies or similar areas between noise reduction and noise, as noise can help prevent banding or posterization.

Resizing

There are two schools of thought when it comes to resizing. One is to resize the image early in the workflow and do all your edits on the final output image. The other is to wait as long as possible to resize the image, resizing immediately before sharpening.

We recommend waiting to resize because it will save time (you process smaller files in the interim) and will make it possible to have different output sizes later.

Cropping

Deciding when to crop an image can be difficult. Basically, not cropping early means that annoying branch, useless dead corner, or other area of your photo will distract you. At the same time, cropping before you know exactly how the image is going to be used (which is common) means that you might lock your image into a size or format that does not work with the final output.

Some photographers find that they use only a certain aspect ratio. For example, there is a growing trend toward square images. If you crop an image into a square, but later realize that your image needs to be a rectangle, you either have to crop again (losing more image information and maybe image detail important to the image itself) or you have to go back to the beginning and do everything all over again.

If there is any possibility that you might need to change the crop, either to allow more artistic freedom or if you are not entirely sure of the printed result, hold off cropping until later.

RAW presharpening versus sharpening

Many an Internet flame war has started over whether or not to apply RAW presharpening, shown in Figure 2-13. We explore RAW presharpening in Chapter 10, but sharpening is part of the workflow and you need to decide whether the image is worth it or not.

Some photographers argue that performing a RAW Presharpening step prepares the image for editing and makes it possible for the output sharpening step to create more

optimally sharpened images. Other photographers argue that RAW presharpening
adds an extra step to the process, slowing the entire workflow without adding any
discernible difference in the final image. We haven't seen any incontrovertible proof that
RAW presharpening is needed, but we have seen amazing images and heard convincing
arguments on both sides of the debate for why it should or should not be applied.

We recommend that anything that makes the workflow faster and more efficient is
best for your photo (and for your sanity), but knowing the pros and cons (as described in
detail in Chapter 10) can help you decide whether RAW presharpening is for you.

Output sharpening

One of the biggest gripes that photographers have, especially photographers working
in high-volume jobs like portrait and wedding photographers, is that sharpening differs
based on the output.

You can take the optimal approach and sharpen each image for output after it has been
optimized for that output (meaning you resize each image for each output size and then
sharpen according to that size and output system) or sharpen once and accept that the
different sizes and results of different output devices won't be optimally sharp.

This is purely a decision you will have to make based on your own balance of quality
and efficiency. In the end, the result won't be night-and-day, but it will be noticeable, so

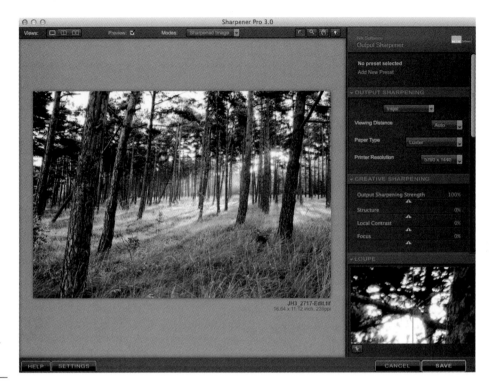

FIGURE 2-14. The Output Sharpener filter in Sharpener Pro 3.0

you'll have to see which is more important. (We cover sharpening more in Chapter 10.)

Living in the land of 2 percent versus the real world

A photographer that we work with often talks about the land of 2 percent. This is a special land, with a very small population, and you need to decide if you want to live there.

The denizens of this land believe that *anything* that makes their image at least 2 percent better is worth the extra time, money, and effort. In this land, time and money are not objects, and whatever is best for the image is done.

Living in the land of 2 percent is basically the opposite of an efficient workflow, but it can result in truly spectacular images. It is not a land we recommend for everyone, and it can be difficult to make any money with this approach to image creation. Furthermore, the consumers of these images often can't tell the difference. Very often, the photographers that live in this land do it for themselves or their peers, not their clients.

Many people know right away if they want to be part of this world, while others have to go through a journey of self discovery to learn which world they live in. Of course, it doesn't have to be so black-and-white, as many photographers (us included) find that we have a time-share in this magical world of no sleep and maxed-out credit cards.

Your Personal Workflow

Now that you have a list of recommended steps, an understanding of some of the compromises, and things to think about, you can create your own custom workflow.

We have different workflows, one for HDR images, one for panoramas, one for weddings, one for portrait sittings, one for travel photography essays, one for landscapes, and so on. Don't try to create one master workflow that works for all the types of photography you do, but rather adapt your workflow based on the needs of that specific shoot.

Keep these things in mind:

■ As much as possible, strive to get the shot in the camera with the best possible settings.

■ Use a basic organizational system when transferring your images to your computer.

■ Edit only the images that have a possibility of seeing the light of day — editing images that no one will ever see only reduces the time for sleeping or spending with loved ones.

■ Always keep in mind what the final use is going to be. That is, will the image be printed larger than life on a billboard or as a small image on a web page? If the image might be used in different places, you might need to treat it differently, such as making sure there is the possibility of changing the crop, not applying sharpening, and more.

■ Go from global (things that affect the entire image) to local (things that only affect a small part of the image).

■ Noise reduction should be done as early as possible.

■ Resizing should be done as late as possible, but right before sharpening.

■ Sharpening should be done as late as possible, and be specific to the output.

■ Find out if you are living in the land of 2 percent or not, and create your workflow accordingly.

■ Finally, be flexible and adapt as needed!

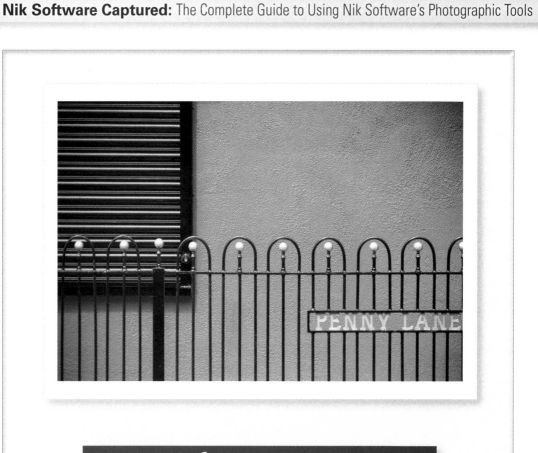

Chapter 3

The Nik Software
Editing Environment

To get the best results from any of the Nik Software tools, it is important to understand how their interfaces were designed and how to best use them. In this chapter, we describe the differences between working in various host applications, the intricacies of the interface (including the small differences of each interface), and the Selective tool in the Photoshop version of the software.

Differences in Host Applications

All Nik Software products are designed to work in another application, which is often referred to as the *host application*. All the most recent versions of Nik Software plug-ins can also be used as standalone applications, thus not requiring a host application. However there are limitations to using the Nik products as standalones.

Keep in mind that apart from the Complete Collection for Lightroom and Aperture, every Nik plug-in installs in each of the host applications you have.

Adobe Photoshop

Nik Software designed its first products to work with Photoshop. Because Photoshop is a complex product, and because it has been around for quite a while, there is a lot you can accomplish with this application.

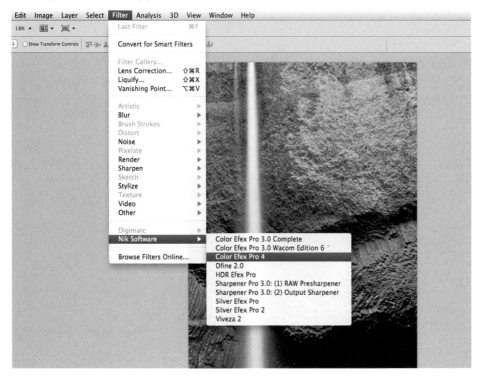

FIGURE 3-1. Accessing the Nik filters in Photoshop.

Photoshop pros

There are many reasons to work in Photoshop; here are a few pertaining to the Nik filters.

- ■ **Layers**. The ability to work with layers is one of the biggest advantages to working with Photoshop. Each layer can include a different version of the image or a portion of the image, can be selectively mixed with other layers, and can even be blended into other images based on the tonality of the image results. The sheer number of possibilities that layers offer makes Photoshop the king of photo editing.

- ■ **Selectively applied enhancements.** Using either the layer masks connected to a layer or using the many selection tools (Lasso, Magic Wand, and Paths, to name a few), you can apply a special enhancement to only a portion of an image. The selection tools let you isolate one area of an image and adjust it without affecting the rest of the image. The result is far more control over the finished product than ever before in photography.

- ■ **Smart filters.** Smart filters are a unique function in Adobe Photoshop that make it possible to nondestructively apply filters, which lets you disable the edits you made and go back to the original, unedited images. Nondestructive edits also let you adjust any settings you have already made. When applying a Nik plug-in as a smart object, you can apply a filter and then at any time, even after closing the image, adjust the settings of the filter to refine or alter the enhancement applied. Photoshop is the only host application that lets you nondestructively edit with all the Nik filters.

- ■ To apply a Nik product as a smart object to your images in Photoshop CS4 and later, choose Filter ⇨ Convert for Smart Filters. Then, any time you apply a Nik filter to your image, it is applied as a smart object. Double-clicking the filter's name opens the filter interface and lets you change any of the settings you previously made to your image. To ensure that the smart filters are not removed, make sure to save the file as a native Photoshop (`.psd`) file or as a TIFF file with layers.

- ■ **Batch processes.** Although Lightroom and Aperture offer a level of batch processing (and with Color Efex Pro 4, a more traditional type of batch processing), only Photoshop offers a true, traditional batch processing capability for all the Nik filters. (We provide information later in this chapter on how to apply a batch process with Photoshop.)

- ■ **Native support for 32-bits-per-channel files**. If you're working with HDR and want full control over your images, we recommend working with Photoshop.

Although Lightroom and Aperture let you create an HDR image, you cannot work with the 32-bit version of the file — all the 32-bit processing happens only in HDR Efex Pro.

Photoshop cons

As with any software, there is no such thing as a perfect host application. Here are a few of the problems you might encounter when working with Photoshop.

- **Photoshop is expensive.** Price is obvious. Unless you are a student or educator, Photoshop is expensive.
- **Files are significantly larger after editing with multiple layers.** Every time you add a layer to your image, you are essentially adding another file of the same size as the image you started with to your overall file size. There is compression with the native Photoshop or TIFF file formats (which are needed to retain the layers), but you will still see your file grow considerably if you save the layers.
- **Filters can fight Photoshop for memory.** The RAM battle is a bit more difficult to understand, but it could have an effect on your workflow. As you may know, Photoshop is memory-hungry. Even on systems with lots or RAM, you can use up all that memory quickly. Photoshop lets you select the amount of memory it uses, and when setting that memory, Photoshop tries to lock in that RAM for its use. It won't then share that memory with the filters. Lightroom and Aperture tend to play nicer regarding the amount of memory used and allocated to the filters. If you have a limited amount of memory, you may need to reduce the amount of RAM allocated to Photoshop (in Photoshop's Preferences dialog box) to ensure there is enough RAM available for the filters.

How to access Nik filters in Photoshop

To access Nik filters in Photoshop, you can use either the Selective tool (cover later in this chapter) or you can use the Filters menu shown in Figure 3-1. To merge multiple images with HDR Efex Pro, choose File ➪ Automate.

Adobe Photoshop Elements

Photoshop Elements is the middle child in the Adobe photographic editing line-up, not quite as old as Photoshop but older than Lightroom. As Elements was designed as a lower-priced, easier-to-use editing tool than its bigger brother Photoshop, there are limitations in what can be done in it. For example, you cannot perform batch processes, there are no

smart filters, and until the most recent versions, there were no layer masks. Still, there are benefits to this image editing application that make it a favorite with a large number of photographers.

Photoshop Elements pros

Elements provides most of the power of Photoshop but at a much lower price, making it a powerful application:

- **Least expensive editor with full support for Nik Software plug-ins.** Although there are less expensive host applications out there, none of them offers full Nik support. The filters might not work completely, might crash, or might have other problems. Photoshop Elements doesn't have any of these problems.

- **Layers.** Just as with Photoshop, you can use layers on your images and, with the latest versions of Elements, you can even use layer masks.

- **Selectively applied enhancements.** You can selectively enhance images using either the built-in selection tools, or, with more recent versions of Elements, layer masks.

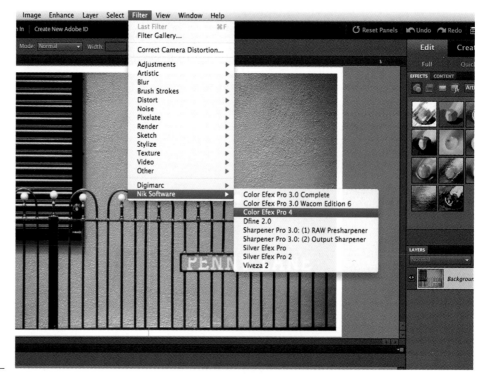

FIGURE 3-2. Accessing the Nik filters in Photoshop Elements.

Photoshop Elements cons

Of course, there are differences between Photoshop Elements and Photoshop. These may or may not be deal-killers for your workflow:

- **No smart filters.** Filters added in Elements cannot be applied nondestructively, but they can be applied to a separate layer, making it possible to remove the enhancement applied.
- **No batch processing.** If you are working with many images and you want to apply the same enhancement over and over again, you might need to use a different host application.
- **No 32-bit support.** You cannot use HDR Efex Pro to create HDR images. Because of the lack of 32-bit support in Photoshop Elements, HDR Efex Pro is the only Nik Software product that is not compatible with Elements.
- **Filters share memory with Elements.** Just as with Photoshop, memory constraints might happen more frequently than when working with Lightroom or Elements.

How to access Nik filters in Photoshop Elements

You access the Nik Software products through the Filters menu (shown in Figure 3-2).

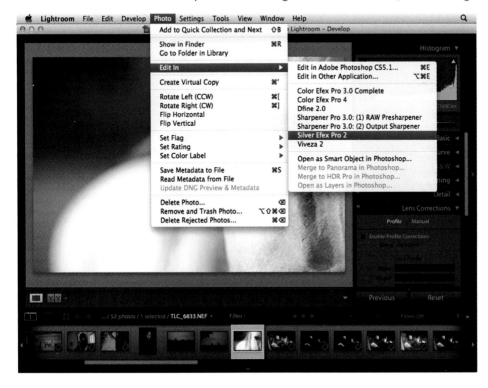

FIGURE 3-3. Accessing the Nik filters in Photoshop Lightroom.

Adobe Photoshop Lightroom

Lightroom is the most recent photographic editing application from Adobe, and it has quickly grown in popularity. Lightroom, as does Aperture, takes a photographic-only approach, unlike Photoshop and Photoshop Elements, which also offer features for the graphic design community. Due to its workflow-specific approach, Lightroom has limitations that you should understand before using Nik filters with it.

Lightroom pros

Due to Lightroom's photographic nature, there are plenty of reasons to use Lightroom with Nik filters:

- **Cheaper than Photoshop.** Although not as inexpensive as Elements, Lightroom is still less than half the cost of Photoshop.
- **Organizational approach well suited for HDR.** If you are working with HDR images, the way images are organized in Lightroom is very helpful and makes finding and creating HDR images easy.
- **Filters do not share memory with Lightroom.** Because Lightroom does not share its RAM, opening filters is often faster and causes fewer memory issues than working with Photoshop or Elements.
- **Ability to edit multiple images in a row with different effects.** Apart from Color Efex Pro 4, you cannot use Lightroom to do a traditional batch process (applying the same effect to a range of images), but you can open multiple images in the interface at once, reducing the number of steps needed to process each image, thereby speeding up the process.

Lightroom cons

There are limitations inherent in the single-image interface that Lightroom uses that you should be aware of:

- **No layers.** The only way you can apply enhancements selectively is by using the control points in every Nik filter.
- **No batch processing.** Apart from Color Efex Pro 4, you cannot apply the same effect to a series of images quickly and easily.
- **No smart filters.** All filters are applied to a TIFF file that is created based on the original image, breaking the connection to the original RAW file and preventing a true nondestructive workflow.
- **Costlier than Elements and Aperture.** If cost is the biggest factor in your selection of a host application, you can find cheaper options.

How to access Nik filters in Lightroom

You access plug-ins, other than HDR Efex Pro, by either right-clicking on the image and choosing Edit In from the popup menu or by using the Photo menu while in Lightroom's Develop module (see Figure 3-3). You access HDR Efex Pro either right-clicking an image series and choosing Export from the contextual menu or by choosing File ➪ Export with Preset.

Aperture

With the recent price reduction in the Mac App Store, Aperture now is the least-expensive host application for Nik filters, making it an attractive option. Aperture is, of course, only available for Macintosh computers and so isn't available for all users. It also uses a different interface, terminology, and shortcuts from Adobe products. Aperture does many things very well and is certainly a strong contender in the photographic application segment.

Aperture pros

If you use a Mac and are looking for a solid host application, Aperture offers many pros

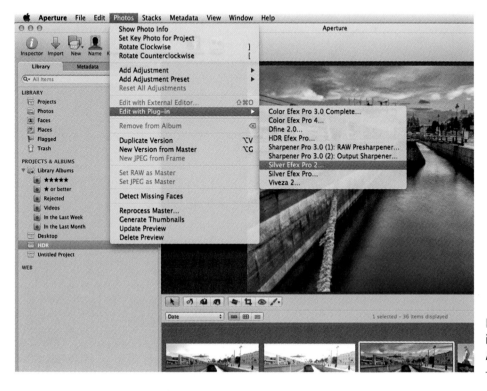

■ **FIGURE 3-4.** Accessing the Nik filters in Aperture

over other host applications:

- **The least-expensive host application.** At the time of publication, Aperture cost only $79 in the Mac App Store. You can now get a pro-caliber application for less than Photoshop Elements (depending on where you shop).
- **Organizational approach well suited for HDR.** Just like Lightroom, the file organization approach in Aperture is great for finding and processing HDR image series.
- **Ability to edit multiple images in a row with different effects.** Also like working in Lightroom, apart from Color Efex Pro 4, you cannot use Aperture to do a traditional batch process (applying the same effect to a range of images), but you can open multiple images in the interface at once, reducing the number of steps needed to process each image.

Aperture cons

Aperture has many of the same cons as a plug-in host as Lightroom, as the approach is similar:

- **No layers.** Without selective capabilities built into the software designed to work with plug-ins, the only way to selectively apply a filter is through the control points.
- **No batch processing.** Filters cannot be applied to a number of images to create the same effect.
- **No smart filters.** There is no way to undo or adjust the settings made with a filter in Aperture, other than starting over from the beginning.

How to access Nik filters in Aperture

As shown in Figure 3-4, you can access the plug-ins by either right-clicking and choosing Edit with Plug-in in the contextual menu or by choosing Photos ➪ Edit with Plug-in.

Standalone Nik Software plug-ins

All the Nik Software plug-ins can be used as separate applications, outside a host application.

Because Lightroom doesn't support plug-ins directly, Nik Software designed its plug-ins to be standalone applications. Lightroom creates a TIFF file, opens a separate application, and sends that generated TIFF file to the application that requested the TIFF, such as a Nik plug-in. This essentially requires that any product that works with Lightroom be a standalone application.

Standalone plug-in pros

There are few positives about running the Nik plug-ins as standalones:

■ **No host application needed.** If you really don't want to use a host application, the Nik plug-ins could be a plus for you.

■ **Lowest memory footprint, because no host application is required.** If you have a severely limited amount of RAM available, a Nik standalone might be your only option.

■ **Ability to used a standalone with other host applications.** For host applications that do not support the plug-ins natively (such as Capture NX), you can use the Nik standalone version.

Standalone plug-in cons

To us, the cons outweigh the pros — we don't recommend using the Nik filters only as a standalone. Here are a few reasons:

■ **Awkward workflow in which the interface is closed after each image is edited.** Because the standalone versions were originally designed to work with Lightroom, pressing the Save button closes the interface. Closing the application makes perfect sense when working with Lightroom because you would then be in the Lightroom interface again looking at your processed image, but it doesn't make sense when you are working with the filters as a standalone.

■ **Inability to open RAW files.** If you shoot RAW as we recommend, you cannot open the files directly into the standalone plug-ins.

■ **Overwriting of the original images.** When you click Save, the original image is overwritten without an option to choose a different name. You have to copy or duplicate the file *before* you start editing it if you want to keep the original image.

■ **No selective application.** Apart from the control points in the plug-in, applying a filter as a standalone application applies the effect to the entire image.

How to access the standalone plug-ins

To use the Nik filters as standalones, you either need to drag an image file directly on top of the application icon or right-click on the file, choose Open With from the contextual menu, and then locate the application that you want to use to open the image.

Other Host Applications

As this book went to press, there were no other available host applications that provided 100-percent compatibility with the Nik Software plug-ins. But there are other host applications in which the plug-ins might load and might work — but you could also experience problems. We recommend you try the software combination a few times before embarking on a deep image-editing process to make sure you don't lose any of your work due to an unexpected crash.

Which Host Application to Use?

We get this question all the time. You can, of course, use our descriptions to determine which application meets your needs. Most photographers these days work with both a photographic organization tool such as Lightroom or Aperture *and* a pixel-editing application such as Photoshop or Photoshop Elements. Of course, this implies that

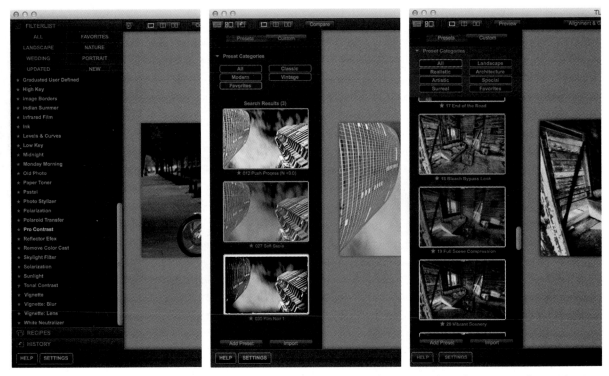

FIGURE 3-5. The left panes, from left to right, for Color Efex Pro, 4, Silver Efex Pro 2, and HDR Efex Pro. In the left pane stores the filters, recipes, and history. In Silver Efex Pro 2, it stores the presets and history. In HDR Efex Pro, it stores the presets.

you have the time and money to learn and purchase two host applications. Many new photographers are starting off only with Lightroom or Aperture and then later add a pixel editor. As with everything, it will completely depend on your particular needs.

Standardized user interface

All the Nik Software filters use similar interfaces. By keeping the look and overall feel consistent from product to product, you have a more intuitive feel with the filters. Although there have been changes to each subsequent generation of plug-ins, the placement and goal of the functions remain the same.

The interface is broken into five main areas: the left, top, right, bottom, and image areas. In addition to the interface, in Photoshop and Elements there is the Selective tool as well.

Left pane

Color Efex Pro 4, Silver Efex Pro 2, and HDR Efex Pro all have a pane on the left side.

FIGURE 3-6. The top toolbars for the Nik plug-ins. From top to bottom: In Dfine 2.0, you get the typical viewing controls, the Preview check box, the Modes popup menu to display different masks, zoom controls, and the Background Color button. In Viveza 2, you get the typical viewing controls, preview check box, the Background Color button, and a control mechanism to hide the right pane. In HDR Efex Pro, you get the typical viewing controls, the Preview button, the Alignment and Ghost Reduction Settings buttons, zoom controls, the Background Color button, and a control mechanism to hide the right pane. In Color Efex Pro 4, you get a control to hide the left pane, the typical viewing controls, the Compare button, zoom controls, the Background Color button, and a control mechanism to hide the right pane. In Silver Efex Pro 2, you get a control to show the presets or history browser, the typical viewing controls, the Compare button, zoom controls, the Background Color button, and a control mechanism to hide the right pane. In Sharpener Pro 3.0, you get the typical viewing controls, the Preview check box, the Modes popup menu to display different masks, zoom controls, and the Background Color button.

The contents and purpose of the pane differ slightly from product to product. Figure 3-5 shows the various plug-ins with a left pane.

Top toolbar

The controls in the top toolbar affect the display of the image. There are tools to show the complete image, compare the image with the original either side by side or with a split view, tools to zoom or interact with your image, and sometimes tools to show a mask or other view of the image. Figure 3-6 shows each of the top toolbar for the six Nik Software plug-ins.

Right pane

The main controls specific to each product are in the right pane, including all the sliders that adjust the effect of the filter. We describe the filter controls in each filter's chapter.

Each product also has variations of the loupe, navigator, and histogram. These mechanisms make it possible to see the details of the image zoomed into 100 percent; in some applications you can also see a histogram showing the distribution of lightness values.

Tip: To lock the position of the loupe without clicking on the thumbnail icon, right-click on top of the image wherever you would like the loupe to stay.

Bottom toolbar

The bottom toolbar controls are generally the same for each plug-in, however they differ slightly depending on the host application used to launch the plug-in. Figure 3-7 shows the various bottom toolbars.

FIGURE 3-7. The bottom toolbars, from top to bottom: When launched from Photoshop or Elements, the Brush button is available and the control that will apply the filter is listed as OK. When launched from Lightroom or Aperture, the Brush button is not available and the filter control is listed as Save. When multiple images are launched from Lightroom or Aperture, the control that applies the filter is Save All. The Next and Previous controls let you navigate through the opened images.

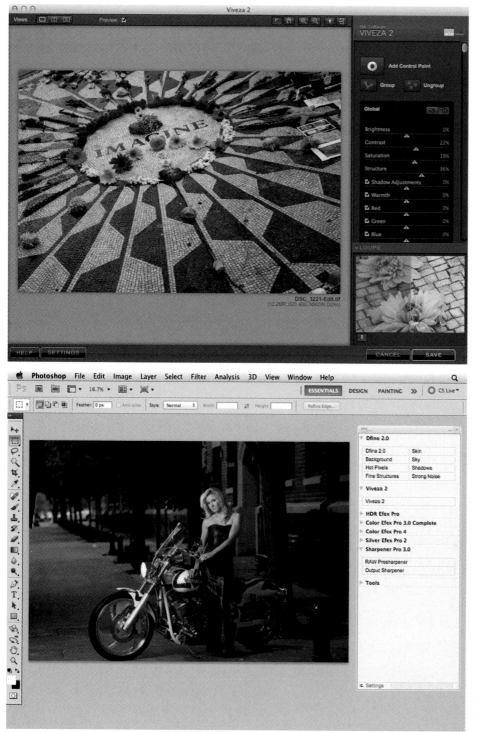

■ **FIGURE 3-8.** Below the image is the file-name, image size, and information stored in the image file.

■ **FIGURE 3-9.** Photoshop with the Selective tool open

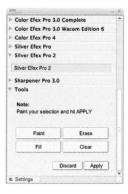

FIGURE 3-10. The Selective tool after clicking the Brush button.

Image area

The image area shows the image you have open into the software, along with information about that particular image (see Figure 3-8).

The Selective tool is available in both Photoshop and Photoshop Elements. This tool acts as a launching pad for the various Nik plug-ins as well as provides a way to simplify selectively applying filters, thus the name. Figure 3-9 shows the Selective tool in Photoshop.

To launch a filter, click the filter that you want to apply. This automatically creates a new layer and performs the Stamp Visible command, filling that new layer with whatever you see on the screen. Using the tool speeds up the application of filters for images with multiple layers or with adjustment layers.

Clicking the Brush button in the filter interface applies the filter to the image, adds a layer mask hiding the effect, and opens the image in the Selective application mode. Figure 3-10 shows the Selective tool in its Selective application mode.

Clicking the Brush button switches the active tool to the Brush tool and makes it possible to paint the current enhancement into your image.

Clicking the Erase button changes the color painted in the layer mask to ensure that painting removes the effect, showing the original image.

Clicking Fill shows the effect on the entire image.

Clicking Clear removes the effect from the entire image.

When you are done, click Apply or Discard to either keep the effect or completely discard the effect from your image.

Batch Processing in Photoshop

Batch-processing Nik filters in Photoshop is straightforward. If you have ever done any batch processing in Photoshop, you follow the same steps in the Nik filters. If you have never batch-processed before, the basic steps are as follows:

■ **FIGURE 3-11.** The Actions pane

1. Open the Actions panel in Photoshop by choosing Window ➪ Actions.
2. Click the Create New Action icon button (it looks like a sheet of paper with one corner folded), found at the bottom of the pane, as shown in Figure 3-11.
3. Give the action a name that describes what the action is to be used for. After clicking OK, the record button (red circle) is activated, letting you know the steps you then take are being recorded as an action macro you can reuse.
4. Apply the filter you want to your images. You must choose the filter from the Filter menu. If you want the resulting image to include the effect on a separate layer, first duplicate the background layer by choosing Layer ➪ Duplicate Layer *before* selecting the filter you want to apply.

■ **FIGURE 3-12.** Setting up the batch settings in Photoshop.

5. After you have applied the filter, choose File ➪ Save As and then save the file in the format you want. This important step ensures that the batch process does not pause and wait for you to indicate the file format settings.
6. Next, click the Stop button, which is the rectangle button next to the Record button in the Action panel.
7. Start the batch process by choosing File ➪ Automate ➪ Batch.
8. In the Batch dialog box, make sure that the action you created is selected in the Play section's Action popup menu. (If it was the last action you made, it should be automatically highlighted.) Choose the image source in the Source section (we typically do a folder at a time), select the output in the Destination section (we normally send the results to a different folder), make sure to check the Override Save As Commands option (this ensures that the image filename you used when creating the action will be ignored, but ensures that the file format type and file format options are observed), and then click OK. Figure 3-12 shows the Batch dialog box.

You see images open in Photoshop and be edited, as if by magic. When the batch process is finished, you can check all the files you created. If you want to stop the batch at any point, press Esc on your keyboard.

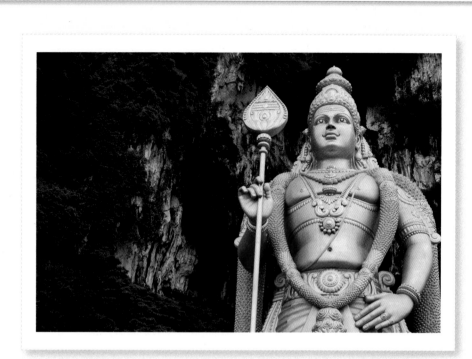

Chapter 4

U Point Technology

U Point technology is often referred to as the most powerful and special part of each Nik Software product. Learning how to use U Point technology effectively and efficiently will ensure you get the maximum benefit out of the Nik product line and can selectively enhance your photos faster than ever before.

U Point Technology Explained

U Point technology was developed by Nik Software as a way to solve one of the largest issues facing both professional and amateur photographers: making selective adjustments. Since its release, U Point has won several awards and is often cited as one of the primary reasons to use the Nik Software editing workflow. Each product contains U Point technology, and the capabilities have evolved over time.

Before releasing U Point, Nik had performed several focus groups and interviews with photographers of different skill levels that revealed a pattern: making natural photographic selections was very difficult and time consuming. For professional photographers, the problem was either that the tools available in Photoshop took a long time to use (thus reducing productivity) or did not create natural transitions from the selected area back to the original image. For amateurs, the tools themselves were often very difficult to learn and even more difficult to master.

No matter which host application you use, image-editing applications treat pictures as a series of arbitrary numbers strewn together in a rectangular array. The host application has no way of differentiating objects that we people easily recognize, such as sky, face, tree, house, and so on. To be able to make a selection using traditional tools, you must isolate one group of pixels from another, typically using one of only a few techniques.

The lowest-tech method of making a selection is to manually describe the area, using either the Lasso, Pen, or Brush tool. The Lasso and Pen tools both require that you identify the edges and normally create an incredibly precise, thin border, something that often results in an obvious selection. Figure 4-1 shows a selection made using the Lasso tool. The Brush tool, usually used in a layer mask or quick mask, lets you paint a selection onto the image and generally has a much softer (and less precise) edge.

The next method is using a color or range of colors to identify an object. Each image-editing application uses a different method. Normally, when using one of these tools, you identify a color that you want to adjust. Then you select an area that you then adjust, or you adjust the color range directly with an enhancement such as brightness or saturation. Figure 4-2 shows the Color Range tool in Photoshop used to make a selection based on the color of the statue.

FIGURE 4-1. Drawing a selection around the statue with the Lasso tool took a while and even, after spending time on the selection, a good deal of refinement is needed to make the selection look natural.

FIGURE 4-2. Using the Color Range tool in Photoshop to make a selection based on colors in the image.

The last common method is based on edge detection, with the most frequently used tool being the Magic Wand. The Magic Wand tool tries to detect, or identify, an object's edge based on various methods, the most common being some threshold of a difference between pixels. That is, the tool assumes that there is an edge if the difference between two pixels is greater than the threshold. This is similar to how our eyes detect different objects, through the contrast between the object and the area surrounding it. The Magic Wand tool is normally set to a low value (often 32 shades), which means that it detects an edge and therefore stops selecting when there is a difference greater than 32 shades brighter or darker than the selected object. Of course, you can change this threshold and even make it more natural by smoothing the selection (known as *feathering*).

U Point uses a different method, but one related to using the color range method. The name U Point comes from the idea that you, the photographer, point to what you want to adjust and then can make the adjustment on that specific object. This makes it possible for photographers to interact with their images in a more natural and familiar way. Figure 4-3 shows how an image can be enhanced with three easy-to-use control points, eliminating the need for other selection tools.

FIGURE 4-3. Control points in Viveza 2 can be used to selectively enhance an image.

How U Point Technology Works

U Point technology really refers to the invisible selection engine in all Nik Software products. To use U Point technology, you need an interface control element. For that purpose, Nik Software products use control points. (The U Point technology itself doesn't actually perform the enhancements — those are up to the particular plug-in being used.) We often recommend learning how to use control points in Viveza 2 as it's easy to see the results and selective effects of using U Point's control points.

When you place a control point on your image, you are providing the first piece of information needed for U Point to start making its selection: a reference pixel, with a specific set of colors, a specific location in the image, and a distance bias (based on the value set in the Size slider). The colors are based on the red, green, and blue values of that reference pixel, but the hue, saturation, and brightness characteristics are also calculated based on those RGB values.

In addition to the red, green, blue, hue, saturation, and brightness values, U Point reviews the pixels surrounding the reference pixel to determine the texture of the object (for example, smooth and without detail versus rough and with lots of details) that the reference pixel was placed on. Thus, U Point can distinguish among objects that might have the same color but different textures.

U Point uses the location of the reference pixel in combination with the Size slider's setting to determine if objects that are similar but far away from the reference control point should be affected.

With these three points of data, U Point makes its first selection by comparing every pixel in the image to the reference pixel and then determining how similar the pixel being reviewed is to the reference pixel as well as how far away that pixel is from the reference pixel (based on the setting of the Size slider). As an example, when you place a control point on the sky, U Point determines a certain red, green, blue, hue, saturation, brightness, and texture, as well as the X and Y coordinate. Figure 4-4 shows the Viveza 2 interface with a single control point added to the sky, along with the mask created by that control point.

U Point technology starts at the top left pixel of the image and scans through it pixel by pixel, coming up with a map of similarities. U Point measures each characteristic and determines a similarity value. That is, it compares the first pixel at the top left's red, green, blue, hue, saturation, brightness, and texture values to the reference image. Because the first pixel is also a similar shade of sky blue, there is a strong match in each and every one of these values. Because the Size slider was set to be quite large, the fact that the top left pixel is relatively far from the reference pixel doesn't matter much: The higher the Size slider is set, the less important is the distance between a pixel and the reference pixel. With

FIGURE 4-4. Top: A control point added to the sky. Bottom: The selection of that single control point displayed as a black-and-white mask.

a very high Size value, any pixel similar to the reference pixel is affected, regardless of where it is in the image.

As U Point continues to scan through the image and gets to a cloud, it finds that the cloud's color values are compared and the cloud pixels differ from those in the sky pixel. Because the cloud has similarities to the sky color (you may notice that clouds are often tinged with a bit of blue), U Point partially selects the cloud based on how similar the cloud pixel is to the sky pixel. We describe how to avoid having the clouds become affected by the sky control points later in this chapter. U Point continues to scan through the rest of the image and determines the state of selection for each remaining pixel.

The real magic of U Point technology comes when you use more than one control point. Each additional control point makes a more refined, more precise selection. The additional control points enable you, the photographer, to provide additional information about your image. These additional control points might identify new objects (for example, selecting the clouds in addition to the sky) or might make it possible to expand the selection of the same object (such as selecting a lighter or darker shade of the sky to make sure the selection is uniform across the entire sky). These additional control points can help you ensure that only the areas you want to change are changed.

When you add an additional control point, U Point re-analyzes each pixel in the image. Instead of comparing each pixel to only one control point, U Point compares each pixel to each control point in the image and determines how much of an effect each control point should have on that pixel. U Point takes into consideration the similarity in color, as well as the proximity of the pixel to each control point, along with weighting the proximity as determined by the Size slider's setting for that control point. For example, in an image in which there is a control point on the sky, another on a cloud, and another on a building, U Point reviews each pixel and compares that pixel against the three control points.

When reviewing a pixel in the sky, U Point finds that a pixel is very similar to the control point placed on the sky but not very similar to the control point on the clouds and foreground. Therefore, the sky pixel receives nearly 100 percent of the effect from the sky control point.

As U Point continues to scan through the image and reaches a cloud pixel, it determines the cloud pixel to be very similar to the cloud control point, but not very similar to the other two control points, and so receives nearly 100 percent of the effect of the cloud control point.

When U Point reaches a pixel in the building, it finds that this pixel is mostly similar to the foreground control point but is also similar to the sky control point and so receives part of the enhancement from the foreground control point and part of the enhancement

from the sky control point. To explicitly control the effect applied to that building pixel, you can add another control point to enhance that building pixel. Figure 4-5 shows an image with all three elements (sky, cloud, and building) selected, along with the masks for each item.

You can continue working in this fashion, but we strongly recommend that instead of adding a control point for each and every object in the image, you focus on the effect on your image. That is, look at how your image is shaping up and add a control point only because you can see a need in the photograph.

Using Anchor Control Points

Just like with any tool, you need to learn the ins and outs of U Point technology to become truly proficient. One technique you should learn is to use what is often referred to as *anchor control points*.

These control points prevent what some refer to as *overspray*, when a control point affects an area just outside the object you want to enhance. This effect occurs often if there are elements similar to the primary object you want to enhance and when there are too few control points added to the image to properly differentiate among objects. But it could also be partially due to the smooth transitions that U Point technology strives to make. In terms of making a natural-looking edit, having a smooth transition is not always a bad thing.

To resolve or reduce the overspray effect, all you need to do is add another control point to the area with the overspray. Adding a control point with all the sliders set to their zero position, such as by clicking the Add Control Point button and placing a control point on the area of the image with the overspray causes that area to revert back to its original pixel values. If the area receiving the overspray effect is part of an area that is affected by another control point, the best way to reduce the overspray effect is to duplicate one of the other control points and place that duplicated control point on the area affected by the overspray. Figure 4-6 shows how to use control points to resolve overspray.

The Different Uses of U Point Technology

Because U Point is only a selection technology and not an image-editing technology, there are many things that you can do with U Point-powered control points. Each Nik Software product uses control points slightly different, using U Point to enhance the goal of that specific product.

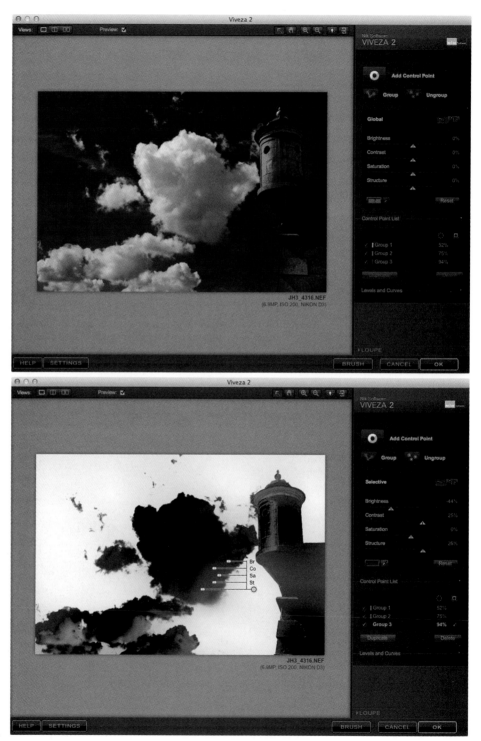

FIGURE 4-5. Top, this page: An image with three main elements: sky, cloud, and building. Bottom, this page: The selection of a control point added to the sky. Top, opposite page: The selection of a control point added to the cloud. Bottom, opposite page: The selection of a control point added to the building.

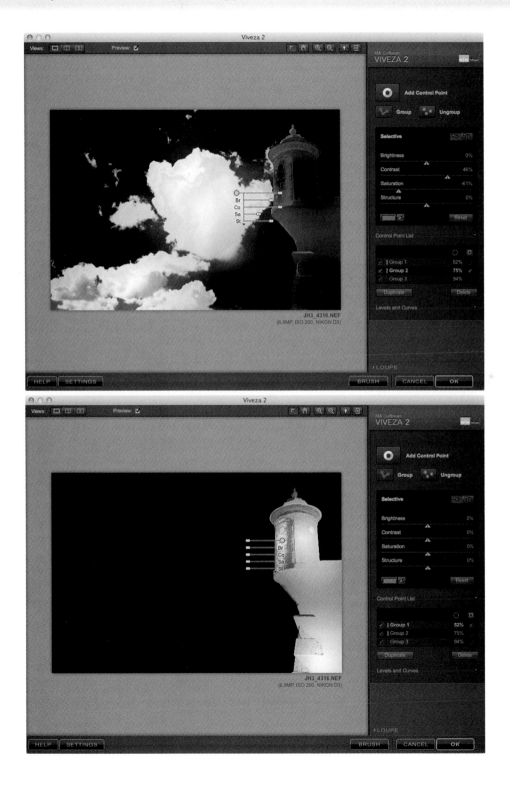

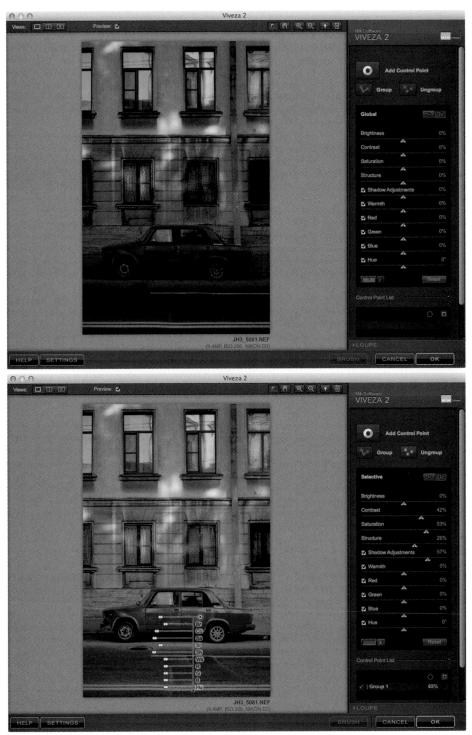

FIGURE 4-6. Top, this page: The original image. Bottom, this page: Note that a single control point group on the car causes overspray on the other parts of the image. Top, opposite page: Adding a few control points to the street helps U Point isolate the car from the background and corrects the overspray.

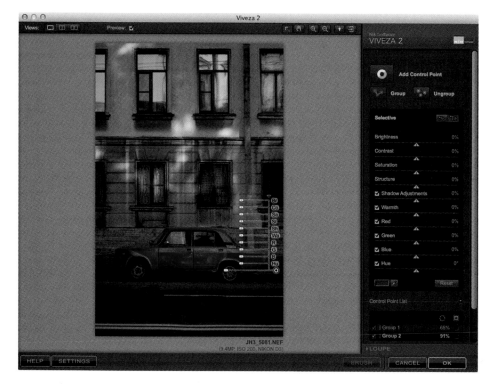

In Dfine 2.0, control points are available to selectively apply noise reduction. When you place a control point in Dfine, you are provided with the Size slider, as with every control point, and with sliders to affect contrast and color noise reduction.

In Viveza 2, control points are used to make light and color adjustments. In addition to the Size slider, controls are provided for brightness, contrast, saturation, structure, red, green, blue, warmth, and hue.

In HDR Efex Pro, U Point is done on the full 32-bits-per-channel file information, so you can adjust the exposure and work selectively with all the information in an HDR image.

With Color Efex Pro 4, U Point lets you selectively apply the filters to your images. The only control (in addition to the ubiquitous Size control) is for the filter's opacity.

Silver Efex Pro 2 provides similar controls to Viveza, but specific to black-and-white images.

Sharpener Pro 3.0 gives you control points with the ability to selectively adjust sharpening. Sharpener Pro makes it possible to both sharpen and soften with a control point, so you can selectively blur one area while sharpening another.

Chapter 5

Dfine 2.0

What Is Noise?

Dfine 2.0 is arguably the only tool in the Nik Software toolbox that is designed to exclusively fix potential problems, rather than enhance or stylize your image. Dfine makes it possible to reduce artifacts that might otherwise distract the viewer, as well as make it possible for you to shoot in imperfect lighting environments.

What Is Noise?

Noise in all sense of the word is unwanted elements that affect our interaction with the world around us. We often use the word *noise* to refer to unwanted sounds, but it can also be used to describe elements around us visually (graphic designers refer to cluttered layouts as "visually noisy"). In electronics, noise is the unwanted elements captured when recording something. The first place many of us heard about noise is probably with Dolby NR (Dolby Noise Reduction), something that you may have had on your tape player that reduced background hum or hiss when playing a tape. Most recently, noise reduction has probably come to your attention through noise-reducing headphones.

In nearly any situation though, noise is often thought of in a negative sense, something that should not be there, as Figure 5-1 shows.

In digital photography, noise is often visible as variations in what should be smooth areas, such as the sky or skin tones. These variations show up as one of two things: contrast (also known as *luminance*) noise and color (also known as *chrominance*) noise. To

FIGURE 5-1. To capture this image without a tripod, a high ISO value was needed. Using Dfine 2.0, we could reduce the unwanted noise while keeping the photographic details.

FIGURE 5-2.
Contrast noise in a zoomed-in portion of an image

best see noise (and noise reduction) in an image, we recommend that you zoom in to 100 percent.

Contrast noise looks like small variations of the same color. For example, Figure 5-2 shows the contrast noise present in the sky. Often, contrast noise is compared to photographic grain because it looks similar and can be less distracting than color noise.

Color noise looks like small patches of red, green, or blue that have been added to the image and are most visible on neutral objects. Color noise is often seen as a telltale sign of a digital image, as it is something that appears only in digital images. Because color noise identifies an image as digital, we recommend reducing color noise as much as possible. Figure 5-3 shows another portion of the same image where color noise is a problem.

Noise in digital photography comes from the susceptibility of cameras' image sensors to statistical quantum fluctuations — put another way, a random fluctuation in how image sensors react to photons hitting their surface. When a photon hits a photosite (a pixel) on the image sensor, a certain voltage is generated. Later, that voltage is converted to a lightness value specific to that photosite's color component (red, green, or blue). Due to the fluctuation caused by the nature of the sensor, even areas receiving a uniform amount of photons have slightly different voltages at each photosite. When converted to lightness

FIGURE 5-3. Color noise in a zoomed-in portion of an image

values, the variations of the voltage turn into variations of lightness values, which appear as contrast noise.

Color noise comes from a combination of the factors that create contrast noise and the process that occurs in a digital camera to create a full-color image. Because most cameras only capture a certain color at each photosite, the RAW conversion process must re-create the missing color components for that specific pixel. The software does that through interpolation — basically, an educated guess — based on the colors of the surrounding pixels. Because each surrounding pixel also contains noise, interpolation can introduce a different type of noise because it has to guess what value should exist based on those variations.

Every sensor of every camera captures noise in the image, and several factors affect the amount and visibility of noise in the resulting image.

The most obvious component is the sensor itself. Each generation of sensor design sees an improvement in the ability to capture image detail with reduced noise. Just like everything in technology, even the cheapest digital sensors available today have better signal-to-noise ratios than the most expensive cameras from a few years ago.

In addition to the generation and design of the sensor, the size of the photosite, which

is roughly based on the size of the sensor and number of pixels on that sensor, has a big impact on the noise. Generally speaking, the larger the photosite, the less noise. This is why compact cameras and camera phones usually have much higher levels of noise than digital SLRs.

The next factor that affects the amount of noise of the image is the camera's ISO setting. The ISO setting is based on the old sensitivity values of film, letting you trade increased sensitivity (meaning less light is required for an equivalent exposure) for image quality (in the form of increased noise).

In the film days, you used one piece of film rather than another based on ISO ratings to increase the sensitivity and thereby reduce the amount of light needed. In digital, the only thing you can do is amplify the light captured. Put another way, each time you increase the ISO setting on your camera, you are not taking out one sensor and replacing it with another sensor. Instead, you are instructing the camera to take the same amount of light and change how that light is mapped to certain pixel values. This is done by amplifying the signal so that each value is increased, creating a brighter image compared to the same exposure at a lower ISO value. This amplification also increases the existing noise, exaggerating the visibility of that noise.

Another factor that affects the visibility of noise is types of processing done to the image, either in the camera or during image processing. Increasing brightness, contrast, saturation, and sharpening can all intensify the appearance of noise in your images, and resizing can make the noise larger.

The last common cause of noise is the heat of the sensor. Sensor heat increases the longer a current is passing through the sensor (such as when capturing very long exposures) or due to the ambient temperature of the camera. So, when capturing long exposures, wait between shots for the sensor to cool off slightly.

As we describe in Chapter 2, performing noise reduction on every image is not always necessary. In fact, noise reduction can sometimes be detrimental to the quality of your image or sometimes to the efficiency of your workflow. Noise reduction always reduces the amount of detail in your images, adding a softness that is more distracting than the noise is. Always keep this in mind, and apply noise reduction only to the images that need it.

How Dfine 2.0 Works

Dfine 2.0 uses a method of reducing noise known as a wavelet noise-reduction algorithm. Using this type of algorithm, Dfine transforms an image into a map of spacial frequencies and then identifies and removes the unwanted (noise) frequencies.

A spacial frequency is a way of describing an image by focusing on the relationship of

pixels to one another. A high spacial frequency means that there is a fast and large change of values from one pixel to the next. The highest possible spacial frequency is an image with pure white and pure black pixels that alternate. A low spacial frequency means that there is little to no change from one pixel to the next. The lowest possible spacial frequency is a series of pixels with the exact pixel values, such as a pure gray image.

When Dfine measures the image, it needs to differentiate unwanted details from wanted details. Unwanted details should be noise, whereas wanted details should be the elements in the scene that you want to remain in the image after the noise reduction has been applied. Dfine accomplishes this by automatically identifying a few areas that it believes are adequate representations of the noise specific to the image; it displays these in the measuring step as rectangles on top of the image. What those rectangles represent however is a way for Dfine to profile the noise specific to the camera, sensor, and RAW processing that was used to create that specific image.

Dfine can then use that noise profile to remove elements matching that profile from the entire image. As an analogy, think of the way noise reduction headphones work: They measure the noise and then produce the opposite of that noise, resulting in a neutral (quiet) environment.

Step 1: Measuring Noise

Dfine's first step is measuring the noise in the image. This measurement process is controlled in Dfine by measurement rectangles that are overlain on the image. It places measurement rectangles on areas that do not have photographic detail. You can make your own rectangles as well. The content in those rectangles, provided you locate them in areas that should be otherwise smooth, is determined to be noise. Dfine then creates a noise-reduction profile based on the noise it discovered. To create a quality profile, Define usually needs the data from a few rectangles to represent the noise characteristics of different shades and colors. Normally, three or four rectangles are sufficient, provided they are placed on different shades and colors.

When you first launch Dfine, the software performs an automatic measurement. Shown in Figure 5-4, this measurement tries to identify areas in the image that Dfine believes do not have photographic detail. Unfortunately, this automatic process cannot be perfect, but the engineers at Nik did create a process that works well in most situations. Because the software cannot truly differentiate between noise and photographic detail, the algorithm was made to be slightly conservative and to err on the side of not placing a measurement rectangle on areas that are questionable.

To add an additional measurement rectangle to your image, choose Method ➪ Manual.

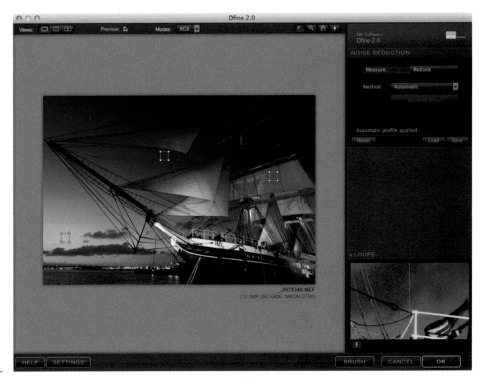

FIGURE 5-4. The Dfine 2.0 interface after it has measured the image

Then click the Add Measurement Rectangle button and click and drag an area on your image, as shown in Figure 5-5. The rectangle does not need to be large; it just needs to cover an area that has noise in it and no photographic details. You can also move or adjust the size of measurement rectangles. To remove a measurement rectangle, select it and press the Delete key.

After adding or adjusting the measurement rectangles, click the Measure Noise button to update the noise profile based on your changes.

Step 2: Reducing Noise

Once you have measured the noise, you can adjust how noise is reduced in your image. Dfine always applies a normal amount of noise reduction to your image once a noise profile has been created. This is why, after measuring the image, you'll already see some noise reduction (as shown in Figure 5-6). For many photographers, the default values are sufficient. If you find the noise reduction works well, just click OK and continue working on your image.

To adjust the noise reduction applied to your image, go to the Reduce pane (click its tab at the top right of the Dfine 2.0 interface).

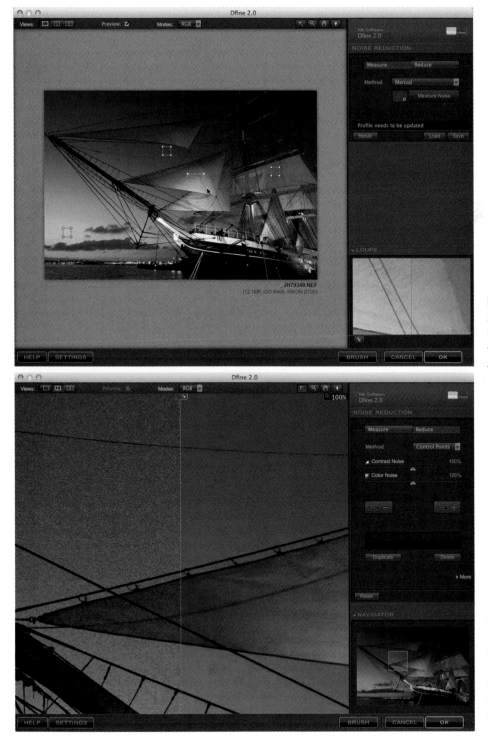

FIGURE 5-5. An additional measurement rectangle being added to the image

FIGURE 5-6. The Dfine 2.0 interface zoomed into 100 percent showing the default noise reduction after the noise has been measured

Reducing noise globally and selectively with control points

In the Reduce pane are two sliders, one for contrast and one for color noise reduction. There are also two buttons to add control points for adding and removing noise reduction, a control point list, and a disclosure triangle labeled More.

The Contrast Noise and Color Noise sliders let you control the amount of noise reduction applied to the entire image. The default setting of both sliders, 100%, is a good starting point for most images. Reducing either slider decreases that type of noise reduction from the image, letting the original details and noise show through more and more.

If you find that the default amount of noise reduction reduces details too much, we recommend reducing the Contrast Noise slider to find a good balance between noise and noise reduction. As described earlier in this chapter, color noise is often the more distracting of the two types of noise in a digital image and, as such, you can often reduce the amount of contrast noise reduction applied to your image while keeping the color noise-reduction value at a higher level. This balance between noise and noise reduction is tricky, so we recommend you experiment to find where your preferences lie: toward a

FIGURE 5-7. Images with a lot of detail often benefit from selectively applied noise reduction.

smoother and more-noise-free image or toward a more-detailed but noisier image.

One great way to improve the quality of noise reduction applied to your image is by selectively applying the noise-reduction effect with control points. This approach is especially useful with highly detailed images, such as shown in Figure 5-7. By using control points, you can prevent noise reduction from softening certain crucial areas while applying greater levels of noise reduction to areas where the noise is most distracting. Figure 5-8 shows an image in which noise reduction softens image detail too much.

The Control Points method in Dfine 2.0 make it possible to apply the two types of noise reduction — contrast and color — selectively to the image.

To use the control points, first determine how much noise reduction you want to apply to the entire image. You can approach this in one of two ways: selectively applying the noise reduction to the image or selectively removing the noise reduction from the image.

When selectively adding the noise reduction to the image, start by clicking the + control-point button and then clicking on the image, as shown in Figure 5-9. After you add a + control point to your image, the Contrast and Color Noise sliders automatically change to a value of 0%. This automatic change removes the noise reduction from the entire image, with the subsequent noise reduction applied only from the control point

FIGURE 5-8. The noise reduction applied via the Dfine interface on the right side of the red line results in too much detail loss in the trees and leaves.

FIGURE 5-9. A control point on an image

FIGURE 5-10. Adding a – control point to the image removed some noise reduction from the trees.

you just added to your image. This is often a good process to use if the noise reduction is prominent only in one area such as the sky in the image. Use those sliders to apply the desired noise reduction to the control points.

You can then add additional control points to reduce noise to other areas of the image — or even increase the global sliders to add a small amount of noise reduction back to the entire image. Often, although a value of 100% may be too much, a value of 20% or 30% adds a good base level of noise reduction without softening details too much.

If you find that noise reduction is applied to areas that you don't want to apply it to, click the – button and add a control point to the area where you *don't* want noise reduction applied, as shown in Figure 5-10. Continue adding control points until you have achieved the desired amount of noise reduction. You can use the options in the Modes popup menu to visualize where the noise reduction is being applied to your image. (We describe how modes work later in this chapter.)

Reducing noise globally and selectively with color ranges

The Color Ranges method makes it possible to selectively control noise reduction in your image based on an object's color. This is especially handy if you want to apply noise reduction selectively on a batch of images. Control points are location-specific, so they don't work for batches of images where the objects are not in the same exact position in all images.

You can select a color either with the color picker or the Eyedropper tool. Using the Eyedropper tool, click on the object at a location that has the color you want to affect. The color picker lets you select a specific hue and tone from its color space. Either way, Dfine selects all colors in the image that matches your selection.

When you first select the Color Ranges method, three color ranges are available. Nik recommends you select at least three different colors in your image, as this helps the selection algorithm work optimally. If you have a very limited range of colors in your image, you can remove one of these ranges by clicking the – button to the right of the color range.

To add a color range, click the + icon below and to the right of the last color range.

Each color range lets you select the amount of contrast and color noise reduction to apply to that range, as shown in Figure 5-11.

Using the Advanced Noise Reduction tools

Although most of the time the default noise-reduction settings create adequate results,

FIGURE 5-11. Using the Color Ranges method to reduce noise selectively

there are times when you need more control and thus more advanced tools. Both the Control Points and Color Ranges methods provide access to these advanced controls when you click the disclosure triangle labeled More.

In the More section are controls for Edge Preservation, JPEG Artifact Reduction, and Debanding.

Edge Preservation check box

The Edge Preservation check box adds an optimized sharpening algorithm only to the edges of the objects in the image. This technique can help sharpen the edges that are otherwise smoothed too much by the Noise Reduction tool, preventing the image from appearing too blurry. Keep in mind that, depending on the amount of noise in your image, sharpening the edges of objects could increase the visibility of noise around the edges of the image. Edge Preservation is connected to the contrast noise reduction, though, so you don't have to worry about the edges of areas that have no contrast noise reduction applied. Figure 5-12 shows an image where we used the Edge Preservation feature to ensure that the stamen of the flower stayed sharp.

After checking the Edge Preservation check box, use the slider to increase the result

FIGURE 5-12. Using the Edge Preservation feature to maintain sharpness around edges

until the edges seem a bit sharper and more defined. If you go too far and noise starts showing up around the edges again, move the slider back until you no longer see the noise artifacts.

JPEG Artifact Reduction check box

The JPEG Artifact Reduction check box uses an artifact-reduction algorithm specially designed to reduce the appearance of JPEG artifacts, as shown in Figure 5-13. JPEG artifacts are created by saving an image as a JPEG file and are more likely to appear if you use a very high compression setting. These artifacts often show up as a grouping of pixels in a square shape. These artifacts normally only become a problem after the image has been resized, but recognizing them early can help save a lot of retouching later.

The JPEG Artifact Reduction feature tries to blend the artifacts back into the image, reducing their prominence and preventing them from distracting the viewer from the image.

Debanding check box

In rare circumstances, digital cameras create an unwanted artifact called *banding*. This type of noise banding is different from posterization, which is also sometimes referred to as banding. (Chapter 3 explains posterization.) A faulty image sensor or a bad analog-to-

■ **FIGURE 5-13.** This section of an image shows JPEG artifacts.

digital converter in the camera sometimes causes banding. Usually, banding can be fixed by sending the camera in for repair, but as luck normally has it, you have already taken some great pictures that you need to salvage.

These banding artifacts often show up as faint vertical or horizontal lines as you are processing an image, and they can be pretty strong. Figure 5-14 shows an image being converted to black-and-white in Silver Efex Pro 2 where the previously unnoticed banding artifacts suddenly come into sharp relief. When you see this type of artifact, it is best to stop processing the image and switch to Dfine 2.0 for its debanding function.

After checking the Debanding check box, you identify the direction of the artifacts as well as the strength of the algorithm. Banding always happens in the same direction on the sensor, but the direction changes relative to the orientation of the image. Use the Direction radio buttons to tell Dfine the direction of the artifacts.

Next, move the Debanding Strength slider to increase or decrease the amount of banding reduction to be applied to your image.

Keep in mind that the debanding algorithm can add artifacts of its own, as Figure 5-15 shows, so you may need to reduce those artifacts later. We have found these artifacts often appear around the transition of a sharp edge and smooth surface, such as where a building intersects the sky. If these debanding artifacts show up and you find them distracting, you will have to decide if you can live with the original banding artifact, if

FIGURE 5-14. An image being converted into black-and-white in Silver Efex Pro 2 demonstrates banding artifacts that were in the original image.

FIGURE 5-15. Although you probably will never need to use a value of 200% for the Debanding Strength slider, we used it here to demonstrate the potential artifacts this tool can create.

you can live with the new debanding artifact, or if you want to manually clean up the debanding artifacts.

To clean up the debanding artifacts, you will need Photoshop or Photoshop Elements. Apply the noise reduction to a separate layer and then add a layer mask. You can then selectively blend the noise-reduced layer to the original image, hiding the noise-reduced layer immediately around the debanding artifacts, as shown in Figure 5-16.

Using the Modes Popup Menu to Review the Noise and Selection Masks

Although noise is usually easy to see (provided you have zoomed in to at least 100 percent), there are situations in which the noise may not be immediately evident or where you would like to see exactly where the noise reduction is being applied to your image. In both these situations, you use the Modes popup menu to change how your image is displayed.

The default viewing mode, RGB, shows your image in color. Changing the mode to Red, Green, Blue, Luminance, or Chrominance shows your image in that channel only, displayed

FIGURE 5-16. The filtered layer is blended with the original layer by adding a layer mask and painting away the area with the artifact.

FIGURE 5-17. An image showing the noise in the Luminance view (top), and an image showing the Chrominance view (bottom)

as a grayscale image. These channel-viewing modes are available because noise often shows up differently on each channel. For example, many cameras have more noise in the blue channel than in other channels, so being able to see just the blue channel makes it easier for you to review the effect of the noise reduction and the prevalence of the remaining noise by looking at just the blue channel. Alternatively, if you want to see the difference between luminance and chrominance noise, you can use the Modes menu to switch between these channels. Figure 5-17 shows an image with the Modes popup menu switched to Luminance and Chrominance modes.

When in one of the channel-viewing modes, you can turn on or off the noise reduction preview by using the Preview check box or the split or side-by-side preview modes. The preview modes make it possible for you to see Dfine's effect on noise only on those areas, and they can help you learn the effects of the contrast and color noise-reduction sliders. Figure 5-18 shows noise reduction being applied to an image in a before-and-after split view while in the Chrominance mode.

These two options make it possible to see the selection mask created by either the control points or color ranges. Seeing the selection mask can be helpful if you would like to review the selection made, but we definitely recommend you base your selection and

FIGURE 5-18. You can use the split preview to show the effect on noise only on one part of the image, such as the chrominance component of the image in this example.

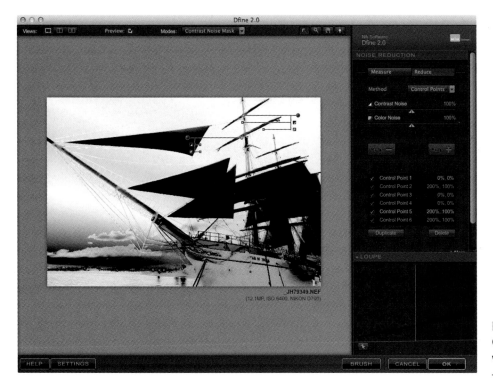

FIGURE 5-19. The Contrast Noise Mask view mode

settings based on what you see in the image itself instead of based on the mask views. That is, instead of worrying about whether an area is selected properly based on the black-and-white mask view, look at the image in the RGB mode and determine if there is too much or too little noise reduction applied to the image based on what you see.

You can see where the noise reduction is being applied to the image while in the Contrast Noise Mask view mode, shown in Figure 5-19. Access the Contrast Noise view by choosing Methods ⇨ Contrast Noise. Areas that are white have noise reduction applied, whereas areas that are black have no noise reduction applied.

When to Use Dfine 2.0 to Reduce Noise

Obviously, you should use Dfine on any images where noise is really visible and detracts from the subject. What can be less obvious is the noise that exists in the image but becomes distracting only after you start editing the image.

It is always a good idea to imagine how the image will be enhanced before you start your image-editing workflow. You might want to apply noise reduction before going through the image-editing steps if any of the following apply:

■ You know the image needs to be brightened (including selectively brightening only one area).

■ You are going to make several contrast adjustments.

■ You plan to convert the image to black-and-white.

■ You are going to create a grungy HDR image.

It is always easier to do noise reduction before editing your image, so having a good plan in advance can help you avoid starting all over again.

Chapter 6

Viveza 2

Viveza is one of the most straightforward applications in the line-up of photographic plug-ins offered by Nik Software. At the same time, it is also one of the most difficult products for many new photographers to grasp. Viveza makes it possible to do almost everything you want with your image, but it doesn't offer recommendations or suggestions. Figure 6-1 shows the Viveza 2 interface.

The first thing we recommend to new users of Viveza is to identify their postprocessing goals. (In Chapter 1, we describe editing basics, and if you haven't read that chapter yet, now would be a good time.) Basically, Viveza is all about adjusting color and light in your photographs, either selectively or globally. The photographer's typical goal when using Viveza is to mold the light that was available at the time the photo was shot to something closer to what the photographer had seen in his or her mind when capturing the image. You can think of Viveza as a modern, color equivalent of dodging and burning, with the end result being the emphasis on the main subject in the image.

Ansel Adams has a famous quote that we believe pertains quite well to Viveza: "Dodging and burning are steps to take care of mistakes God made in establishing tonal relationships." Although you can wait for days, weeks, months, or years for the perfect position of sun to subject, you might never get exactly what you want. Viveza (and

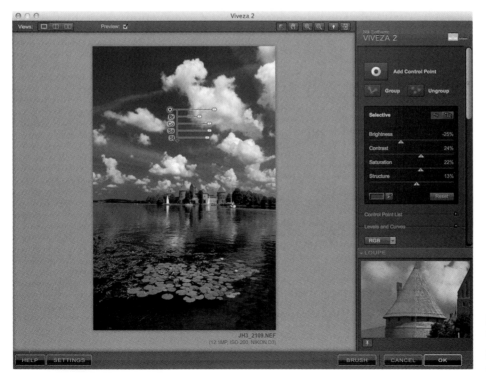

FIGURE 6-1. The Viveza 2 interface in selective mode

dodging and burning, for that matter) can help, but it should never be used to completely change the colors and tones in the image.

Like all Nik Software products, but perhaps more fundamental to its capabilities and usage than the others, Viveza is powered by U Point technology. As Chapter 4 describes, U Point technology makes creating selections and adjusting parts of an image easier.

In addition to its selective capabilities, Viveza also offers powerful global enhancements. In this chapter, we cover both the selective and global enhancements, as well as techniques on how to use Viveza most efficiently.

The Viveza 2 Interface

Viveza has the familiar look of the user interface and the consistency with the other Nik Software plug-ins, covered in Chapter 3.

Adding control points

To add a control point, first click the Add Control Point button (shown at left) from the top of the right pane and then click the area of the image where you want to add a control point.

A newly placed control point in Viveza always defaults to neutral slider settings, meaning that every slider has a 0 value, except the Size slider. The Size slider starts with the default value set in the preferences, which is 25% unless you have adjusted the preferences.

You can add a new control point other ways as well:

1. Press the shortcut Shift+⌘+A or Ctrl+Shift+A.
2. After selecting a control point, press ⌘+D or Ctrl+D.
3. Copy a control point by pressing ⌘+C or Ctrl+C, select where you want to paste the new control point, and press ⌘+V or Ctrl+V.
4. Press and hold Option or Alt and drag a control point to position a copy of it. Release the mouse and the Option or Alt key when done.

Grouping and ungrouping

Grouping multiple control points makes it possible to use multiple colors or tones to identify and adjust complex objects. When control points are grouped, you are presented with a single set of sliders for all grouped control points, and a Size slider for each control point in the group. Use the Group and Ungroup buttons, shown at left, to manage control point groups.

The real benefit of grouping control points is that you only need to click on a single

control point to adjust the sliders of a complex object. For example, a large object such as the water in a seascape or the sky in a landscape might require placing multiple control points across the image. Without a group, you would have to click and select each control point and either adjust the sliders manually for each control point (certainly not recommended) or press and hold the Shift key while selecting each control point, add those control points to a temporary group, and then adjust the sliders. If there are other control points in the vicinity — for example, if there are control points on the clouds — it's more difficult to select only the control points in the sky versus those in the clouds.

Another benefit of grouping is that all the control points for that one object are listed as a single item in the Control Point List. The list lets you turn on or off all those control points with a single check box, making it easy to see what that group of control points is doing to your image.

To group control points, select the control points you want and click the Group button. Alternatively, you can use the shortcuts ⌘+G or Ctrl+G.

One thing to keep in mind of when grouping is which control point is the super-selected control point. A super-selected control point is identified by a faint yellow outline around it, which indicates that control point is used as the basis for the group, and therefore which set of sliders is used for all the grouped control points. If the currently super-selected control point is not the correct control point, just click on another of the selected control points to super-select it instead.

It is important to have the desired super-selected control point *before* you click the Group button. If you had the wrong control point super-selected when you grouped the control points, use the undo command (⌘+Z or Ctrl+Z) and then try again.

If you find one or more control points that should not be in the group, first click the main control point for the group to show the sub-control points. Then select the sub-control points that you do not want in the group and click the Ungroup button, or use the shortcut Shift+⌘+G or Ctrl+Shift+G.

You can also delete control points directly from a group by clicking and highlighting those unwanted control points and pressing the Delete key.

Global and selective indicators

The Global and Selective indicators are small but important indicators in the interface's right pane. Figure 6-1 shows Viveza in global mode, whereas Figure 6-2 shows it in selective mode. The controls are the same in both modes: In global mode, the sliders affect the entire image. In selective mode, the sliders affect the area selected by the control points.

If you want to switch from selective to global, all you need to do is click on a part of the

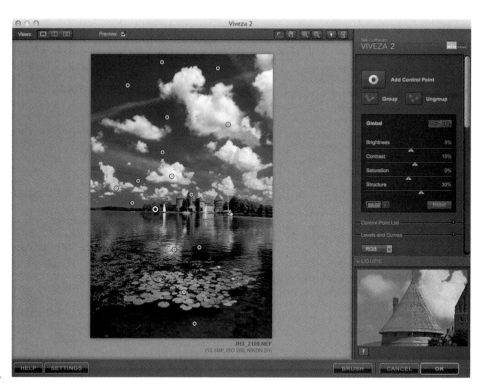

image that does not have a control point. If you want to switch from global to selective, just click on a control point.

Expand and Collapse buttons

The Expand and Collapse icon buttons (shown at left) toggle between showing you the top four sliders or all ten sliders. The main reason for this control is to reduce clutter on your image if you are only using the top four sliders. We most frequently use the top four sliders to cover the majority of our enhancements. There are certainly situations in which we expand the sliders, as noted later in this chapter. You will probably find that you use the top four sliders for most of your edits as well.

You can also expand or collapse the slider set by clicking the disclosure triangle found below the control point's sliders.

Enhancement sliders

These extra sliders provide all the enhancements and adjustments in Viveza 2, apart from the Levels and Curves control. The sliders pane (shown in Figure 6-4) adjust either the entire image or only the selected area, depending on if you have selected a control

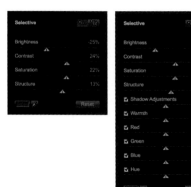

FIGURE 6-3. The sliders in their collapsed and expanded states.

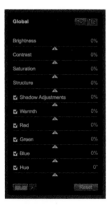

FIGURE 6-4. The enhancement sliders in Viveza 2

point.

Viveza provides controls to adjust the following enhancements:

- **Brightness.** Brightness works just as you expect: Moving the slider to the right brightens the image whereas moving the slider to the left darkens it. One thing to keep in mind when trying to lighten very dark objects is whether you should use the Brightness slider or the Shadow Adjustments slider. As a general rule of thumb, use the Brightness slider for everything except really dark areas; use the Shadow Adjustments slider for those areas.

- **Contrast.** Contrast is another common enhancement, moving the slider to the right increases the difference between objects, whereas moving to the left decreases the difference between objects. Because of the relationship of tonality and saturation, there is a chance that adjusting contrast will either increase or decrease the saturation of objects that you enhance. Often, adjusting contrast may require an adjustment of saturation.

- **Saturation.** Saturation is the last of the common enhancements. Put simply, saturation increases or decreases the intensity of a specific hue. The higher the saturation, the more intense that hue, whereas the lower the saturation, the less intense the hue (the absolute lack of saturation creates a gray).

- **Structure.** Structure is an enhancement first introduced in Silver Efex Pro 1 to emphasize details without introducing halos or artifacts. Moving the Structure slider to the right exaggerates details. Structure can also be used to reduce the appearance of details. It has a different look from a normal blur: Structure reduces details without affecting an object's edges, making the details in an object smoother but

keeping the edges sharp. Thus, images whose structure has been reduced still seem in focus but have less detail. Often, structure is used to soften skin or even create a calming effect in water or skies.

■ **Shadow Adjustments.** Shadow Adjustments controls the lightness of dark objects. While the Brightness slider works well for the majority of tonalities, adding brightness to very dark objects can sometimes result in strange and unwanted colors (because adding a normal brightness routine to a dark area adds brightness uniformly to those different areas, creating highly saturated colors). The Shadow Adjustments enhancement works to add brightness, but it also considers the relationship of colors in dark areas and ensures that the brightened areas have natural looking colors.

■ **Warmth.** In Viveza 2, the Warmth slider lets you shift colors to be cooler, by adding blues, or to be warmer, by adding red-orange. You usually adjust the warmth of an image or area to neutralize an unwanted colorcast (because of an improperly set white balance or because of the mixture of different light sources in an image) or to enhance the viewer's perception of those colors. Most people consider cool images to be mechanical or uninviting, while warm images are cozy and happy. Playing off this perception can help you get across the story of your image.

■ **Red, Green, and Blue.** The Red, Green, and Blue sliders let you control the amount of each color in the entire image or in the selected area. These sliders are often used to correct for a colorcast in the image, or to refine the color of an object. (Chapter 1 has more information about the relationships of colors.)

■ **Hue.** The Hue slider makes it possible to shift the hue of the entire image or the selected area along the hue spectrum. This is our least-often-used control.

Color picker and Eyedropper tool

The color picker and Eyedropper tools (shown at left) below the sliders are available only when control points are selected. Clicking the color picker opens the color chooser in the host application, so you can select a target color for the selected area. (Viveza tries to turn the object you selected into that target color.) Alternatively, you can use the Eyedropper tool to select a color in the image as the target color.

In both scenarios, Viveza adjusts all ten sliders to try to change the current color to the target color, with varying degrees of success.

This technique can be helpful if you want to match the color of two similar objects or if you want to ensure a uniform sky color. In practice, this adjustment seldom works precisely, but it can sometimes get close enough to let you manually further adjust the

sliders to create the desired effect.

Pressing the Reset button at the bottom of the right pane resets the slider values back to their neutral state. Depending on whether you have a control point selected, it either resets the control point's slider values or resets the values of the global effect.

The Reset button does not delete the control points added to the image.

Control Point List

Shown in Figure 6-5, the Control Point List lists all the control points and groups available in the image. This list makes it possible to turn on and off each control point or group independently, and to see the selection made by each of the control points or groups.

Click the check box to the left of a control point or group to enable and disable the effect on that control point or group. This visibility control is helpful for seeing whether the image changes for the better. We have found that sometimes a control point added earlier in the editing process is no longer necessary or that a control point is doing something undesirable to the image.

The other control available in the Control Point List is the Show Selection check box.

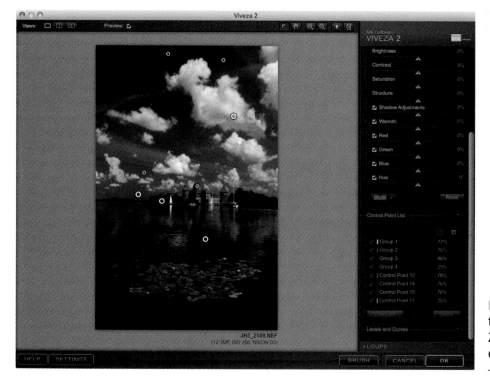

FIGURE 6-5. The Control Point List in Viveza 2 appears at the bottom of the right pane

Turning this on or off shows the selection of that control point or group.

We normally recommend using the check box to turn off the selection when learning how to the use U Point technology because people have way too much desire to be absolute and precise with the controls. U Point technology is designed to naturally and effectively blend results into the image, without worrying about the exact selection used. In fact, paying too close attention to the selection mask is completely contrary to benefit of U Point technology and slows interaction without any improvement in selection. To put it another way, U Point was designed for you to use based on what you see in the image, not based from the selection. If you spend too much time focused on the selection mask, you miss how the control point is actually affecting your image.

Levels and Curves control

The Levels and Curves control in Viveza 2, shown in Figure 6-6, works the same way as the Levels and Curves control in other image-editing applications, such as Photoshop, Lightroom, or Aperture.

The curve area lets you adjust the relationship of the input to output values. Clicking on the curve adds an anchor point and lets you adjust the curve itself. The angle of the

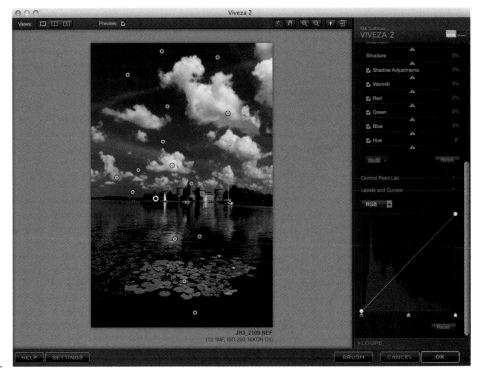

■ **FIGURE 6-6.** The Levels and Curves control

curve represents contrast; the steeper the curve, the more contrast; the shallower the curve, the less contrast.

The most common thing to do is to add an S-curve, which is a crucial and integral part of the photographic look of an image. To add an S-curve, click the bottom-left area about one-tenth of the way above the bottom-left corner and move that anchor point down. Then, click the top-right area of the curve about one-tenth of the way below the top-left corner and move that anchor point up. You typically don't want either of the anchor points to touch the top or bottom boundary of the curve area. We recommend experimenting with what looks good in the image. The closer to the center you move these two anchor points, the more contrast you add to the image.

The bottom three sliders control the shadow, midtone, and highlight values. Moving the left slider (shadow) to the right darkens all values in the image and increases the amounts of blacks in the image. Moving the right slider (brightness) to the left brightens all values in the image and increases the amounts of whites in the image. The middle slider controls the midtones; move this slider to the left to brighten the midtones or to the right to darken the midtones.

Normally, working the anchor points and adding an S-curve is sufficient, but the sliders provide more control, especially the middle slider to affect midtone brightness.

Although you can adjust contrast easily with the Contrast slider, the Levels and Curves control provides more control, albeit on the entire image only.

In addition to working with all the colors simultaneously, you can also select and work on one color channel at a time, just as with the Curves control in Photoshop. This makes it possible to do color adjustments or create stylistic enhancements by changing the relationship of the different color channels.

Applying Viveza 2 to Your Photographs

The most important thing to have in mind before working with Viveza is knowing what you want to do to your image. Viveza doesn't offer recommendations or potential looks for your image, so what you do with Viveza is entirely up to you.

As described in Chapter 1, we recommend that you start with issues that affect the entire image. Keep in mind that you might want to hold off enhancing contrast globally until later, as you will likely go through your image, adding control points to different areas and adjusting the brightness of those areas, making some areas brighter and other areas darker. This is essentially what contrast is, but with control points you can be more precise.

Working with landscape images

With the goal of drawing attention to your subject in mind, for landscape shots (meaning photos of landscapes, not necessarily those in landscape orientation), this often means adding a control point to the sky. Reducing brightness and increasing contrast and saturation helps draw attention to the bottom of the image while helping to create pop as well as the expected color and shade of the sky. It is often not a good idea to increase the structure of the sky, as that can bring out unwanted artifacts and noise — normally the sky is smooth and free of details.

A good starting size for the control point is one where the circle of influence covers the entire area you want to adjust, as shown in Figure 6-7. The size can be refined further at a later state if needed.

Next, add a control point to the clouds, again making the size control large enough to encompass all the clouds in the image. Figure 6-8 shows a control point being added to the clouds. With this control point, increase the brightness, contrast, and structure, and decrease the saturation. The goal is to make bright, white, fluffy clouds with lots of texture. It is important to pay attention to the highlights, though, and make sure you don't go too far and blow out the highlights.

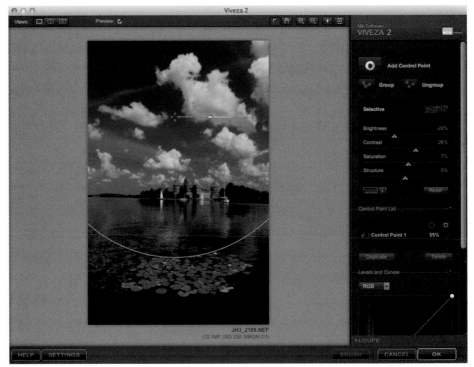

FIGURE 6-7. Adding a control point to the sky and adjusting the Size slider

These first two steps can be considered a super-powerful polarization filter, but one that works at any angle to the sun.

Next, take a look at your image to determine what is remaining. In this image, the water in the foreground is a bit dull, the lily pads are too yellow, the trees along the edge of the water are too dark and lacking in detail, and the castle is lacking in color and detail.

Because the order that control points are applied doesn't really matter, you can address any areas you want to enhance in whichever order you want. We normally address the issues in the order we see them, so in this example we will work on the water in the foreground next.

Adding two control points to the water (shown in Figure 6-9), one to a reflection of the sky and the other to a reflection of a cloud, we can approach enhancing the water in a way similar to how we enhanced the sky. It is important to keep in mind that the water should be darker than the sky, so watch the tonality as you make your adjustments. And unlike the sky, adding structure to the water is often a good idea.

We can next address the yellowness of the lily pads. We added a control point to the center of the lily pads and increased the size to cover them, as shown in Figure 6-10. In addition to being too yellow, the lily pads are also too dark, so first we raised the brightness to the desired level. To bring out a bit of the detail in the lily pads, we added

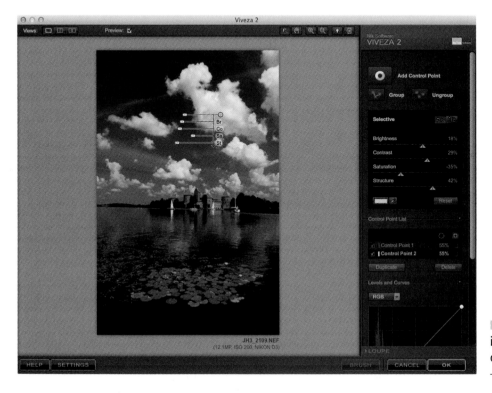

FIGURE 6-8. Enhancing the contrast in the clouds

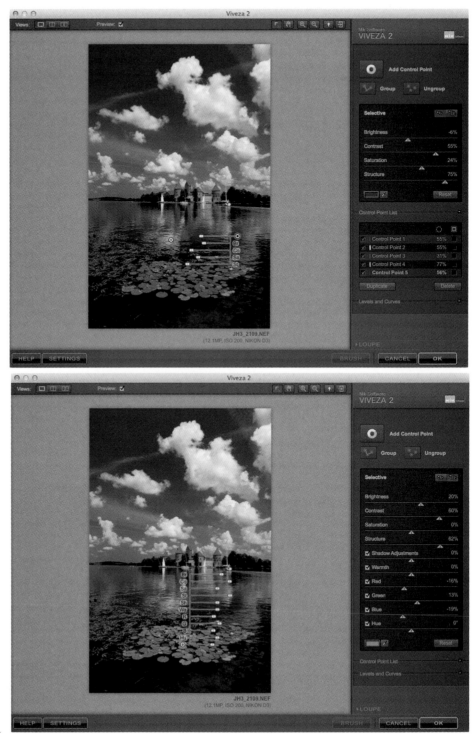

FIGURE 6-9. Adjusting the tonality of the water

FIGURE 6-10. Enhancing the color and tonality of the lily pads

structure as well. To address the yellow issue, we need to expand the control point by clicking the disclosure triangle. Now with access to all the controls, we can either reduce yellow by increasing blue, or just add green to make the lily pads more their natural color. In this case, adding green had a better end result.

The next distracting item in the image is the cluster of trees around the water line, so we added a control point (see Figure 6-11). Because the trees are dark, the best tool to use is the Shadow Adjustments slider. In addition to the Shadow Adjustments slider, adding a small amount of green helped make the trees look nice and healthy.

To adjust the trees on the other side of the castle in the same way as the first group of trees, we can either increase the Size slider to encompass them, or we can duplicate the control point we just made for the first group. We've found that you often get better results by using multiple control points with small Size slider values rather than by using fewer control points with large Size slider values, so we duplicated the control point and added the duplicated point to the other side (as shown in Figure 6-12). The fastest way to duplicate the points is to press the Option or Alt key and drag the control point to the other side. Grouping the points makes it easy to go back later and adjust those points in case you need to increase or decrease the effect.

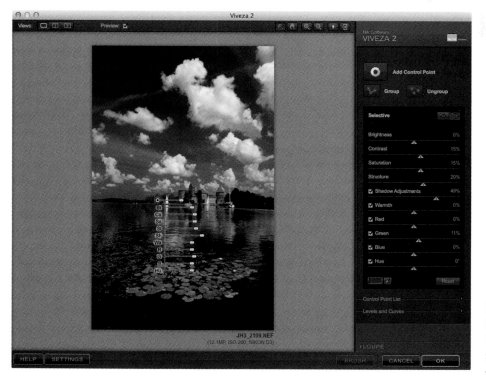

FIGURE 6-11. Brightening the trees with the Shadow Adjustments slider

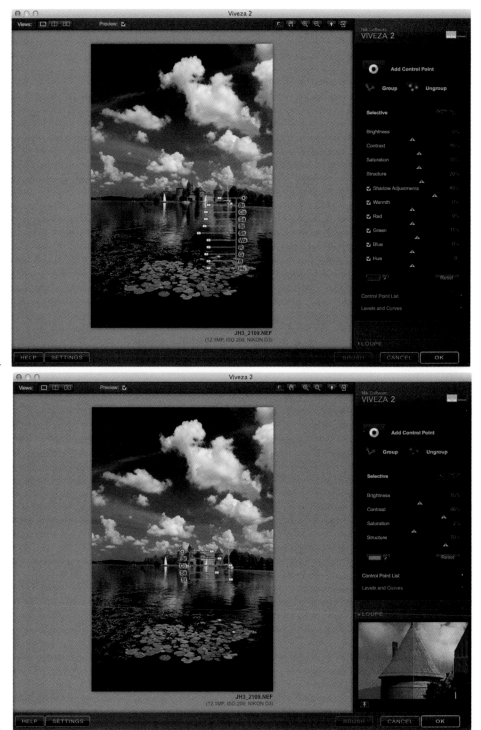

■ **FIGURE 6-12.** Duplicating and then adding the three control points to a group

■ **FIGURE 6-13.** Adding a control point to the top of the castle and adjusting the structure and contrast

The final issue we've identified is the castle, so we added a control point and increased the contrast and structure to help polish the image (see Figure 6-13).

We can now look at the adjusted image and see if any additional areas need to be addressed. A few areas such as the sky on the left side of the image near the water line and the water close to the bottom of the frame could use enhancement.

By adding another control point to the sky, as shown in Figure 6-14, we added color into what was slightly gray. Increasing the contrast, reducing red (to add cyan), and increasing blue can all help create a nice sky blue color that matches the rest of the image. It is important not to go overboard with these types of adjustments, as it is typical for the sky area close to the horizon to be less saturated and often lighter than the sky directly overhead.

By adding one last control point to the bottom of the image and increasing the Shadow Adjustments slider, as shown in Figure 6-15, we helped ensure there is detail throughout the image. It is often good to have the bottom edge very dark because that acts like a barrier to the eye — but it is also good to have details in those areas, not a pure black section.

Working with portrait images

Working with portrait images (meaning photos of people, not necessarily those

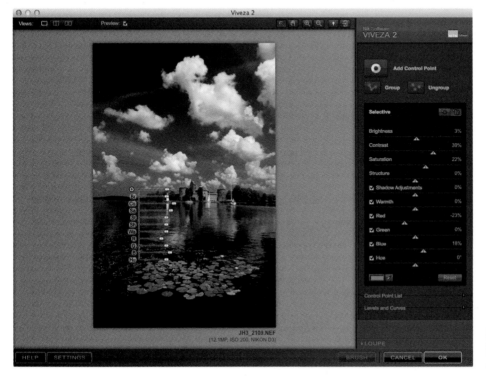

FIGURE 6-14. Refining the color of the sky

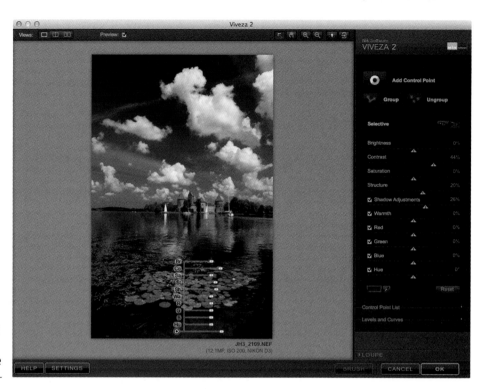

in portrait orientation) isn't that different from working with landscape images. The principles we describe in Chapter 1 are the same: Draw attention to the subject while reducing distractions.

Often, a first good step with a portrait image is to darken the background to draw attention to the subject. With the example image in Figure 6-17, we dropped a control point onto the bottom left to reduce brightness and saturation with a small boost to contrast. Then, we duplicated the control point by pressing the Option or Alt key and dragged a new control point to the top-right portion of the image and the bright object behind the subject's left ear. We then grouped the three control points to make it easier to select next time. Figure 6-17 shows all the control points added to the image.

Next, we added a control point to the face and increased the brightness, contrast, and structure. Because this is a portrait of a man, adding structure can be acceptable. By contrast, adding structure to a portrait of a woman, and thereby increasing the appearance of wrinkles and blemishes, would never be acceptable — our society calls for women's skin to be porcelain and smooth.

To enhance the skin a bit more, we increased the Warmth slider's value to add a small amount of warmth to the skin tones.

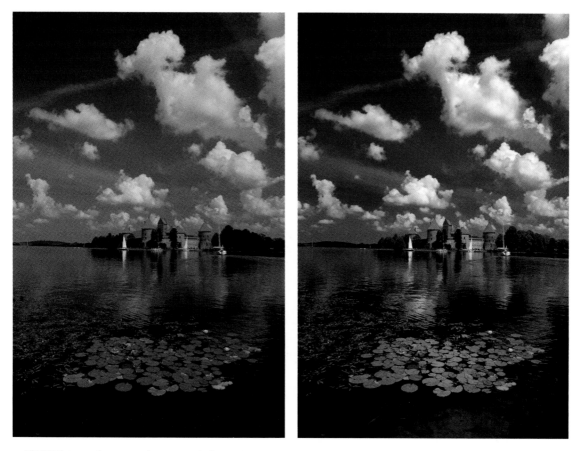

FIGURE 6-16. The original image at left and the adjusted image at right

We duplicated another control point from the first skin control point and placed it near the hat to even out the shadow cast by the brim of the hat. This second control point was then grouped with the first control point, as Figure 6-18 shows.

As the saying goes, the eyes are the windows to the soul, so you need to pay special attention to the eyes in a portrait photograph. Viveza makes this easy by letting you make precise selections of the eyes for enhancing them.

Zooming into the image makes it easier to make adjustments to the eyes. Double-clicking on the image lets you zoom in 100 percent in one simple step. Once zoomed in, we added a control point with a very small Size setting to the cornea of the left eye, increasing the contrast, brightness, saturation, and structure. We then duplicated this control point and placed it on the other eye. We added another control point to the whites of the eyes with increased brightness and decreased saturation. Finally, we grouped

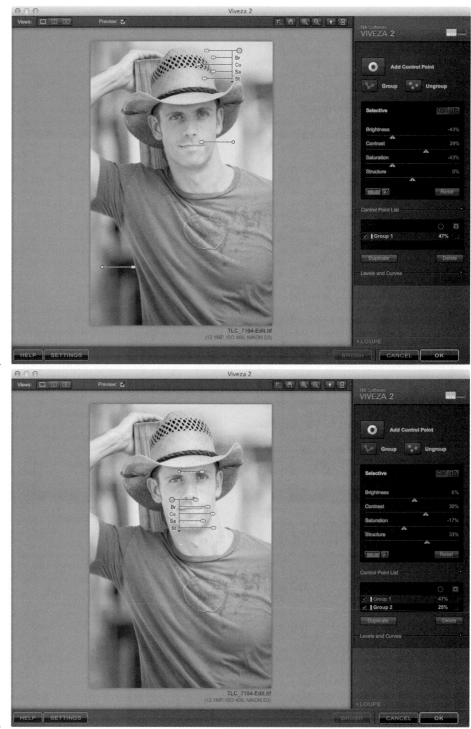

FIGURE 6-17. Adding a few control points to the background to draw attention to the subject

FIGURE 6-18. Adjusting the tonality of the skin

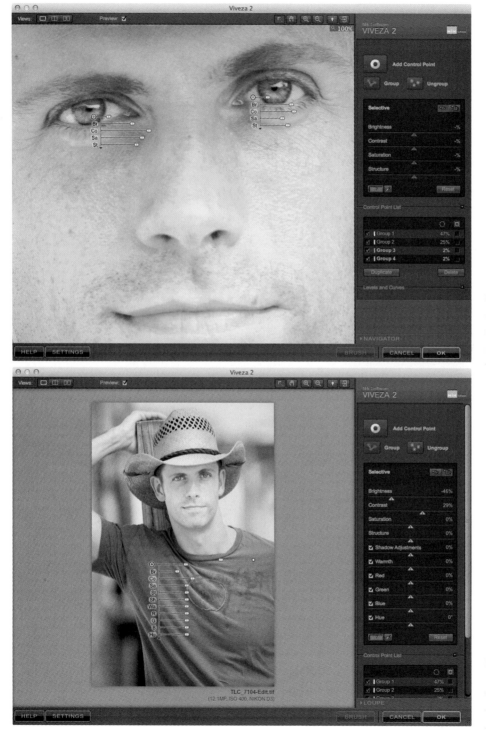

■ **FIGURE 6-19.** Using control points to enhance the eyes in a portrait

■ **FIGURE 6-20.** Darkening the clothes to draw further attention to the face

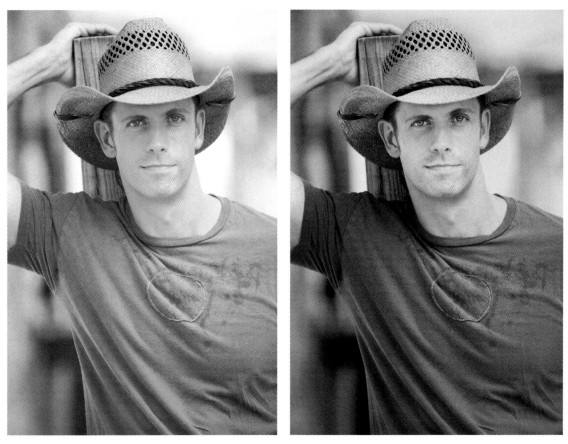

■ **FIGURE 6-21.** The original image at left and the adjusted image at right

both sets into two groups: one group for the corneas and one group for the whites of the eyes. Figure 6-19 illustrates how we adjusted the eyes.

After zooming out, we added a control point to the shirt to darken the shirt thereby drawing even more attention to the face. We duplicated the control point and placed it on the opposite side of the shirt and then grouped, as Figure 6-20 shows.

After taking a look at the enhanced image (see Figure 6-21), we can confirm that the viewer's eyes are now drawn to the subject and away from the distractions in the original image.

Chapter 7

HDR Efex Pro 3.0

N ik Software's entry into the world of HDR image editing is a powerful and full-featured photographic plug-in that can help you get the best possible results when you need to go beyond what your camera can capture.

HDR Imaging Explained

HDR imaging, which stands for high-dynamic-range imaging, is a process designed to let you capture images with a larger dynamic range than your camera can capture on its own. Figure 7-1 shows an illustration of the HDR process.

Since photography was first introduced, there have been limitations with the materials and devices used to capture images. One of those limitations has been the difficulty in capturing scenes containing a large tonal difference between the brightest and darkest objects.

Over the years, many techniques have been introduced in an attempt to overcome these limitations. Some of the first techniques involved capturing the same image with different exposures and then blending the exposures together by cutting negatives by hand and using masks to print the appropriate portion of a negative onto a print. One of the first popularized HDR processes is the zone system extensively described by Ansel Adams in his photography books *The Camera, The Negative,* and *The Print.* If you have not read his books yet, by the way, we highly recommended you do so because, although they focus entirely on analog photography, their lessons easily carry over into digital.

With digital photography, new and powerful algorithms designed specifically for the HDR process were created. These algorithms work to blend multiple exposures together into a 32-bits-per-channel file and then automatically convert the results to a 16-bit file while providing control over the look and feel of the image.

Regardless of the method used, HDR imaging's goal is to overcome the limitations of the device used to capture the scene. With digital, just as with film, only a limited range, known as the *dynamic range,* can be captured. Outside this range, details appear as pure black or pure white, and no details are retained.

Often, photographers describe HDR as a way to capture what the eye saw. We go one step further and say that HDR strives to re-create what *you* saw. That is, while the eye may arguably have a wider dynamic range than a camera, the human visual system (over a short duration) has an even larger dynamic range, "seeing" far more than any digital camera's current capability. This is because our brains capture not only one fraction of a second's worth of light, but also a constant stream of light and images. During this time, our eyes' pupils can expand and contract, adjusting how much light is allowed in, making it possible to see details in bright objects like the clouds and dark objects alike, as in the

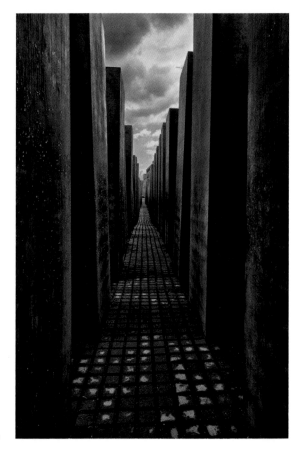

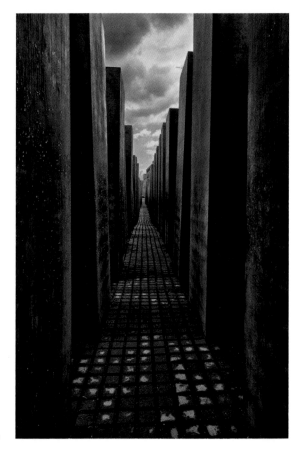 **FIGURE 7-1.** HDR imaging combines multiple exposures of the same scene into one image with details across the entire range of tonality. Here, the two images on the opposite page left are combined to create the final image at right on this page. On the opposite page, the image at left was exposed for shadows and the one at the far right was exposed for highlights.

shade. Our brain combines all this input and "sees" a scene.

Because a camera typically captures only one exposure, it cannot adapt to the different amount of light needed to capture the details in the clouds and the objects in the shade, so you are stuck deciding whether the highlights or the shadows are important and then exposing the image accordingly. Figure 7-1 on the opposite page shows an example of what you are likely to be familiar with: choosing whether to lose details in the highlights or the shadows.

With HDR imaging, you capture a series of images using different exposures, called a *bracketed image series*, and then use software such as HDR Efex Pro to create a photograph with details throughout the entire range of tonality.

The two stages of HDR image processing

In any HDR process, there are two stages for creating an HDR image: the merging stage and the tone-mapping stage. In the merging stage, multiple images are brought together

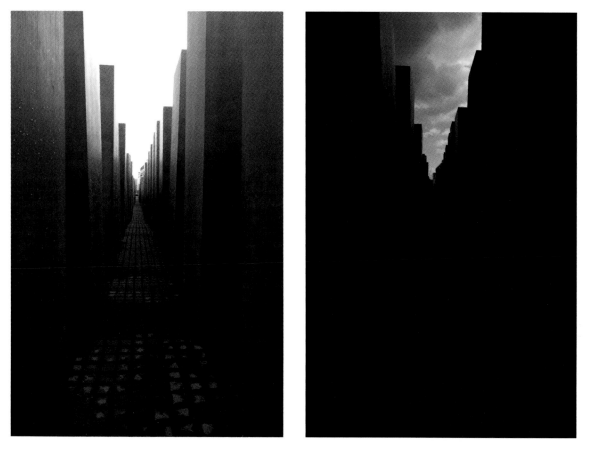

into a single, high-dynamic-range image. In the tone-mapping stage, the HDR image is compressed into a normal (also called *low-dynamic-range*, or LDR) image, with control

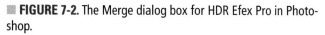

FIGURE 7-2. The Merge dialog box for HDR Efex Pro in Photoshop.

over where the tonal values and image detail is maintained.

The merging stage

The merging stage of any HDR imaging process is important, and one for which software developers have used various approaches. To merge a series of images, the HDR merging function must be able to open each image in the HDR series and then assign the tonal value from each image into the appropriate tonal value of the combined HDR image. Figure 7-2 shows the Merge dialog box for HDR Efex Pro 3.0 when used in Photoshop. (Merging in Lightroom and Aperture happens automatically.)

One way of thinking about merging is to imagine a number of bus loads of people who want to all get on the same train. Each bus represents the individual files, while the train represents the HDR image. To keep the analogy, imagine that on each bus are members of different families. These families can be considered different tonal areas of the image. On the train, each family wants to sit together. Likewise, the HDR merging process has to direct each family (tones) to the appropriate part of the train (HDR image).

Of course, there are differences between people and tonal values, and one of the biggest differences is that two tones from different images might need to be mapped to the same value in the HDR image. To merge them, a percentage of the values from one image is mixed with a percentage from another image. During a merge, image data might overlap, which ultimately means that if there are differences from one image to the next (caused by motion of the camera or objects in the scene), the differences appear as either partial or semi-opaque, leading to the term *ghosts*. To reduce ghosts, various algorithms are applied, each designed to reduce different types of ghost artifacts.

Finally, the color of the source images must be considered as it relates to the HDR image. This is because an HDR image uses a unique method of representing color and uses color spaces designed especially for HDR images. Because each HDR application uses its own approach to adapting the colors from the image series to the HDR image, different applications may create different results.

The differences from one merging process to another is just something to consider when you are working with your HDR images, as applications like Photoshop make it possible to use their built-in merging process but use HDR Efex Pro for the tone-mapping, which produces a different result from using HDR Efex Pro for both the merging and tone mapping.

The tone-mapping stage

Monitors and printers cannot display the range of details in an HDR image. To view or output an HDR image, you need to convert the HDR image to a normal image. You do

this by assigning a value from the HDR image to a value in the final processed image; this is called *tone mapping*.

The tone-mapping stage consists of two basic parts: first, compressing a large range of tonality (basically going from a 32-bits-per-channel image to an 8- or 16-bits-per-channel image) and, second, adding contrast and detail to keep objects properly separated, each with its own contrast and detail. Figure 7-3 shows an image with different amounts of tone mapping applied to it.

At a very basic level, the compression of the tones from an HDR image into a normal image reassigns the highlight values and the shadow values. If you have ever used a Levels tool and the Highlight and Shadow sliders to increase the contrast of an image in Photoshop or other image-editing application, you have basically performed this type of tone mapping.

But with an HDR image, you are doing the opposite process from what you did when moving the highlight and shadow points together via the Levels tool, which increases contrast. Tone mapping in HDR *reduces* the apparent contrast by squeezing the histogram, taking the highlight and shadow values that would otherwise not fit into a normal image and making sure they show up in the image.

During this process of squeezing the histogram, some information is lost. The HDR process has to somehow fit the 32-bits-per-channel image into an 8- or 16-bits-per-channel image. The 16 bits per channel of information lost (when going from 32 bits to 16 bits per channel) is mostly fine detail information that will not be noticed in the final image. That is, this tone-mapping process doesn't really lose quality or important image information. What does happen is that detail can be lost — which you can address via some type of image processing.

Because normal contrast tools affect the entire image, including the highlights and the shadows, HDR images require a different approach. Instead of applying a global contrast adjustment, most tone-mapping algorithms use a midtone contrast algorithm, also referred to as a *microcontrast algorithm*. A midtone contrast or microcontrast algorithm strives to adjust the contrast of the tones in the middle part of the tonal range, leaving the highlights and shadows unaffected. Adjusting the contrast of the midtones makes it possible to accentuate the details that are reduced by tone mapping. Most HDR imaging tools do some midtone contrast automatically and also let you make further midtone adjustments.

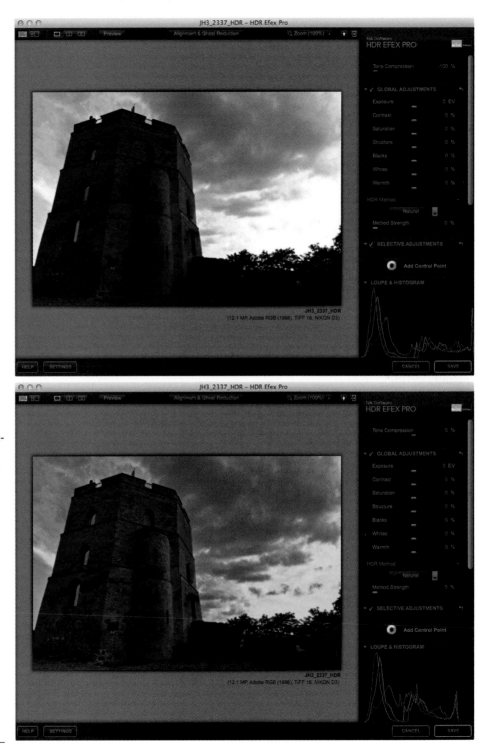

■ **FIGURE 7-3.** Tone mapping adjusts the contrast of the image and controls how the range of details from the HDR image are compressed into a normal photo. The image at the top of this page shows no tone compression, and you can see how there are no details in the highlights of the clouds. The image at the bottom of this page shows a medium amount of tone compression. The image on the opposite page shows the maximum amount of tone compression, resulting in a very strange-looking image.

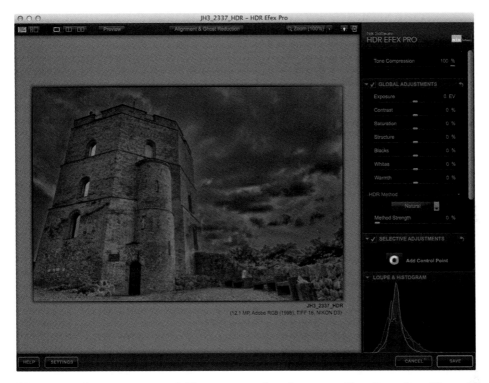

How to Capture and Process the Image Series for Best Results

Capturing images for an HDR series is a bit different from capturing images for normal photography, and so there are a few things to keep in mind.

Reducing motion

To create an HDR image, you need a series of images. Any movement in the scene, either from the camera or from objects in the scene, needs to be addressed to maximize the image quality. Reducing the amount of movement in the image means less work for you and increased quality of the final image. One way to reduce motion is to keep the camera as steady as possible by using a good-quality tripod with a high-quality head or, at the very least, stabilizing yourself by leaning against a wall or tree. We recommend using a remote or cable release to capture the series. After all, just touching the camera to fire the trigger can introduce enough camera shake that will negatively affect your image series.

Another consideration is to capture scenes where there is a minimum amount of movement by the subjects. Of course, there are times when there will be motion, such as

lapping water or areas with foliage when there is wind. Keep an eye out for moving objects such as a person walking through the scene, and reshoot when that moving object is still or gone. You'll get significantly better results.

Optimal camera settings

Next, consider the settings of your camera.

First, make sure the focus and zoom do not change from one shot to the next. If you have a lens that exhibits a bit of zoom creep, avoid shooting at angles that cause gravity to adjust the zoom of your lens. Also, focus the scene before capturing the HDR series, and be sure the focus is set to manual.

Second, set the exposure and white balance manually to make sure they don't change. If you would rather save time by not setting both the exposure and white balance manually, at least set the camera to aperture-priority mode so that the aperture stays consistent throughout the exposure series, with only the shutter speed changing from one exposure to the next. You may also need to set the white balance to the same setting for each image in your RAW conversion application. (We assume you're shooting in RAW, but if not, you really should do so at least when shooting HDR.)

Third, noise can be an issue with HDR imaging. We recommend using the lowest possible ISO setting to reduce the amount of noise introduced in the images.

Last, when you capture your image series, set the exposure series so that there's no more than one stop apart between each image. The farther apart the exposure series is, the more difficulty the HDR algorithm has recombining the images. You need to determine the number of exposures to capture based on the scene. For the most part, a series of five, seven, or nine shots one stop apart produces excellent results. A range of five stops (five shots one stop apart) is usually sufficient for most scenes. But you might need seven or nine stops if you are shooting directly into the sun or capturing a dark room with a window showing the outside fully lit by the sun.

Although rare, some photographers that do high-end architectural photography insist on no more than ⅓-stop increments. In that case, because most cameras limit you to three to nine exposures in a series, you either need to set up multiple exposure series or use an advanced remote such as the Promote Control.

Processing a series of images

After transferring your images to your computer, you may want to do other things to your images. But apart from the enhancements listed next, we do not recommend making

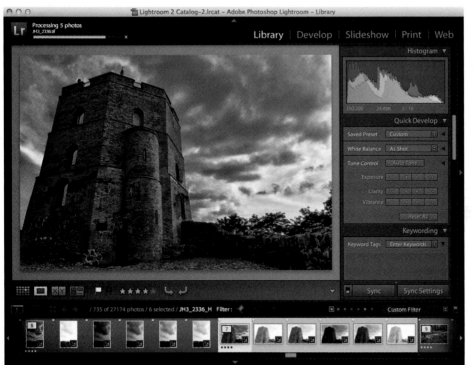

FIGURE 7-4. A series of images stacked in Lightroom

any other adjustments to the image series before creating the HDR image, as they may result in a lower-quality final result.

First, if you are using a photographic management software application such as Lightroom or Aperture, we recommend grouping each series and either tagging or labeling the series for easy identification later. Figure 7-4 shows a series of images in Lightroom stacked together with the processed HDR at the top of the stack.

Next, ensure that each image in the series has the same white balance. One easy way is to set the white balance for the middle exposure image and then duplicate that white balance for the rest of the images.

After you have ensured the white-balance settings are consistent, we recommend turning off sharpening (if it is on), applying noise reduction (either with Dfine or with your RAW conversion software), performing lens distortion and chromatic aberration correction (such as with Adobe Camera Raw, Lightroom, or Aperture), and cropping and straightening (ensuring that each image receives the exact same cropping and straightening effect).

With all these settings made, you are now ready to start the HDR process itself.

Working with HDR Efex Pro

HDR Efex Pro, like other HDR applications, has the two main stages described earlier in this chapter: merging and tone mapping.

Merging with HDR Efex Pro

During the merging process, a series of images is automatically merged into a single 32-bits-per-channel file. The images are also aligned and have any ghosts reduced. The specific process varies based on the host application you use.

Using Lightroom or Aperture

We generally prefer working with Lightroom or Aperture when creating HDR images. This is partially because the images are easier to locate and work with and partially because the merging process is significantly faster than when working in Photoshop.

But there are drawbacks to using Lightroom or Aperture, such as the inability to work nondestructively, so you need to determine which is more important: speed or flexibility.

When working in Lightroom, select the series of images you want to work with, then Control+click or right-click and choose Export ✣ HDR Efex Pro from the contextual menu (see Figure 7-5). With Aperture, select the series of images and then Control+click or right-click and choose Edit with Plug-in ✣ HDR Efex Pro.

HDR Efex Pro automatically aligns your images and reduces any ghosts in them based on the defaults set in the Settings dialog box. If you want to override these settings, click the Alignment & Ghost Reduction button at the top-center of the screen and select the appropriate settings (described later in this chapter). If you want to use the same settings every time you open the software, such as to disable alignment (which saves time and isn't necessary if you are using a sturdy tripod), open the Settings dialog box in HDR Efex Pro and adjust the Alignment & Ghost Reduction options.

Using Photoshop

Because Photoshop is designed to work with one image at a time, creating an HDR image from multiple images requires a script that opens and merges all the images into a single file. You can use either Photoshop's built-in HDR Pro mechanism or the functionality automatically installed with HDR Efex Pro.

To start, choose File ✣ Automate ✣ Merge to HDR Efex Pro (as shown in Figure 7-6) to open HDR Efex Pro's Merge dialog box. Select the images you want to include in your HDR image by clicking the Select button. Use the File dialog box to select a range

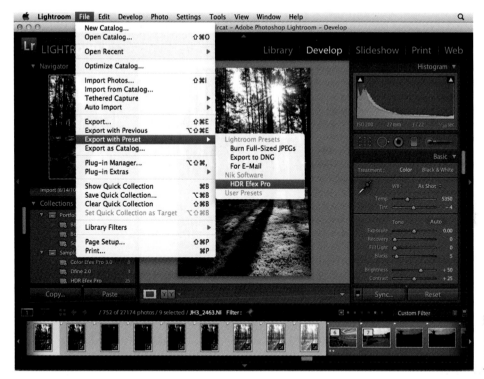

FIGURE 7-5. Accessing HDR Efex Pro from Lightroom

of images. Press and hold Shift to select a range of files, and press and hold ⌘ or Ctrl to select multiple images one at a time. HDR Efex Pro uses Photoshop to open the images, so any RGB or RAW file that Photoshop can open is opened in the Merge dialog box. (Any 32-bits-per-channel HDR images are ignored.)

If the file is a RAW file, HDR Efex Pro uses Adobe Camera Raw to open the RAW file and applies your previously applied settings to them. Be careful: If you previously changed the white balance or other image settings on one image of the series, you won't have a chance when opening the images to adjust those settings. If in doubt, open the series of images in Adobe Camera Raw as you would normally and make sure the settings are uniform by selecting all open images in the series, adjusting the settings, pressing Synchronize, and then pressing Done. This updates the sidecar's XMP file for each file so that when you open the files using the Merge to HDR Efex Pro script, they all have the same processing.

Once you have selected all the images, you have an option to open the image as a smart object as well as to select the alignment and ghost-reduction settings. We describe the alignment and ghost-reduction options later in this chapter. The smart object functionality is a bit more complex and has implications on your workflow (both positive

FIGURE 7-6. Accessing HDR Efex Pro from Photoshop.

and negative) that you should be aware of.

When you make an HDR image in Photoshop, the merging and tone mapping are two separate processes, not combined into one process as in Lightroom and Aperture. This separation is due to the nature of how Photoshop works with multiple files, but it means that you cannot change the alignment or ghost-reduction settings after the merging process has started. Once the merge has begun, if you see any problems with the alignment or ghost-reduction settings, you will need to start over again.

HDR Efex Pro's Merge dialog box automatically opens the HDR Efex Pro filter interface to perform tone mapping, but its options vary based on whether you enabled the Open as a Smart Object check box.

Enabling the Open as a Smart Object check box leaves the image as a 32-bits-per-channel image, with HDR Efex Pro applied as a smart filter. Working with HDR Efex Pro as a smart filter lets you adjust the settings you made in HDR Efex Pro and thereby change the processing even after you have closed Photoshop. Keep in mind that if you work with HDR Efex Pro as a smart filter, you won't be able to apply other filters or enhancements or save the image as a JPEG or TIFF that others can open until the image is converted to an 8- or 16-bits-per-channel file. To keep the benefits of the smart object, we recommend

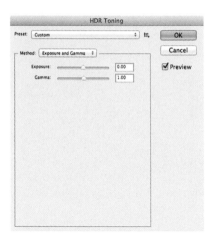

FIGURE 7-7. The Photoshop HDR Toning dialog box appears when you convert a 32-bit smart object to a 16-bit file.

saving the 32-bits-per-channel smart object as a working file. Then, you can create a separate 16-bits-per-channel file that you've further edited.

To convert your image to a 16-bits-per-channel file, choose Image ⇨ Mode ⇨ 16 bits/ Channel. At this point, you might see a warning that the smart filter won't work properly on the new image and be asked if you want to merge the document. We recommend that you merge the results, which will flatten the image. After you click Merge, the Photoshop HDR Toning dialog box displays. Its default option is to tone-map your images again, which is not what you want. Instead, choose Method ⇨ Exposure and Gamma. Leave the values at their defaults (0.00 for Exposure and 1.00 for Gamma), as shown in Figure 7-7, and click OK. You now have a 16-bits-per-channel file that you can continue processing or save as a TIFF or JPEG for others to view.

The downside of using the Open as Smart Object option is that there are more steps involved getting a file you can print or share. And if you save the 32-bits-per-channel smart object, you will have a significantly larger file. If these drawbacks are not a concern, or if you need the additional control provided, using the Open as Smart Object option may be a good option for you.

Applying HDR Efex Pro without enabling the Open as a Smart Object check box automatically converts your image to a 16-bits-per-channel image, so you will not be able to adjust any of the settings after the filter has been applied.

The Exposure Values dialog box

If HDR Efex Pro cannot automatically read the exposure EXIF information from the images in your series, you may be presented with the Exposure Values dialog box. This dialog box lets you manually indicate the exposure of each image in the series. It is important that you set these values correctly, at least relative to one another. It is

FIGURE 7-8. The Exposure Values dialog box in HDR Efex Pro

not important to indicate exactly which image was shot at EV −2 versus EV 0. But it is important to indicate the relative exposure values from one image to the next. For example, if you shot each image one stop apart, you only need to make sure that each image is one EV apart from the next and in the correct order.

Unless you set the exposure values manually and did not use evenly spaced stops, the best way to set the exposure values is to use the E.V. Spacing menu in the Exposure Values dialog box to choose the appropriate option. For example, to set the bracketing of the images one stop apart, choose E.V. Spacing ⇨ 1. The Exposure Values dialog box then tries to automatically order the files from darkest to brightest and then assign a relative exposure value to each image, each image being one stop brighter than the next. Figure 7-8 shows the Exposure Values dialog box.

Alignment and ghost-reduction settings

HDR Efex Pro offers controls for aligning images that were not captured with a tripod as well as options to reduce ghost artifacts from objects that moved while the image series was captured.

The alignment tool in HDR Efex Pro is basic, but it does work for most situations. As long as you held the camera as steady as possible and anchored yourself to a stationary object like a tree or a wall, the alignment function should align the images. The most likely cause of the alignment in HDR Efex Pro not working is if the camera rotated or moved

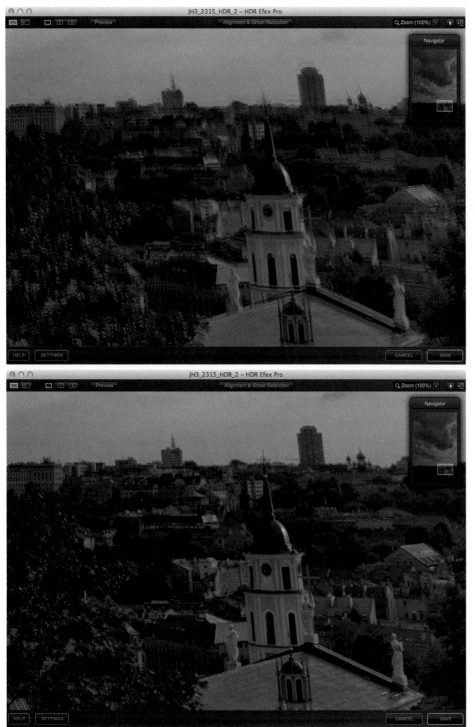

FIGURE 7-9. A hand-held image without alignment (top) and with alignment (bottom)

toward or away from the focal plane. To put another way, HDR Efex Pro can resolve movement or rotation in which the sensor stays parallel to the focal plane throughout the series of exposures. But if the camera rotates or moves in a way that the focal plane changes from one shot to another, HDR Efex Pro cannot adjust or adapt the image details from one shot to another. Figure 7-9 shows an image that was captured handheld with and without alignment.

If you do always shoot with a tripod (as we recommend) it is best to turn off Alignment in the settings. Turning off Alignment will save time each time you open an HDR image series because HDR Efex Pro will not need to process the alignment.

The ghost-reduction tools are a bit more complicated, and you need to understand the methods possible to select the best tool to reduce ghost artifacts.

Adaptive ghost reduction

The adaptive ghost-reduction method is designed to work on images in which there are small objects moving almost randomly. This method is called *adaptive* because the ghost reduction is evaluated and applied based on each image in an attempt to adapt to the movement from one image to the next.

FIGURE 7-10. The three images show the difference between no ghost reduction (bottom, this page), global medium reduction (top, opposite page), and global high reduction (bottom, opposite page). Ghost artifacts are evident in the image without ghost reduction and in the image with ghost reduction set at medium.

Adaptive is the best option to use if there are small objects with motion, fast-moving clouds, trees, or water.

Global ghost reduction

The global ghost-reduction method works best on images that have one image in which there are objects moving through the image in a continuous direction. Each object can move in its own direction, but they should keep moving in their same directions from image to image. For example, global works best if there are people or cars moving through the image. This method is called *global* because one image is selected automatically to be used as the base image and the other images are compared to the base image to determine what has moved from what is stationary.

With both the adaptive and global ghost reduction methods, we recommend starting with the medium strength value and increasing the strength if there are remaining ghost artifacts. Figure 7-10 shows an image with different levels of ghost reduction applied.

If you see artifacts caused by the ghost reduction, you may need to reduce the strength again. Applying — or at least testing — these ghost-reduction variations is relatively easy in Lightroom and Aperture because, as mentioned earlier, the selection is made in the HDR Efex Pro interface. Working in Lightroom or Aperture saves significant time if you need to experiment with different ghost-reduction options, as you won't have to start over each time you want to change the ghost-reduction settings, as you would in Photoshop.

There are situations when an image contains portions that require both the adaptive and global algorithms to be applied in different areas, or where the ghost-reduction algorithm will not reduce the ghost artifacts. In both situations, you might need to selectively mask the ghost artifacts by blending two versions of the same HDR image or by blending in a part of one of the original non-HDR images from the series. You will need to determine if the image is worth the effort this extra work entails.

Tone mapping with HDR Efex Pro

After merging a series of images, regardless of the host application you are using, you are presented with the main interface for HDR Efex Pro. There are three main sections in the HDR Efex Pro interface that you can use to enhance and adjust your image: Global Adjustments, Selective Adjustments, and Finishing Adjustments.

Before starting with the controls in the right pane, you might want to work with the presets in the left pane. These presets represent different snapshots of slider settings; clicking a preset changes all the sliders in the right pane and updates the live image.

The presets are helpful as a starting point for your images, as well as to experiment with possible looks. Very often, you can find a look that you had not originally intended to create by experimenting with the presets. Additionally, you can create your own presets to use as starting points for other image series. These custom presets can then be exported and shared with other HDR Efex Pro users.

Global adjustments

The Global Adjustments section shown in Figure 7-11 contains what we believe are the most important controls for your HDR image. Although the Tone Compression slider is not in the Global Adjustments section, it is really the first global control you should use when starting to work with your HDR image. The Tone Compression slider is the main tone-compression control and is the way to bring the highlights and shadows closer together — basically bringing details back into the brightest and darkest areas of your image.

The next most important control for your HDR image is the Exposure slider. Frequently, you can get close to finishing your HDR edit by simply adjusting the Tone Compression and Exposure sliders.

Note that adjusting one of these sliders may require an adjustment to the other. When

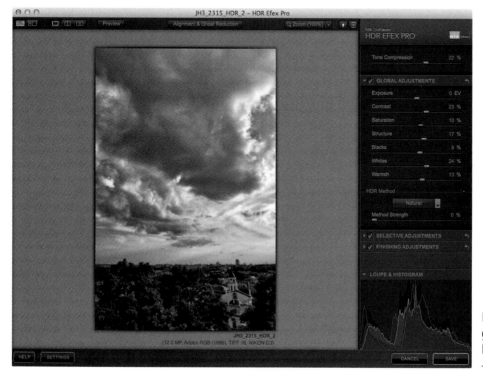

FIGURE 7-11. The global adjustments in HDR Efex Pro

working with the Tone Compression and Exposure sliders, keep an eye on the highlights and shadows. The goal should be to increase the amount of visible details in the highlights and shadows, but to maintain some bright and dark areas.

We recommend adjusting the Blacks and Whites sliders until you have an image with a good range of details throughout the highlights and shadows and then use the background color selector found at the top of the interface. By cycling through the background colors (clicking on the light bulb icon directly to the right of the Zoom tool cycles the background among white, black, and gray), you should be able to tell if the bright areas are bright enough or if the dark areas are dark enough. Often, you find an area you thought was bright is really just a light gray when you put your image against a white background. The same might happen for the shadows when the image is placed on a black background.

Once you have a good range of tonality, maintaining good shadow and detail information, you can move on to the other controls.

The Contrast and Saturation controls offer the same types of control as in other Nik plug-ins, and they are useful in balancing your image's color and tonal ranges. By having these controls in HDR Efex Pro, you also save time with what is often a necessary

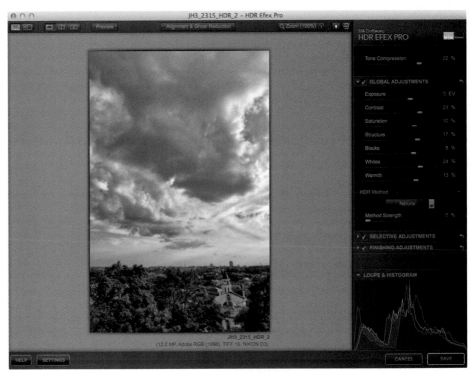

FIGURE 7-12. The three images all contain different HDR Methods. This page: The image has no HDR method applied. Top, opposite page: The image has the Textured HDR method applied. Bottom, opposite page: The image has the Dark Textures HDR method applied.

adjustment that would otherwise need to be made in the host application.

The Structure control is also the same as in other Nik plug-ins, but here it helps with images in which the details might look a bit undefined or muddy.

The Blacks and Whites sliders provide more direct control over the highlights or shadows of the image. Use the Whites slider in case you have an image in which the shadow and midtone tonalities look good but you need to brighten or darken just the highlights of the image. Likewise, use the Blacks slider if the highlights and midtones look good.

The Warmth slider helps you adjust the color balance of the image, either warmer (more red-orange) or cooler (more blue).

The HDR Method and Method Strength controls are a bit more complicated. Each HDR method changes how the image is tone-mapped. The default tone mapping occurs when the Method Strength slider is set to 0%, which is the default. By increasing the Method Strength slider and then selecting an HDR method, you can change the feeling of the image considerably. Keep in mind that the value of the Tone Compression slider also affects how the selected HDR method is applied to your images; if the Tone Compression slider is set to a low value, the HDR Method and Method Strength controls have little to no effect on your image.

The best way to see what the HDR methods can do is to experiment with your image. Figure 7-12 shows an image with different HDR method settings. Some HDR methods increase the texture or grunginess of your image, some soften your image, and others try to reduce the introduction of halos in your images. One of our favorites is the Sharp method, which tends to make everything have clean and sharp details without adding textures or grunge.

After changing the HDR method, you might need to adjust the Tone Compression and Exposure sliders again. We recommend that you decide on a specific look in your images before adjusting the Global Adjustment sliders. Selecting one of the HDR methods and adjusting the Method Strength and then adjusting the Global Adjustment sliders saves time and prevents too much back and forth between the different sections. For example, if you want a really grungy look to your image, select either the Dingy or Dark Textures HDR method and increase the HDR Method value to around 50%. Then, adjust the Tone Compression and Exposure values until you get a good result. You might need to balance these three sliders until you get a good starting point and then continue with Contrast, Saturation, Structure, and so on.

Selective adjustments

HDR Efex Pro, like all other Nik tools, has U Point-powered control points that allow you to selectively adjust your image. In HDR Efex Pro, the control points let you take selective control over the tonality of your image with full control over the 32-bits-per-channel of information.

Each control point offers the same controls on the image as in the Global Adjustments section, apart from the ability to change the Tone Compression and which HDR method is used. Both the Tone Compression and HDR methods are globally set, but the HDR Method control allows you to selectively determine the degree for applying the selected HDR method to each area. Figure 7-13 shows a control point in HDR Efex Pro.

When you first add a control point, you are presented only the Exposure, Contrast, and Saturation controls. To see more controls, click the disclosure triangle directly below the Saturation slider.

Apart from adjusting the tonality of different objects in your image, the most common use for control points is to adapt the color of light between shadows and brightly lit areas. Normally when we take a picture outdoors, we have to choose between exposing for the bright areas (making the shadows completely black) or for the dark areas (making

FIGURE 7-13. Using control points in HDR Efex Pro to selectively adjust tonality

FIGURE 7-14. You can use control points to balance the light temperature of shadows, such as in this image. At top is the original, and at bottom is the adjusted image.

the highlights completely white). With HDR, we can maintain details throughout all these areas which opens a new issue: the light that illuminates objects in the shadows is a different color temperature than the light that illuminates objects in direct sunlight. The result of differently illuminated objects is that either the objects in direct sunlight appear very yellow or the objects in the shade appear very blue. In either situation, the image probably looks a bit strange. Luckily, we can use control points to easily and efficiently resolve this problem, as shown in Figure 7-14.

We recommend setting the white balance of your image series based on the illumination in the majority of the image. If the sun illuminates the majority of the image, use a daylight white balance. If the majority of the image is in the shade, use a shade white balance. Then, when processing the image, add control points to the area that is either too warm or too cool and use the Warmth slider to either cool or warm that area.

Finishing adjustments

After adjusting the global and selective adjustments, you might want to polish off your image directly in HDR Efex Pro. Nik included two popular tools often used to finish images: Vignette, and Levels and Curves. In Figure 7-15, we used both the Vignette tool and Levels and Curves tool to stylize the image.

FIGURE 7-15. The Finishing Adjustments controls make it possible to enhance an image from start to finish using HDR Efex Pro.

The Vignette section lets you darken or brighten the edges of the image. This is especially useful because the HDR process flattens the natural lens vignette in most images, reducing the apparent depth of the image. Adding a subtle vignette helps create a great looking image, whereas more extreme vignettes can give a stylistic effect.

The Levels and Curves tool can refine the tonality and contrast of the image, or even add a bit of a stylistic colorcast by independently adjusting the color channels. A few presets are provided with these colorcasts, but you can certainly create your own effects by adjusting the curves to your taste. Levels and Curves is one of those strong control elements that is best used to save time by minimizing the amount of additional work when you take the image back to Photoshop, Lightroom, or Aperture.

HDR panoramas

HDR and panoramas seem to go hand in hand. Often, when shooting a panorama, the amount of light on one side is completely different from the amount of light on the other side of the scene. This could be because the sun is in the frame in part of the image or because of brightly lit areas in one portion of the image.

Here is a quick primer on how to shoot and process an HDR panorama. Figure 7-16 shows a nighttime HDR pano taken in Hong Kong.

Before starting, make sure you have a tripod, preferably with the ability to rotate without adjusting the angle of the head (and even better if you use a head specifically designed for panoramas), panorama stitching software (we prefer PTGui Pro, and so use it in this example), and patience.

Also consider the scene. If the light is changing rapidly (around sunset or sunrise) or if there are a lot of moving objects (like waves or fast-moving clouds), you might not be

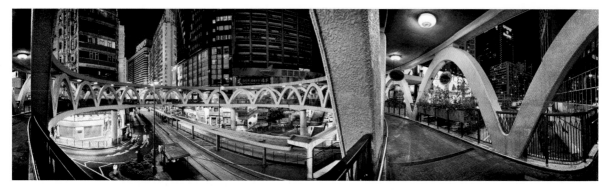

FIGURE 7-16. This panorama can be printed 44 inches wide without resizing

able to get a good HDR panorama. By the time you shoot a full 360-degree panorama, the color or tonality of the light may have changed too much so that the starting and ending frames no longer match. With waves or clouds, one bracketed series will have a different set of waves from the previous or following series, creating obviously broken waves or clouds. Sometimes these issues can be resolved easily, other times though the amount of work can override any enjoyment you might get from the image.

Setting up to shoot an HDR panorama

To get good results shooting a panorama, you need to first level your tripod by adjusting the height of each leg on your tripod that has a spirit level on the base (not on the head), by using a leveling base, or by using a panorama-specific head. Without leveling the tripod, your images will have the telltale bow tie shape and you will likely need to crop out useful areas of your image.

After leveling your tripod, set your camera to the manual exposure, white-balance, and focus settings. Turn on your auto-exposure bracketing according to the appropriate values for your scene (as described previously in this chapter). Most panorama tripod heads have markers to show the position of the head; if your head has these markers, make note of the starting position of the panorama. Take your first bracketed series.

Next, without moving the tripod legs or adjusting the exposure, focus, or white balance, rotate the head so that there is approximately a 40-percent overlap between the first exposure series and second exposure series. You can do less overlap, but then you might have difficulties matching image details. Take the second series.

Continue in this fashion until you get back to where you started. We have found it is best to get the image back to the same point as you started, or at least close.

Creating the panoramas

Once you have transferred the files to your computer, convert the files from RAW to TIFF using your preferred image-editing application. Although PTGui Pro does support RAW files, we have found that applications such as Photoshop, Lightroom, and Aperture produce better results in that format. You can also use these tools to do noise reduction, vignette and distortion correction, and chromatic aberration reduction — all things that are as important in an HDR panorama as they are in a regular HDR image.

With the series of TIFF files created, open PTGui Pro and click Load Images. Select the full range of images and click Open. After the images have loaded, click Align Images. PTGui Pro should find that the images are part of an HDR series and ask you if it should

FIGURE 7-17. PTGui Pro's HDR Pano Options dialog box

link the images. As long as you captured the images using a tripod and a panorama head and did not move the tripod through the series, choose the Enable HDR Mode and Link the Images option as shown in Figure 7-17.

You can then adjust the panorama, and if you captured a full 360-degree image, you can adjust the center point of the image as well as crop parts of the image that do not have data.

Next, click the Create Panorama button in the main window of PTGui Pro. In the next window that appears, we recommend first clicking the Set Optimum Size button and selecting Maximum. Next, change the LDR File Format from JPEG to TIFF and click the Settings button next to the LDR File Format to make sure the output images are set to 16 bits per channel. Finally, make sure to enable only the Blend Planes check box in the Output LDR section. This outputs one stitched panorama per exposure series. Figure 7-18 shows the settings dialog box ready to create the panorama layers.

FIGURE 7-18. PTGui's Create Panorama settings dialog box

■ **FIGURE 7-19.** HDR Efex Pro with a panorama loaded

Create the HDR panorama

Once you have a panorama for each exposure (resulting most likely in three, five, or seven different panoramas), open the files in HDR Efex Pro. Keep in mind that the files will now be significantly larger than other HDR series you have worked on so far. So now is the time to be patient. You don't need to do anything differently to an HDR panorama from what you would to a regular HDR image, apart from zooming into some areas more often and panning around a rather large file. Figure 7-19 shows the HDR pano opened in HDR Efex Pro.

The extra effort and time can really pay off, though, as there is seldom anything cooler than a huge panorama full of detail.

More than just about any of the other Nik tools, HDR Efex Pro almost begs for experimentation. The more you test and try new things the more your work will not only take on a whole new look but will also offer options you never dreamed possible.

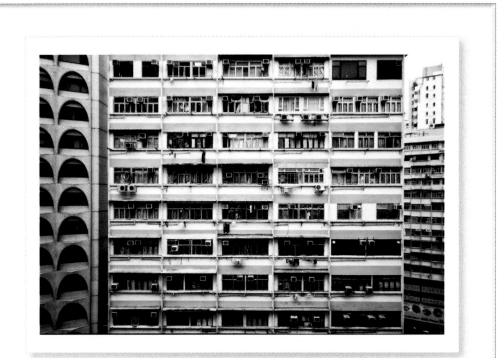

Chapter 8

Color Efex Pro 4

Color Efex Pro 4 is one of the easiest products in the entire Nik product line to learn how to use. This ease of use, however, belies the enormous range of possibilities in this product. In this chapter, we focus on the basic functionality in Color Efex Pro 4 and then focus on example images to show you how we approached each image, which filters we used, and why to create a unique style.

Working with the Filter List and Presets

Color Efex Pro 4 is essentially a collection of individual filters, each geared to a specific look. Figure 8-1 shows the filter list along with some of the available filters. With a total of 55 filters, the biggest problem with Color Efex Pro 4 is often figuring out which filter to apply to your images. Many photographers have found it hard to learn what each filter does without playing with the software for some time. But once you know which filter you want or can visualize the exact result you want with a combination of filters, you might rely on the filter categories and presets less and less.

As with any new tool, practice and patience is needed to master it, but this doesn't help when you have a project looming overhead and have yet to master all 55 filters. This is where the filter categories and visual presets in Color Efex Pro 4 come in.

FIGURE 8-1. The Color Efex Pro 4 filter list

The first thing we recommend new Color Efex Pro 4 users do is to set up their filter categories. The default categories may work fine for you, but we each have different styles and work on different types of photography, so different categories make sense for each of us. For example, Tony does mostly portraits of people and some travel photography, whereas Josh does mostly landscape and travel photography. This means there are a few filter slots that contain photographic styles that we don't use.

To that end, we each customize which categories show up. The All and Favorites categories always show up, but the other six can be customized. To customize your list, open the Settings dialog box, click on the Filterlist Settings section, and then select which categories you want in which slot.

Tony prefers to have the Portrait, Wedding, Travel, Commercial, Fine Art, and Detail categories displayed (shown in Figure 8-2), while Josh prefers the Landscape, Architecture, Contrast, Color, Detail, and Softening categories. Of course, the filters displayed in each category are only recommendations, but it is still a helpful way to reduce the total number of filters you need to focus on.

The way we use the categories is as follows: If we have a specific type of enhancement to apply, we go right to the appropriate filter type category, such as Contrast, Color, Detail, or Stylizing. If we are not sure, we go into the type of photography that closest represents the subject matter, such as Portrait, Landscape, and Architecture. Once we have a category selected, we switch over the visual presets for the first filter by clicking on the Visual Presets icon (the icon is shown at left), as shown in Figure 8-3. By showing the visual presets, we can very quickly see what the image could look like with different variations of that first filter. If none of the presets feel right, we then click on the down-pointing arrow to the right of the filter name. This navigates to the next filter in the list, showing the presets for that filter.

FIGURE 8-2. Tony's Filterlist Settings configuration

FIGURE 8-3. Accessing the visual presets

FIGURE 8-4. The Tonal Contrast visual presets

By reviewing the presets filter by filter, we can see our image with different filters at different settings applied to our images and quickly evaluate what we might want to do to our images. Figure 8-4 shows the presets available for the Tonal Contrast filter. If none of the presets speak to us, we might switch categories or even switch to some recipes that we installed from the Nik website at www.niksoftware.com/recipes.

Basic Controls

Every filter in Color Efex Pro 4 has a series of sliders that controls the functionality of that filter. With 55 filters and a pretty good online help system, we won't go into what each slider does in this book. It is more important to understand the controls that all the filters share.

For every filter added to the filter stack, there are a few consistent controls. The first is the ability to turn on and off that particular filter. This is helpful when you have a stack of filters and you want to see how a single filter is affecting that stack. To turn on and off a filter, click the check box immediately to the left of the filter name. Often with complex stacks, it gets hard to anticipate the effect a single filter has after other filters have been applied after it. Turning on and off that specific filter can help you narrow down a specific

FIGURE 8-5. Color Efex Pro 4's control pane

effect if you are having difficulty with a colorcast or too much contrast.

The next controls for each filter are the context menus and the Delete Filter button near the top of the right pane. The context menu lets you copy and paste all the control points of a filter, as well as reset that filter. Figure 8-6 shows the context menu for the Polarization filter: For the Rotate attribute, the options are Copy Control Point and Paste Control Point, whereas for the Strength attribute they are Reset Filter (Keep CPs) and Reset Filter (Delete CPs).

The copy and paste control-point options make it easy to duplicate the exact selection from one filter to another, so you don't have to try to place new control points in the same position and worry about the Size and Opacity slider settings for those new control points. To use these options, click the context menu for the filter whose control points you want to copy and choose Copy Control Points. Then click the context menu for the filter you want to paste the control points into and choose Paste Control Points. You end up with two filters with the identical number of control points, at the identical locations, with the identical Size and Opacity slider settings.

Below the unique controls for each filter are the Shadows and Highlights sliders; note that these sliders are not available in every filter. The Shadows and Highlights sliders let

FIGURE 8-6. Use the filter's context menu in Color Efex Pro 4 to copy and paste control points and reset the filter.

you bring back details that the filter may have removed in the shadows or highlights.

Next are the controls for the control points as shown in Figure 8-7. The control points in Color Efex Pro 4 have two slider settings: Size and Opacity. The Size slider works the same as with all control points: It lets you determine the reach of the control point. The Opacity slider lets you blend the original image details and the filtered image's details. You can add either a + or – control point to your image, but both buttons add the same type of control point. The difference between the two buttons is that the + control point button adds a control point at 100-percent opacity whereas the – control point adds a control point at 0-percent opacity.

Furthermore, if you used + to add the first control point, the global Opacity slider in the Control Point section, which controls the overall opacity of the filter's effect, is set to 0%. Color Efex Pro does this because if the global Opacity slider is set to 100%, adding another control point to the image at 100% would have no effect (you cannot have the filter applied more than 100% to any one part of the image). To put this another way, pressing the + control point is basically instructing Color Efex Pro 4 that you want to add the current filter's effect *only* to one selective part of the image. To achieve this result, first the filter needs to be removed from the entire image (done by automatically adjusting the

▨ **FIGURE 8-7.** Adding control points to an image

global Opacity slider to 0%) and then the filter needs to be added only to one part of the image (done by adding a control point to the image set at 100% opacity). You can also use the global Opacity slider to blend the filter's effect into your image at a reduced amount, even if you do not use control points for that filter.

In addition to the + and – control point buttons and the global Opacity slider, there is a list showing all the control points added in the current filter. This list displays a variety of information, such as whether the control point or group is active, the number of the control point or group, the size of the control point or group, and an option to show the mask for each control point or group.

Click the top icon for either the first column, which shows whether the control point or group is active, or the last column, which controls the visibility of the mask for the control point or group, thereby activating or deactivating the entire column. You can show or hide either or both of these columns this way. This is helpful if you want to quickly turn on or off all control points or display the masks for all control points.

Below the control point list are controls to group and ungroup control points and duplicate and delete control points. These controls work the same as in the other control points and as described in Chapter 4.

Immediately following the control point functions are two very important controls: the Add Filter button and the Save Recipe button.

The Add Filter button lets you add a filter to the current filter stack. Normally, selecting a filter from the filter list replaces the filter that is currently shown, so you can easily switch among various filters to see which filter works best for your particular image. Once you have finalized a filter's effect and you want to add another filter, click the Add Filter button. Then, a new blank filter is added below the current filter, as shown in Figure 8-8 — it doesn't replace the current filter. From that blank filter, you can select an additional filter from the filter list. A faster way to do this same task is to press and hold the Shift key while clicking on a filter in the filter list.

The Save Recipe button lets you save the current filter stack to be applied later on another image. After you click this button, you name your recipe and it is added into the Custom category in the Recipes section, as shown in Figure 8-9. Saving a recipe saves each filter, its slider settings, and the global Opacity slider setting in the Control Points section. The control points themselves are saved because each control point is object- and location-specific and would not create a meaningful result on another image.

There is a way to save the control points into the recipe, but it should only be done if you understand the drawbacks and if you remember to add a reminder to yourself in the name of the recipe. To save the control points, press and hold the Shift key while selecting

■ **FIGURE 8-8.** An empty filter is added to the filter stack after pressing the Add Filter button.

■ **FIGURE 8-9.** Saving a recipe after adding a few filters to the filter stack

the Save Recipe button. The only way to keep track of a recipe with control points in it is to add some reminder text into the name, such as CP. We do not find many uses for this feature, however, so keep in mind it is probably best to not add the control points in the recipe unless you have a good idea how you will use them later.

Finally, the Loupe & Histogram filter lets you see either a 100-percent view of your image under the cursor or a histogram displaying the distribution of tones in the image. In both the Loupe and the Histogram modes, you can click the Show Clipped Shadows and Show Clipped Highlights buttons to add digital "ink" on top of your image areas that are either pure black or pure white. This can be helpful if you are adjusting tricky contrast and tonality adjustments and don't want to lose too much detail in either the shadows or the highlights. Hovering the pointer over either control shows you the clipped areas temporarily, whereas clicking on either control shows the inking until you click the control again.

Taking Advantage of Recipes

Recipes are one of the most important features of Color Efex Pro 4. Designed to add a bit of automation to the Color Efex Pro editing process, recipes offer the opportunity

FIGURE 8-10. The built-in sample recipes, as well as recipes that you have created or downloaded, provide a wide range of possibilities to quickly enhance your images.

to save the settings of individual filters of a series of stacked filters. Figure 8-10 shows an image with the recipes section open.

Recipes are ideal for creating a consistent and predictable result, and they save you time in the process. You can share your custom Recipes by exporting them as files and then e-mailing or uploading them to others.

Hovering the pointer over the recipe you want to share reveals three hot corners with controls on top of the recipe thumbnail, as shown in Figure 8-11. You can also delete or resave any updated recipe. To import recipes, click the Import button at the bottom of the Recipes section and then locate and import the recipes.

When you apply a recipe to your image, the filters in the recipe replace all the filters in your current filter stack. To add the filters from the recipe to the bottom of your filter stack, press the Shift key when selecting a recipe.

If you would like to back up all your recipes, click the Export All button at the top of the Custom recipe category. You can then specify the folder where you want to save all the recipes.

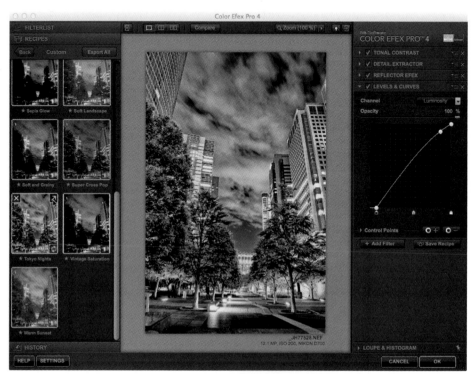

FIGURE 8-11. Hovering over a custom recipe shows buttons to delete, export, and update your recipe.

The Powerful History Browser

When the first History Browser was introduced in Silver Efex Pro 2, many photographers couldn't see how it would fit their workflows. The ability to see a full list of all edits applied to an image (shown in Figure 8-12) is important, but the ability to use the undo and redo shortcuts to accomplish this goal is often easier and faster. The real benefit of the History Browser comes from the ability to see two different states of the same image when used with the Compare button or the split or side-by-side view options.

Access the History Browser by clicking History in the left control pane. To compare any two edits along the way, click the Compare button or switch to the split or side-by-side preview modes. You will see that the History State Selector indicator — the large orange, arrow on the left side of the browser — has been activated. The last edit you made is highlighted in orange on the bottom of the list and is shown in the live preview.

You can then click and drag the History State Selector to any other step in the History Browser to set that point to the before state of the image, as shown in Figure 8-13. You can also change the final or last edit by clicking any other step in the edit history, which then changes which two steps are compared.

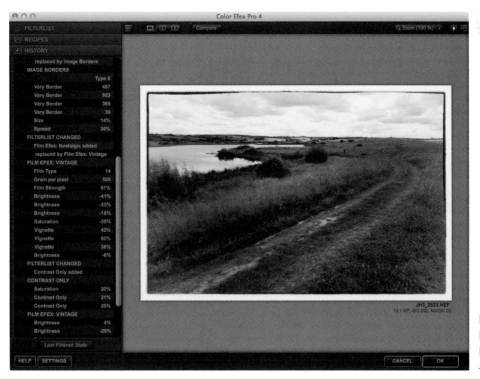

FIGURE 8-12. The History Browser in Color Efex Pro 4

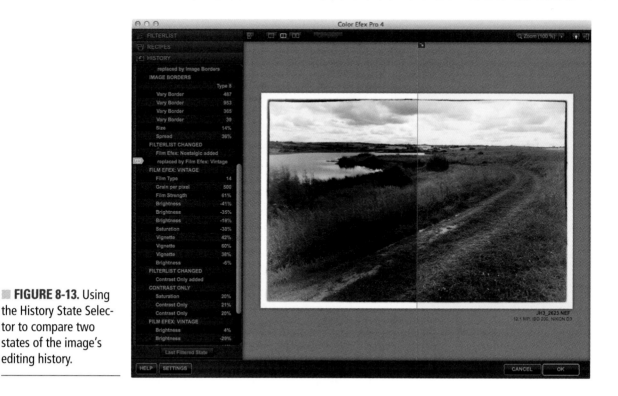

FIGURE 8-13. Using the History State Selector to compare two states of the image's editing history.

Example Images and Enhancements

Now that we've toured the common capabilities of Color Efex Pro's filters, let's explore a few images from start to finish to show how we edited them. With all the different possibilities in Color Efex Pro 4, there is a lot you can do with the software, as you will see from these three examples.

Example 1: A portrait photo

In this outdoor portrait taken of a friend and fellow photographer in Santa Fe, New Mexico, we took care to create a nice, soft light quality using no flash or reflectors. As you know, almost any portrait can be improved with a little enhancement, such as that shown in Figure 8-14.

In this case, the first thing that we did to the image was to add Dynamic Skin Softener, as shown in Figure 8-15. This is our go-to filter in most people-oriented photography as it adds just a bit of skin softening without adding too much diffusion. After opening the image and selecting Dynamic Skin Softener from the filter list on the left, we left the top slider, Color Reach, in the default position of 25%. That setting is ideal when there is much

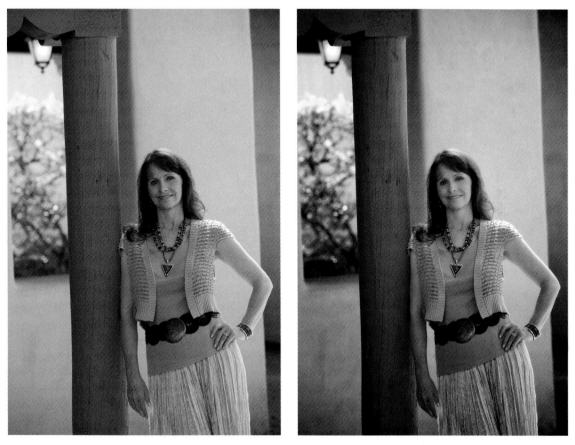

■ **FIGURE 8-14.** Quickly adding a few filters in Color Efex Pro 4 softens the skin and draws attention to the subject in the image. The left image is the original, and the right image is the adjusted image.

of the same tonality in the image as in the area you want to slightly soften (in this case, the skin).

Next, we lowered the Small Details slider slightly from the default position. (Note: It is helpful when working with skin to zoom in to see the effect properly up close. Tap the spacebar to zoom into your image.) The small details refer to areas such as fine lines, textures, and so on that might need a little softening. The key with this slider is to experiment by increasing and decreasing the slider while zoomed in and watching the details change.

You want to create a softening effect without completely blurring the face. Here, we adjusted both the Medium Details and Large Details sliders to minimize the effect and not add too much softening.

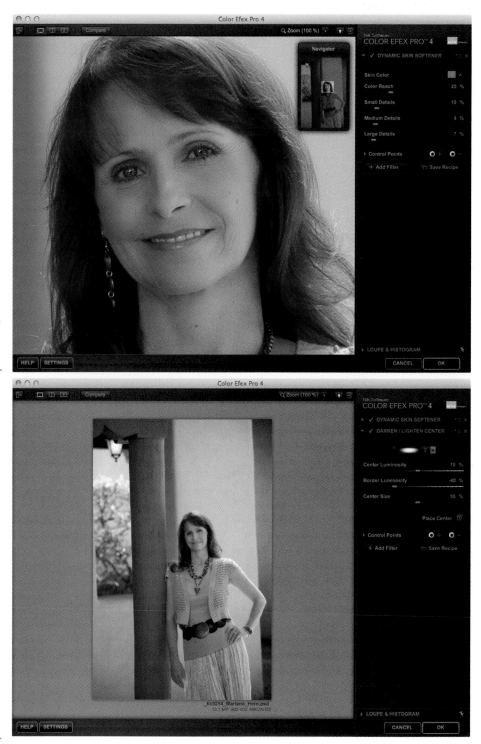

FIGURE 8-15. The Dynamic Skin Softening filter is an indispensable tool for portrait photography.

FIGURE 8-16 . Using the Darken / Lighten Center filter draws attention to the center of the image.

The next filter we used is one of our most-used filters: Darken / Lighten Center. We selected the Add Filter button and then added Darken / Lighten Center to the filter stack. We selected the oval shape (the second filter's menu) to accentuate the image. We then adjusted the center Luminosity slider to 10% to the right and the Border Luminosity to −40% to the left. The result of these settings was to slightly brighten the center of the image while darkening the edges. We then could center the filter effect easily by clicking the Place Center Button and then clicking directly on her face.

The final filter for this portrait is Tonal Contrast, shown in Figure 8-17. This is another one of our favorites. It's a versatile filter that has many uses. Many landscape and wildlife photographers use this filter for its ability to adjust contrast and bring out details. The default setting gives the added spark that we wanted but was a bit too strong. To reduce this effect, we opened the Control Point section and used the Opacity slider to reduce the overall effect. By setting it to 50%, we were able to achieve the look we wanted without going over the top.

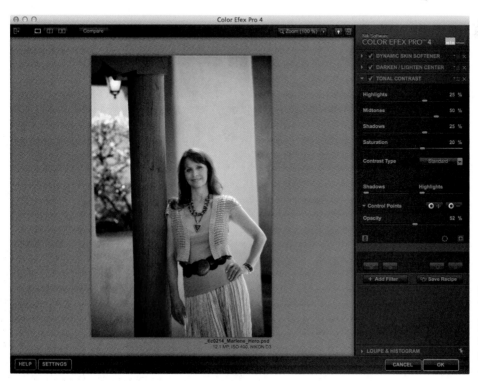

FIGURE 8-17. The Tonal Contrast filter provides a lot of control over the tonality and details in your image.

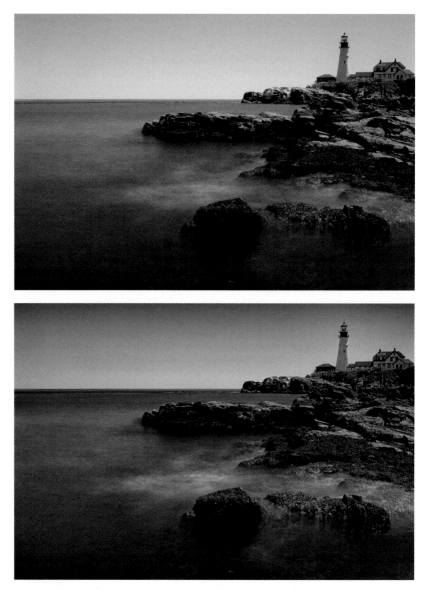

FIGURE 8-18. Color Efex Pro can be used for both subtle and extreme transformations of your photos. Here, some subtle adjustments make a significant improvement. The top image is the original, and the bottom image is the adjusted image.

Example 2: A landscape photo

In this example of a beautiful coastal scene with a lighthouse (shown in Figure 8-18), we could see that with just a few clicks we would be able to move an average picture into a vibrant and possibly more desirable image.

To begin this edit, we first applied the Detail Extractor filter. We moved the top slider to 46% to increase the detail, opening up shadow areas and bringing down a bit of brightness, as shown in Figure 8-19. The long-exposure look of the image created smooth

water, so to avoid the Detail Extractor from bringing details out in the water, we used some control points to remove the effect selectively. Using the – control point button, we placed multiple control points across the surface of the water, removing the effect from that area. Then, we added a single + control point to the rocks to ensure that the result was applied strongly to the rocks.

Next, we added the Graduated Neutral Density filter. In this image it seems to work well to darken the Upper Tonality slider to –40% by moving the slider to the left. We left the Lower Tonality slider in the default position, as well as the Blend and Vertical Shift sliders. Because darkening the upper tones affected the lighthouse, we placed a – control point directly on the white area of the lighthouse with the size adjusted to affect only that subject, as shown in Figure 8-20.

Finally, we added one last filter: Brilliance / Warmth. By increasing the Saturation slider's setting, we were able to increase the vibrancy of the colors throughout the image. Increasing the Warmth slider slightly helped emphasize the sunny areas of the image. Figure 8-21 shows the image with all three filters applied.

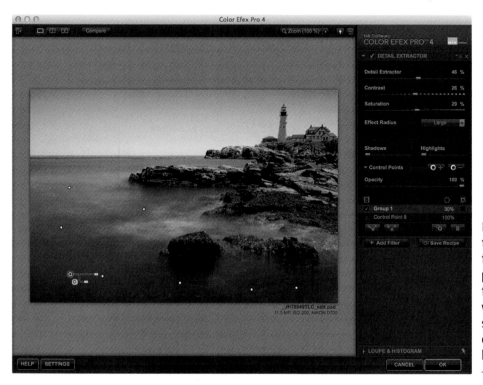

FIGURE 8-19. Using the Detail Extractor filter along with control points that remove the filter's effect from the water helps balance the smooth water and the detailed rocks and lighthouse.

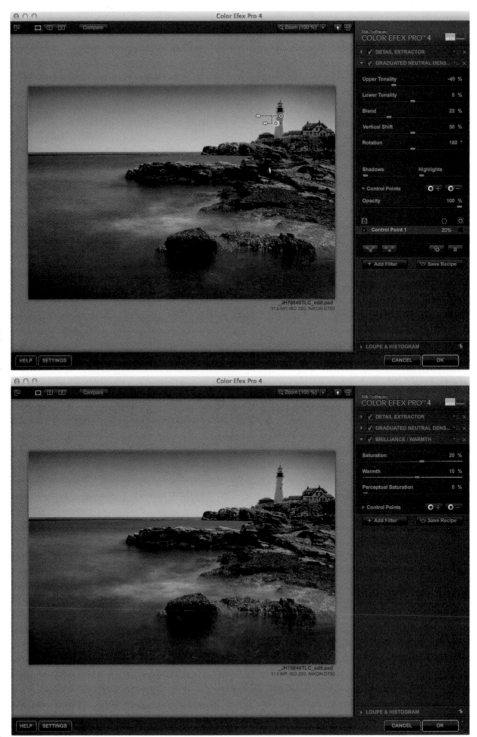

■ **FIGURE 8-20.** The Graduated Neutral Density filter is a very powerful tool to balance the tonality of light throughout an image.

■ **FIGURE 8-21.** The Brilliance/Warmth filter provides control over the saturation and color of an image.

Example 3: An architectural photo

We wanted to accentuate the contrast and color of this high-rise apartment building in Hong Kong (shown in Figure 8-22), playing off the repeating lines and structures.

To start with, we added the Bleach Bypass filter. This filter simulates a traditional film-processing effect and results in a high-contrast, reduced-saturation version of the original image. Figure 8-23 shows the Bleach Bypass filter with the settings we used.

Next, we used the Brilliance / Warmth filter to bring back some of the color to the image. The nature of the Bleach Bypass filter is such that the colors are reduced after the image has been processed. Therefore, the Brilliance / Warmth filter is the only way to bring the colors back to where we wanted. We used a combination of the Saturation and Perceptual Saturation sliders to get the look we wanted, as shown in Figure 8-24.

FIGURE 8-22. One of the most magical aspects of Color Efex Pro 4 is the ability to enhance your image to match to your vision. The top image is the original, and the bottom image is the adjusted image.

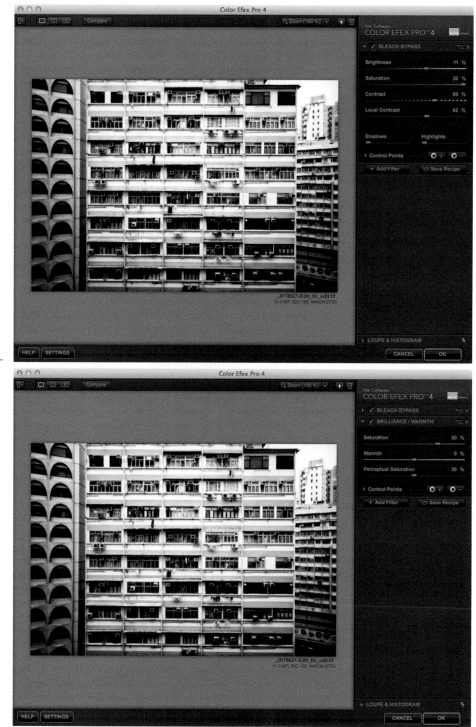

FIGURE 8-23. Using the Bleach Bypass filter adjusts contrast and tonality in the image.

FIGURE 8-24. Applying the Brilliance/Warmth filter accentuates colors throughout the image.

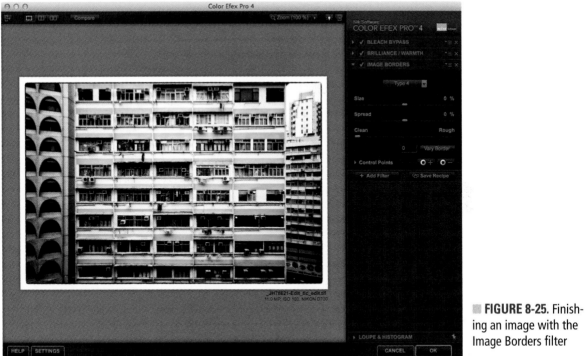

FIGURE 8-25. Finishing an image with the Image Borders filter

The Saturation slider is very similar to any other saturation effect elsewhere: It increases the vibrancy of colors.

But the Perceptual Saturation is unique, letting you increase the perceived saturation of colors without actually adjusting their saturation. To do this, the filter identifies the colors in the image and adjusts the hue (or the specific color component) slightly so that differences between relative colors (that is, colors next to one another in the image) are made more pronounced.

We recommend that you experiment with the Brilliance / Warmth filter and the Perceptual Saturation slider to see how the control affects your images.

Finally, we applied the Image Borders filter to add a border around the image. The Image Borders filter is based on the same technology and functionality in Silver Efex Pro 2, and lets you create a natural-looking border around your images. Figure 8-25 shows the image with a border applied.

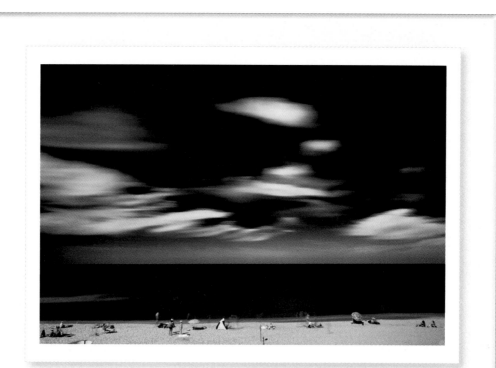

Chapter 9

Silver Efex Pro 2

There has been a recent black-and-white photography revival thanks mainly to the ability to finally produce museum-worthy black-and-white images on our home printers. Printers from companies such as Epson, Canon, and Hewlett-Packard finally have the capability to produce a dynamic range and black level that rivals silver-halide prints. New papers are also available that mimic the look, feel, and sometimes even the smell of the darkroom papers that are so familiar to many of us.

With Silver Efex Pro 2, you have all the control needed to create amazing black-and-white images. Combining a great printer, great paper, and Silver Efex Pro 2 lets you get darkroom quality without the space required to set up a darkroom or the chemicals involved in silver-halide-based photography.

Creating Amazing Black-and-White Images

Black-and-white photography is quite different from color photography. Although the normal rules apply (you still need a great subject, great composition, and great lighting for a great image), black-and-white photography really transforms how people look at a photograph. For most people, looking at a black-and-white image is an abstraction from the real world. Because most people see in color (full color blindness is quite rare), seeing an image in black-and-white means looking at the world in a completely different way.

In recent years, the level of abstraction of black-and-white photography has increased because television, movies, and the photographs normally taken are all in color. The percentage of images we view in black-and-white is quite low compared to the total number of images viewed, and even lower for viewers not in the photographic community. This level of abstraction helps a black-and-white photographer show something that the viewer may never have noticed before.

Whereas color photography is often a depiction of a person, place, or thing, black-and-white photography can be about shape, form, and texture. Black-and-white photography can represent a feeling, emotion, action, or motion. It is this abstraction that in some ways makes black-and-white images more powerful than color photography (surely a debated point) but also less approachable by some viewers.

To make a great-looking black-and-white image, you have only tonality and texture to work with. Whereas in color photography, you can call attention to different parts of your image with a variety of colors, in black-and-white photography you can separate parts of your image only by tone and contrast. This often means reducing the complexity of your images and providing clear focus on the subject.

Many of the points described in Chapter 1 apply. You can use certain elements (like faces or text), brightness, contrast, and focus to draw the viewer's attention to parts of

your image. It is still important to consider the balance of tones and rely heavily on shifts in tonality that can lead the viewer's eye in to the image.

Working with Silver Efex Pro 2

Silver Efex Pro 2 is a powerful application. There are more controls in Silver Efex Pro 2 than in any other Nik plug-in. To make things easier for new users of Silver Efex Pro 2, there are built-in presets you can use, and even more are available for download. The control elements in the software are straightforward and easy to learn, yet provide enough control to allow you to experiment as well as create advanced black-and-white conversions.

Starting with presets

When you first open Silver Efex Pro 2, both the left and right panes display as shown in Figure 9-1. The left pane contains the built-in presets. When you select a preset, the sliders in the right pane automatically adjust based on that preset.

At the top of the left pane are the Preset Categories. These predefined categories let you narrow down the built-in presets based on different styles of presets. The Classic presets are based on the controls that were possible in the darkroom. The Modern presets

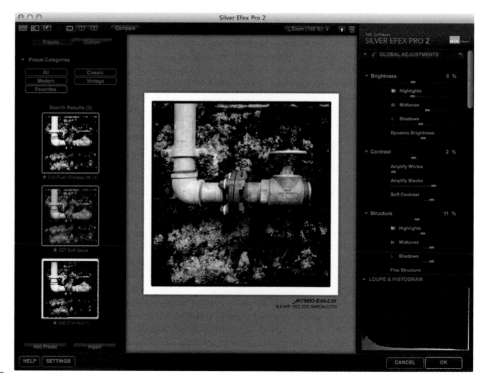

FIGURE 9-1. The presets in Silver Efex Pro 2 let you see your image processed several ways and then enhance it with a single click.

provide looks based on some of the unique functionality in Silver Efex Pro 2. The Vintage category provides presets that strive to emulate older photographic styles and treatments. You can even mark your favorites by clicking the star icon next to the preset's name; these starred presets are then available in the Favorites category.

In addition to the built-in presets, you can create your own presets and import presets made by others. To create a new custom preset, click the Add Preset button at the bottom of the Presets section. Creating a new custom preset saves all the settings in the right pane and lets you name that new preset. To import a preset made by someone else, click the Import button next to the Add Preset button, then navigate to that preset file.

Both custom and imported presets are added to the Custom section. To access the Custom section, click the Custom tab at the top of the Presets section, above the preset categories.

Custom presets keep all the slider settings you made to your images but do not maintain control points. Control points are location-specific and do not work well from one image to another.

A good place to find additional presets to import is on the Nik Software website at www.niksoftware.com/presets.

Brightness controls

Adjusting and balancing the brightness of your photo is a good first editing step, and Silver Efex Pro 2 provides numerous controls to adjust the brightness of your photo. To access the Brightness controls, go to the Global Adjustments section and click the Brightness disclosure triangle to display the four controls: Highlights, Midtones, Shadows, and Dynamic Brightness, as shown in Figure 9-2.

Whereas the Brightness slider controls the brightness of the entire image, the Highlights, Midtones, and Shadows sliders each controls the brightness of that area specifically. Working with the Highlights, Midtones, and Shadows sliders independently provides a lot of control over the tonality of your photo. We show examples later in this chapter that use the different brightness controls.

The Dynamic Brightness slider is one of the unique tools in Silver Efex Pro 2 that is based on a special Nik Software algorithm and approach. Compared to the Brightness slider, which affects all pixels in the same way, lightening or darkening all the pixels uniformly, Dynamic Brightness automatically applies different brightness changes to different areas of the photograph. The software determines how to adjust the brightness of each area based on the original amount of brightness and contrast in that area. The goal behind Dynamic Brightness's ability to apply different brightness changes to different areas

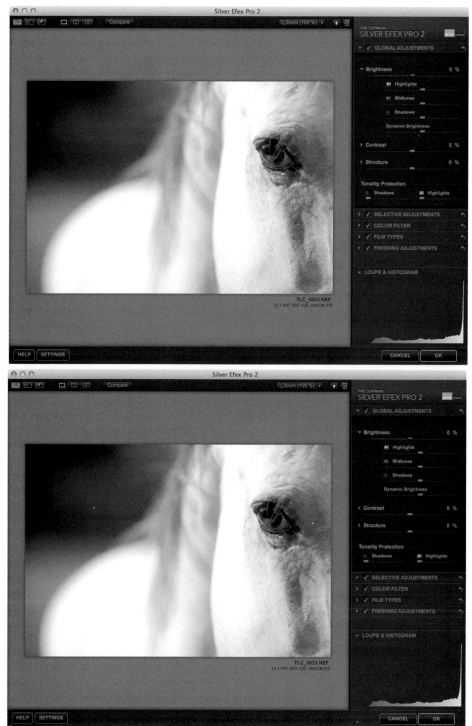

FIGURE 9-2. The controls in the Brightness section of Silver Efex Pro's global adjustments

FIGURE 9-3. The same image without any brightness adjustments (this page, at bottom), with the Brightness slider darkening the image (opposite page, at top), and with the Dynamic Brightness darkening the image (opposite page, at bottom). Notice how the image darkened by the Brightness slider has less contrast and appears muddy compared to the image darkened with the Dynamic Brightness slider.

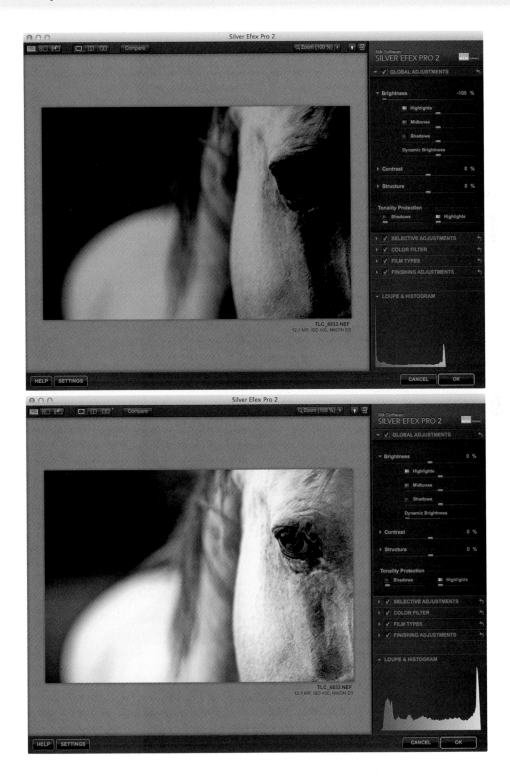

of the photograph is to create the overall feeling of a darker or brighter image without the loss of details in the highlights or shadows and keeping the contrast of the image. The best way to understand the Dynamic Brightness control is to see an example of the difference between Brightness and Dynamic Brightness, as shown in Figure 9-3, or by trying it on your own image.

Balancing each of the brightness controls, as shown in Figure 9-4, is helpful in creating a good starting exposure of your photo to refine using the other controls in the right pane.

Contrast controls

Silver Efex Pro 2 provides a wide array of contrast control options. Clicking the Contrast disclosure triangle displays each option: Contrast, Amplify Whites, Amplify Blacks, and Soft Contrast. You can see the Contrast controls in Figure 9-5.

The Contrast slider applies a typical contrast to your photographs. Increasing the slider makes bright objects brighter and dark objects darker. We have found that Contrast can become harsh if applied too strongly, but is still very useful. More often than not, we adjust Contrast last, after adjusting the other controls.

The Amplify Whites and Amplify Blacks controls achieve their results in similar

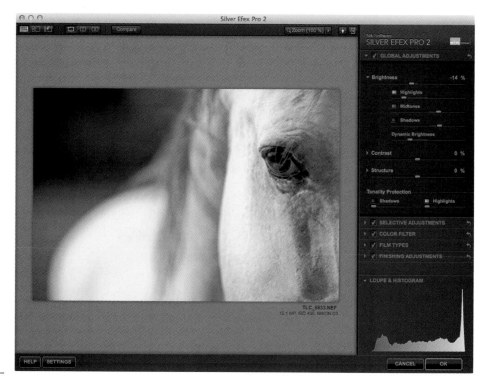

FIGURE 9-4. The image in Figure 9-2 after using all the controls in the Brightness section to balance tonality

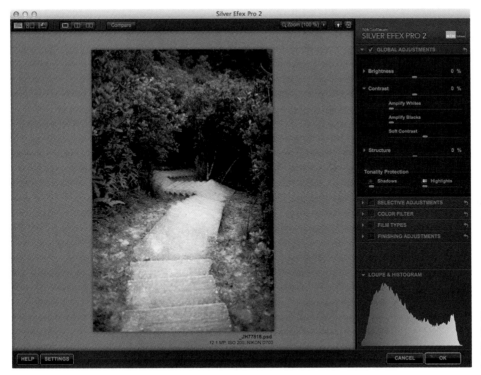

■ **FIGURE 9-5**. The Contrast controls in Silver Efex Pro 2

ways. Both controls use a unique Nik Software algorithm that breaks an image into its component areas. The Amplify Whites slider works to identify the lightest part of each area and makes that brightest area brighter. The Amplify Blacks slider does the same, except for the darkest areas. The difference between the Contrast slider and the Amplify Whites and Blacks sliders is that with Contrast, the brightest and darkest areas in the entire image are identified and then adjusted, whereas with the Amplify Whites and Blacks sliders, a bright and dark point for each area is identified.

This means that multiple bright and dark points in each photograph are identified and then adjusted individually. With the ability to adjust the Whites and Blacks controls separately, you can adjust one more than the other, fine-tuning the effect and creating a tailor-made contrast enhancement. The result of using the Amplify Whites and Amplify Blacks sliders are shown in Figure 9-6.

The last control in the Contrast group is the Soft Contrast slider. Soft Contrast is another unique control, one that is difficult to understand without seeing results and playing with the effect on your images. Nik's goal for this control was to emulate the look and feel of *film noir* movies, with dark, moody contrasts and soft transitions. Like the Dynamic Brightness and the Amplify Whites and Blacks controls, the Soft Contrast slider

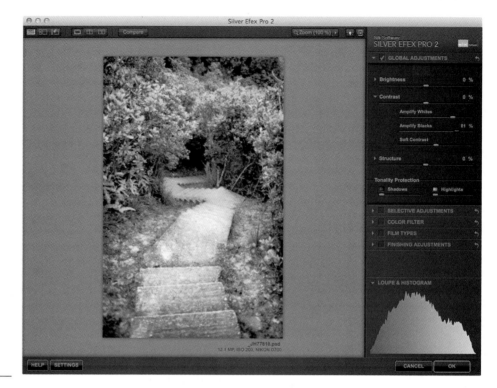

FIGURE 9-6. The image in Figure 9-5 after increasing the Amplify Whites and Amplify Blacks sliders

breaks the image down to different elements. Then it applies contrast to those different elements, and finally applies a smooth, almost blurring transition to connect the areas. The result is a much less harsh contrast, as Figure 9-7 shows.

After mixing all the contrast enhancements, you can apply a small amount of contrast to the image to top off the enhancement (see Figure 9-8).

Structure controls

The final group of controls in the Global Adjustments section is the Structure section. Structure is a unique function first introduced in Silver Efex Pro 1.0 designed to provide control over the texture and fine details in an image. Because black-and-white photography is made up of tonal changes, Structure was designed to provide control over the finer tonal changes.

After opening the Structure control group, you are provided with the ability to adjust structure over the entire image (on the highlights, midtones, and shadows), as well as the ability to control finer details with the Fine Structure slider. Figure 9-9 shows the Structure section.

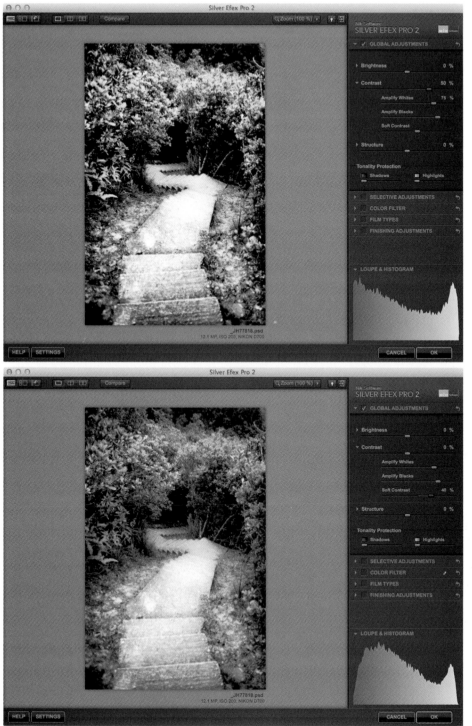

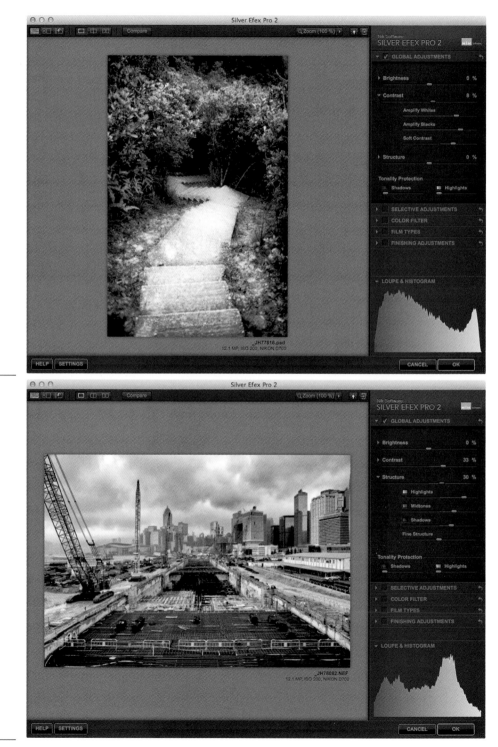

FIGURE 9-8. The image after applying and balancing all the contrast controls

FIGURE 9-9. The Structure controls in Silver Efex Pro 2

Structure works by identifying the edges of an object and then applying contrast only to the area in the identified object. That is, instead of applying contrast across the entire image, Structure applies contrast only in an object area and not to the object's edge. The result is increased detail of the textures of an object without introducing artifacts to the image due to adjusting objects' edges.

Structure is best reviewed while zoomed into the image, as shown in Figure 9-10, as the effect might not be completely visible on the image while zoomed out.

Selective Adjustments section

Like every Nik Software product, Silver Efex Pro 2 has control points built in and tailored to the specific goal of the product, in this case making amazing black-and-white images. The control points in the Selective Adjustments section provide nearly the same controls as in the Global Adjustments section.

On each control point, you find Brightness (Br), Contrast (Co), Structure (St), Amplify Whites (AW), Amplify Blacks (AB), Fine Structure (FS), and Selective Colorization (SC) options, as shown in Figure 9-11.

Brightness, Contrast, Structure, and Fine Structure all work the same as their counterparts in the Global Adjustments section, albeit on the selection made by the control point.

You can use Amplify Whites and Amplify Blacks to add both the Amplify Whites and Amplify Blacks effects, or you can remove or reduce the effect of the Amplify Whites and Amplify Blacks slider settings made in the Global Adjustments section. That is, you can place a control point on an area and then move the sliders in the reverse direction (usually to the left, but the direction depends on whether the control point is placed near the right side of the image).

Reducing the effect of the Amplify Whites or Amplify Blacks sliders from the Global Adjustments section is useful if there is a part of the image where the result of the global sliders is unwanted, creates artifacts, or causes other problems. However, you can remove only as much as was added by the Amplify Whites or Amplify Blacks sliders in the Global Adjustments section. That is, if you did not apply Amplify Whites or Amplify Blacks to the image in the Global Adjustments section, the negative values of these sliders in the Selective Adjustments section will not affect the image.

The Selective Colorization slider is also a unique control for your images. You can use this effect to draw attention to a particular part of your image by making that object colored. This technique is very polarizing, with many people having strong feelings (usually against) selective colorization. There are certainly situations in which the effect is quite powerful and useful, though, so keep an open mind about what can be done using selective colorization. Figure 9-12 shows an example of selective colorization.

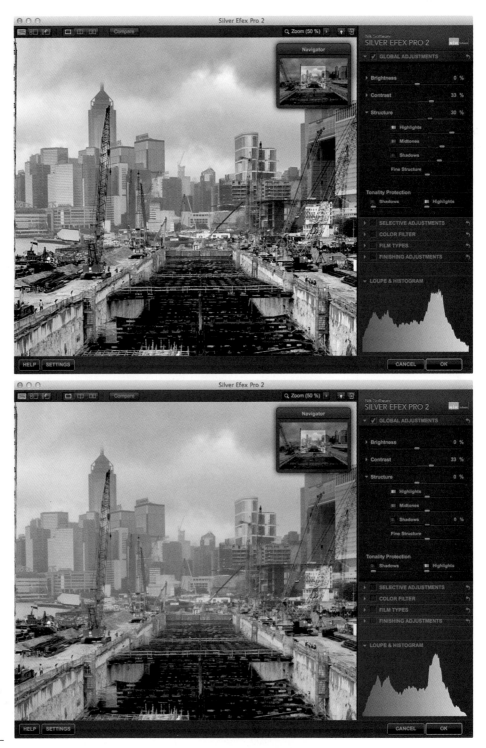

FIGURE 9-10. The effect of Structure on an image zoomed in 50 percent. The original image is at top, and the adjusted image at bottom.

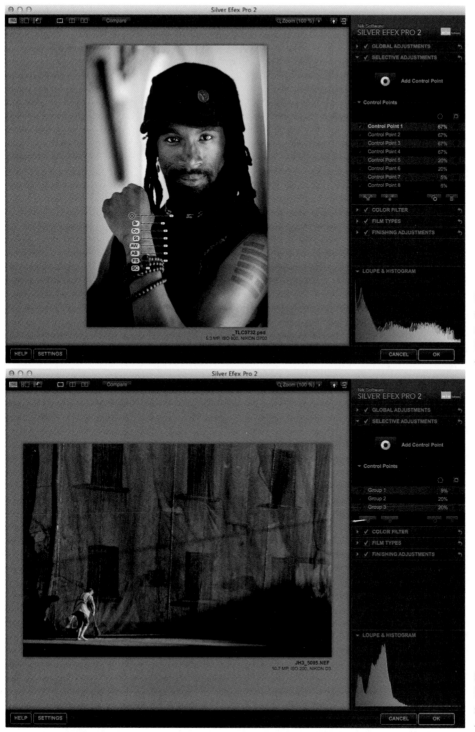

FIGURE 9-11. The controls available on a control point in Silver Efex Pro 2

FIGURE 9-12. An image that has been selectively colored

Color filters

The color filters in Silver Efex Pro 2 emulate the glass filters added to the front of the lens that film-based photographers often use to increase the contrast of their images. By adding a specific colored piece of glass in front of the lens, film photographers can lighten all the objects in the photograph of that color and darken all objects in the complementary color. The most common filter used is a red filter; it lightens red objects and darkens cyan objects. (Cyan is the opposite color of red.)

Both landscape photographers and portrait photographers often use a red filter on their images. Landscape photographers use a red filter to darken skies (which are actually cyan, not blue) and increase the separation between the clouds and the sky. Portrait photographers use red filters to lighten skin tones and reduce the contrast in the skin tones, thereby reducing the appearance of blemishes. Figure 9-13 shows an image with different filters applied.

Silver Efex Pro 2 lets you simulate any color filter at any strength. Use the built-in color-filter presets to quickly select a filter, or open the Details section to select a specific hue and filter strength.

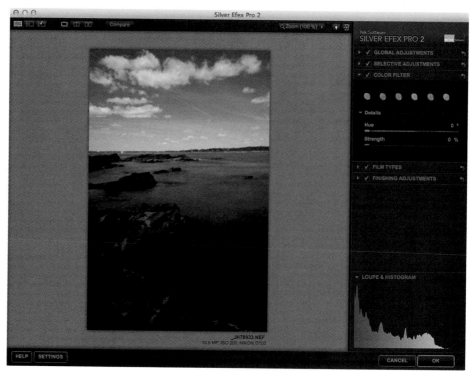

FIGURE 9-13. The same image without a color filter added (this page), with a strong red color filter (opposite page, at top), and with a strong blue filter (opposite page, at bottom). Note how with the strong red filter, the sky is very dark, and with the strong blue filter, the sky is much lighter.

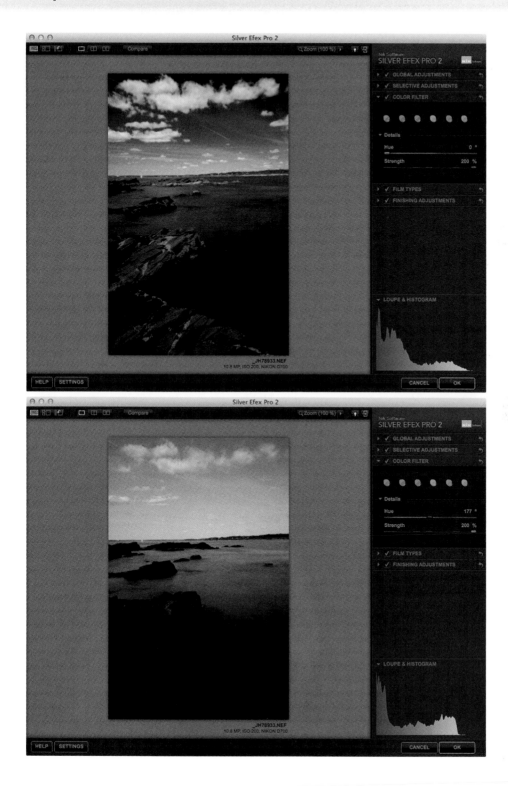

Film types

To completely replace a film-based workflow in black-and-white, Nik Software has included a wide range of film types that you can apply to any image in Silver Efex Pro. Each option in the Film Types section emulates the characteristics of that film, including the grain, color sensitivity, and tonal curve. Figure 9-14 shows an image with a film type applied.

Using one of the predefined film types lets you quickly achieve the specific look of that film. This is helpful if you often used a film and like its look. If your goal is to get the look of a specific type of film, we recommend that you start editing your image by selecting that film first. Starting with the film type first lets you take into consideration the contrast and brightness adjustments made by the film.

The other benefit to using the Film Types section is the ability to use the various controls (grain, color sensitivity, and levels and curves) individually to achieve a specific goal.

The Grain section lets you add realistic grain to your images. One reason to add grain

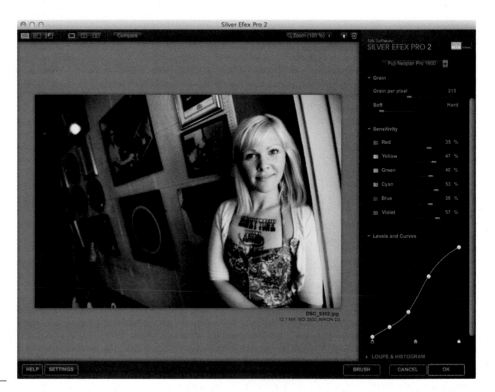

FIGURE 9-14. An image with a Fuji Neopan Pro 1600 film type applied

to your images is to create the look of analog film for stylistic reasons. Another reason is to use grain to cover up a problem. For example, if your image is severely out of focus, adding large grain helps the viewer focus on the grain and not on the out-of-focus image. If your image has posterization or banding artifacts, using grain can help break up the bands and give the impression of a smooth transition.

Use the Color Sensitivity section to make objects of different colors lighter or darker. This is similar to the Color Filters section, but with even more control. Dragging a color slider to the right or left brightens or darkens objects of that color, respectively. We find this especially helpful to darken skies (by reducing the blue and cyan sliders) and to adjust the tone of skin and other objects.

The Levels and Curves section provides the familiar levels and curves control for more fine-tuned control over contrast and tone in your image.

Finishing Adjustments section

The last control section in Silver Efex Pro 2, Finishing Adjustments, provides stylistic effects that help you add polish to your photographs.

The Toning section allows you to add a color toner to your images, much like what is possible in a darkroom. You can either use the Toning popup menu to select a predefined toning option or you can use the sliders after expanding the Toning section to create a custom toning option.

Use the Silver Hue and Strength sliders to control the color and strength of toning applied to the dark tones of the image. This simulates the replacement of silver (which shows up as black in the image) with a toner that would appear as a specific color.

Use the Paper Hue and Strength sliders to control the color and strength of toning applied to the light tones of the image. This simulates staining the paper with different toners and changes the paper from white to a specific hue.

Use the Balance slider to control at what shade the Silver Hue should stop affecting the image and when the Paper Hue should start affecting the image, and vice-versa. Moving the Balance slider to the right makes the Paper Hue affect more and more of the image, whereas moving this slider to the left makes the Silver Hue control affect more and more of the image. Figure 9-15 shows an image where we applied two different toners to the highlights and shadows and where we adjusted the Balance slider to achieve the desired effect.

The Vignette and Burn Edges sections both strive to achieve the same thing: darken the edges of the image. Darkening the edges of your image is an important technique often used in the darkroom to keep the viewer looking at an image for longer periods. When a

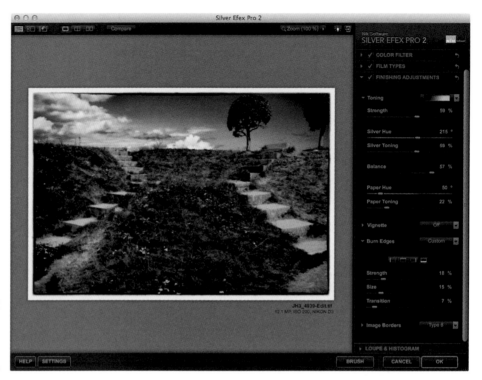

FIGURE 9-15. Applying a split toner to an image, where a different color toner is applied to the silver and paper tones

photograph has a bright edge, the viewer's eye is drawn to the bright edge. Often, this can stop the interaction with the photograph as the viewer essentially exits the image and his or her attention is taken somewhere else. By darkening the edges of your photograph, you can form a barrier to the eye, corralling the viewer's attention in your photograph.

The Vignette section darkens all edges of the image in the same way simultaneously. You can either apply a round darkening effect, simulating a lens's falloff, or apply the effect in a rectangular shape.

The Burn Edges section simulates burning in (darkening) the edges of the image, one edge at a time. You might use the Burn Edges option instead of the Vignette option if you have some edges that need more darkening than others. Of course, you can combine both the Vignette and Burn Edges methods of darkening the edges of your image, as shown in Figure 9-16.

Image Borders, the last section in Finishing Adjustments, lets you create a natural edge around your image. Photographers in the darkroom often print a border around their image as a way of framing the image on the paper. Additionally, printing a border could show that the image was not cropped by the enlarger. Showing a full-frame image is a point of pride of film photographers, showing that they cropped in the camera instead of

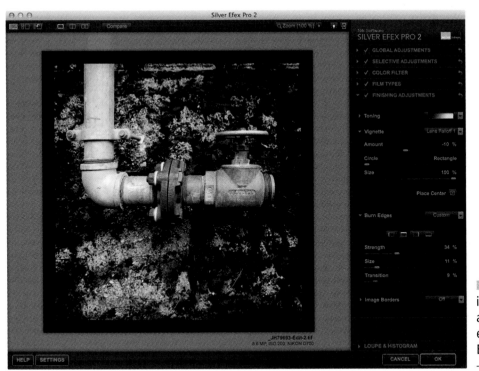

FIGURE 9-16. An image with a vignette applied and edges darkened using the Burn Edges tool.

in the darkroom. In the digital age, there is no longer any way of proving on a print that an image was not cropped in an image-editing application, but the style and look remain.

Silver Efex Pro 2 offers 14 border types. Each border creates a different look, so you would select one based on your particular aesthetic desires for each image.

The Size control allows you to control how much white space is around the image, while the Spread control adjusts the size of the black border. Use the last slider to control how clean or rough you want the image border. The Vary Border button lets you randomize the frame's unique characteristics. We recommend clicking the Vary Border button at least once on your image to make sure that each image you create with an image border has a different border. Figure 9-17 shows an image with an image border applied.

Loupe & Histogram section

At the bottom of the right pane is the Loupe & Histogram section. It provides either a loupe, which shows you the area under your pointer zoomed into 100 percent, or a histogram showing the distribution of tones throughout your image.

An important tool also in the Loupe & Histogram is the Zone System Map. For photographers that use film extensively and are familiar with the Zone System,

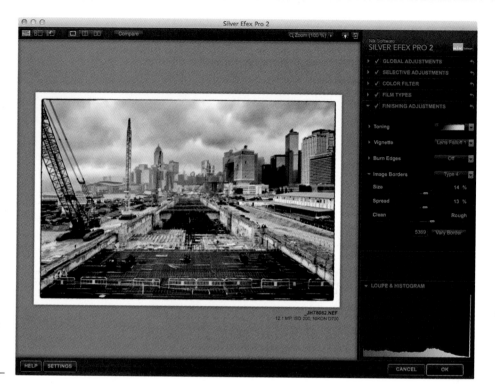

FIGURE 9-17. A photograph with an image border

popularized by Ansel Adams and Minor White, this tool should be rather obvious to use. For photographers that got their start in digital or never learned the Zone System, the Zone System Map is a powerful and useful tool that will help you get the most out of your black-and-white prints.

The Zone System was created to let photographers get more predictability in their image-capture, developing, and print process. A photographer could identify from a scene in front of him where in a range of 11 zones a tone should end up in the final print. For example, a photographer might look at a scene and identify that the clouds should be a zone 9 (one zone below zone 10, which is pure white), that the side of a mountain should be zone 5 (middle-gray), and a shadow under a tree should be zone 1 (one zone above pure black).

Using a complex system of identifying the range of contrast between each object, the capabilities of their film, and notes for developing, photographers could manage the process from capture through to print, ensuring that the clouds, mountain, and shadow all reached their desired destination in the print. Just like with most techniques and controls in photography, the Zone System was all about the final print, and the Zone System Map in Silver Efex Pro 2 is no different.

FIGURE 9-18. Using the Zone System Map to see areas of the image in zone 0.

To use the Zone System Map, hover the pointer over the Loupe & Histogram window (it doesn't matter if it is displaying the loupe or the histogram). You will see 11 separate zones along the bottom, each with a different zone number displayed. Hovering over one of those zones shows color hatch marks on top of the image, showing you which part of your image is in a particular zone, as shown in Figure 9-18.

Showing which parts of your image are in zone 0 (pure black) or zone 10 (pure white) is helpful to make sure your image doesn't print without details in the shadows and highlights. You can also use the Zone System Map to see if an object is too bright or too dark, without having to guess.

History Browser

The History Browser is a relatively new control mechanism currently available only in Silver Efex Pro 2 and Color Efex Pro 4. It provides two main functions: One is providing a list of all the edits you have done to your image. The other is the ability to go back to one of those states and provide control over the before and after views for the Compare button and the split and side-by-side view modes.

To display the History Browser, click the third icon (the down-facing arrow) from the left in the top left control group in the Silver Efex Pro 2 interface. If the presets are visible, the History Browser slides over to replace them.

Every change made to the image creates a new entry in the History Browser. Click any entry to change the slider values in the right pane to match the current slider values of that particular state.

When used with the Compare button or the split or side-by-side preview modes, you are presented with a yellow arrow to the left of the history states called the History State Selector, as shown in Figure 9-19. By dragging the History State Selector to a different state in the history, you can decide what the before state should be when pressing and holding the Compare button or when in the split or side-by-side preview modes.

You can use the History Browser to decide between two different edits or even between two entirely different presets.

Image Workflows

Now that you have a solid foundation for the tools and techniques in Silver Efex Pro 2, let's go over a few images from start to finish so you can see how we approach the image editing process in Silver Efex Pro 2.

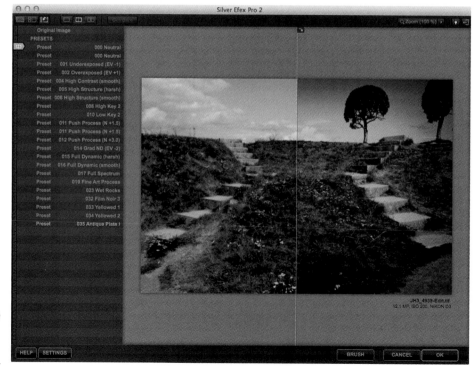

FIGURE 9-19. The History State Selector is displayed in the History Browser whenever the Compare button is pressed or when you are in the split or side-by-side views.

Example 1: A portrait image

In the first portrait image (shown in Figure 9-20), we wanted to emphasize and draw the viewer's attention to the model's eyes. We started off by opening the Brightness section and adjusting the brightness of the various sections of the image. By reducing the brightness of the highlights, we darkened the background, which is a tad too bright and distracting from the model. We then brightened the midtones and the entire image a small amount, as shown in Figure 9-21.

Next, we added a small amount of contrast to the image to expand the range between the highlights and shadows. Most viewers respond to contrast in the same way as they do to salt: Not enough contrast is bland and boring, but with too much contrast the image is ruined.

In this image, subtle control point work is needed to brighten the face and to darken the skin on the hand and arm, which will draw attention to the face. We placed a few control points on the model's hand and arm with reduced brightness. We then added a control point to the face with added brightness and contrast, as shown in Figure 9-23.

Next, we added two control points to the eyes with very small Size slider values, and we increased the brightness and contrast of the eyes (see Figure 9-24).

Now that the tonality is adjusted and the viewer's attention is drawn to the model's face and eyes, we added finishing adjustments to the image.

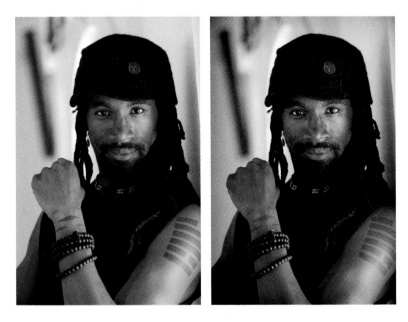

FIGURE 9-20. Editing a portrait with Silver Efex Pro 2. At left is the original photo.

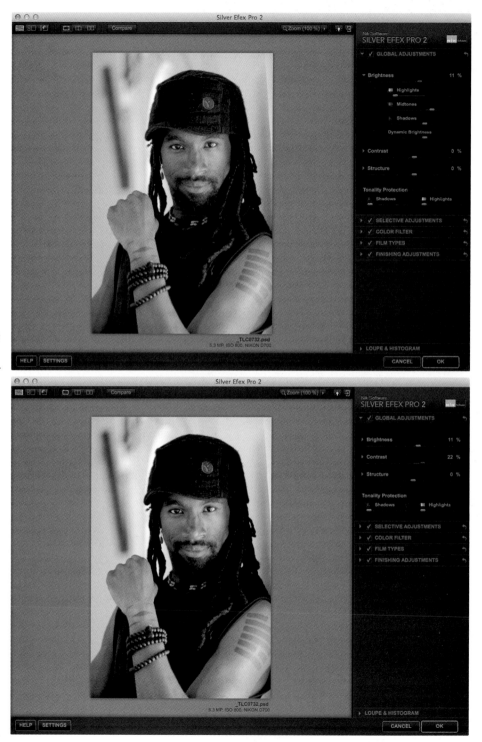

FIGURE 9-21. Adjusting the brightness of the image

FIGURE 9-22. Adding a small amount of contrast to the image

First we added warming tones by selecting the second sepia option from the Toning Preset popup menu. Next, we darkened each edge. Because the left and top edges in this image were the brightest, we darkened them more than the other two edges, but we still applied darkening to each edge throughout the image. Figure 9-25 shows the results of our work.

Example 2: A portrait image

Figure 9-26 shows an image that required very little work to make a great black-and-white photo. The enhancements made to this image are also a good example of a quick workflow in Silver Efex Pro 2.

To start, we selected the orange color filter, which lightened the skin tones of the model, as shown in Figure 9-27.

Next, we added two control points to her skin and reduced the structure to provide a softer skin tone, as shown in Figure 9-28. Then, we added two control points to the eyes and increased the contrast and structure of the eyes.

Then, we added the Lens Falloff 1 predefined Vignette to help bring the viewer's attention to the center of the image. Figure 9-29 shows the image after adding a vignette.

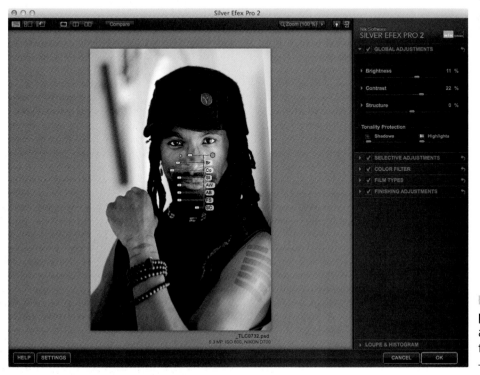

FIGURE 9-23. Control points added to the skin and face draw attention to the model's eyes.

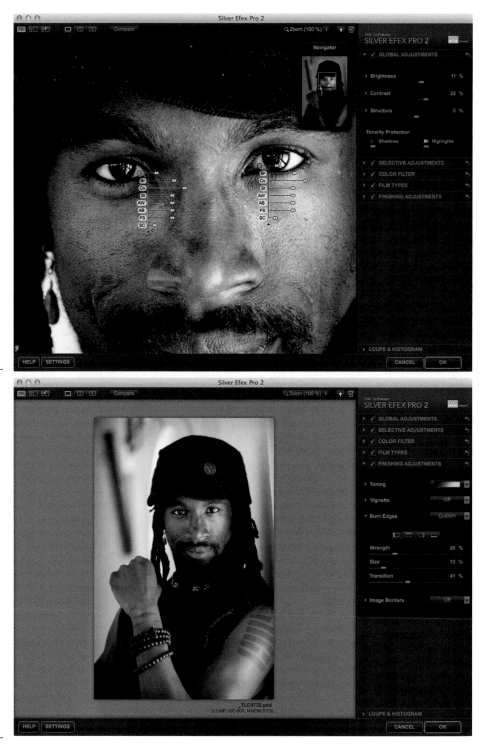

FIGURE 9-24. Adding control points with low Size slider values and increasing contrast to the eyes

FIGURE 9-25. Adding finishing touches to the image using the Finishing Adjustments section

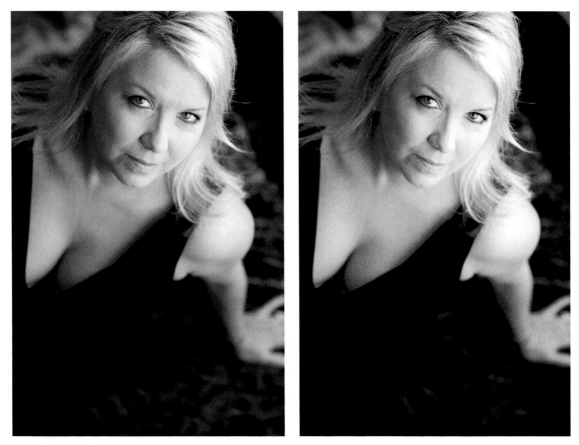

▦ **FIGURE 9-26.** Even though this enhancement took less than a minute to complete, the results are impressive.

Finally, because the bottom right corner was a bit too dark, we experimented with a few sliders and found that adjusting the Dynamic Brightness slider a bit brought the highlights out of the rug without affecting other parts of the image (as shown in Figure 9-30), creating a good balance of tones.

Example 3: A landscape image

When the image in Figure 9-31 was captured, the desired result was to balance the smooth ocean with the liquid clouds. We were able to accomplish this easily with the powerful tools in Silver Efex Pro 2, as shown in Figure 9-31.

To maximize the difference between the sky and the clouds, we first added a red filter and then we used the Sensitivity sliders in the Film Types section to further darken the

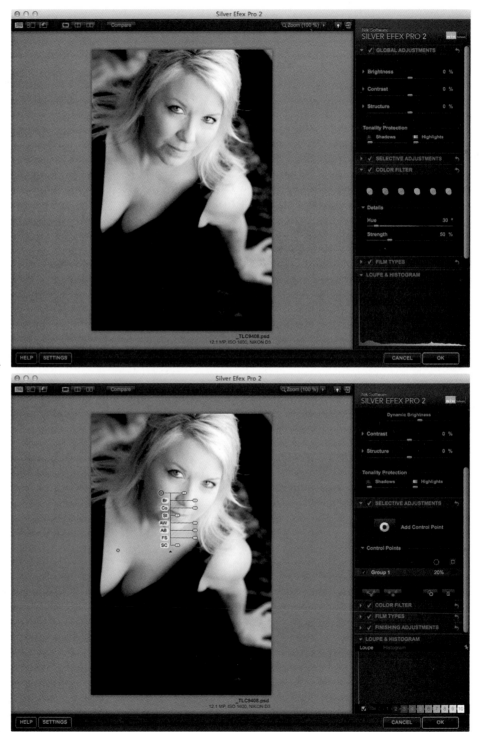

FIGURE 9-27. Applying an orange filter to smooth and lighten skin tones

FIGURE 9-28. Using control points to further soften the skin

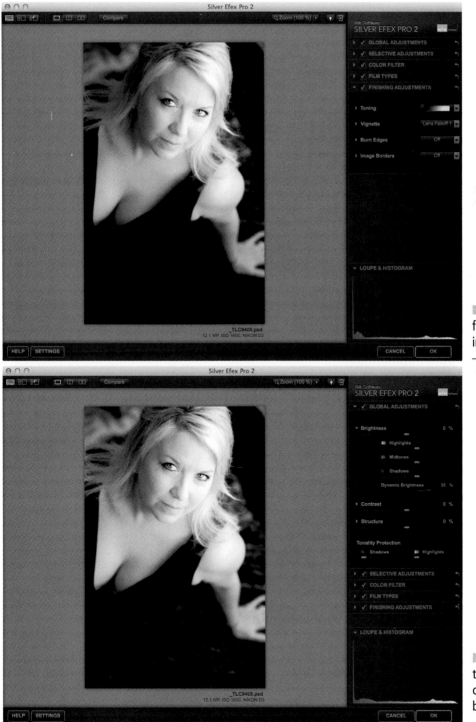

FIGURE 9-29. Adding finishing touches to the image

FIGURE 9-30. Using the Dynamic Brightness control to brighten the background slightly.

sky by reducing the blue and cyan sensitivity sliders. You can see the result of these two enhancements in Figure 9-32.

Next, we used the controls in the Contrast section to maximize the contrast and details in the image. We increased the Amplify Whites and Amplify Blacks sliders' settings and then added contrast to the image, as shown in Figure 9-33.

Finally, we used control points to perfect the balance of tones. We added a control

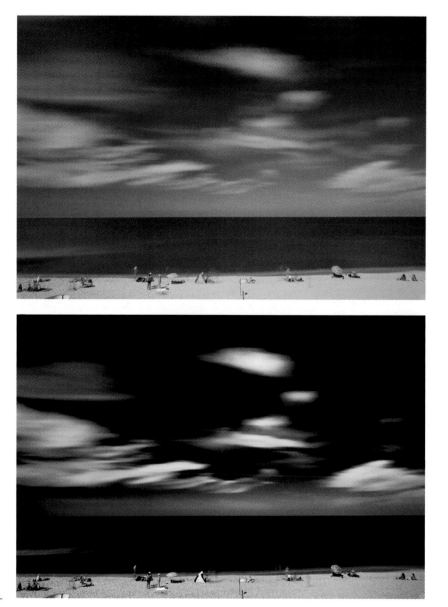

FIGURE 9-31. The powerful controls in Silver Efex Pro 2 let us create the exact look we envisioned at the time of capture.

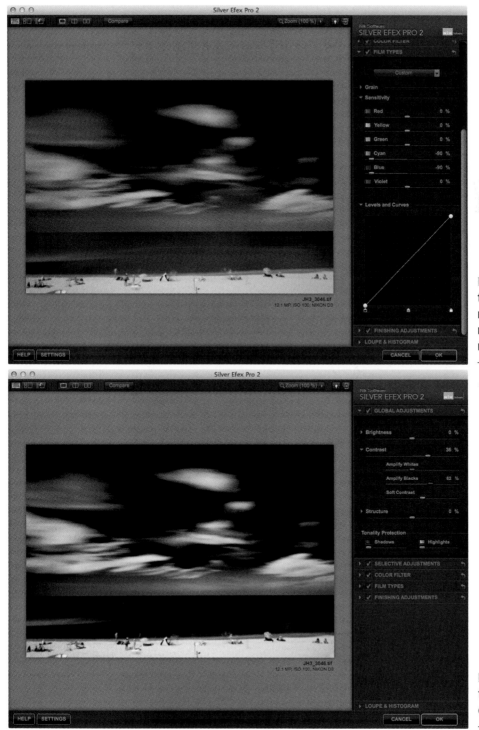

FIGURE 9-32. Even though this enhancement took less than a minute to complete, the result is still impressive.

FIGURE 9-33. Using the Contrast tools to expand the tonal range

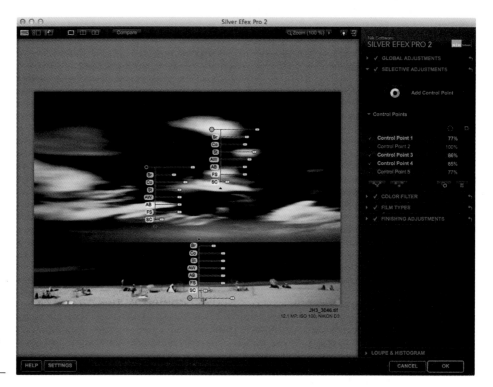

■ FIGURE 9-34. Using control points to fine-tune the tonality of the image

point to the sky and reduced the brightness to darken the sky. We added another control point to brighten and add structure to the clouds. To finish off the image, we added a control point on the beach to darken the sand to maintain a consistent tone throughout the beach. Figure 9-34 shows the positions of the control points added to the image.

Chapter 10

Sharpener Pro 3.0

I mage sharpening is a tricky subject. So much so that an entire product category was created to address the issue. Nik Sharpener! was the first product specifically designed to deal with image sharpening. It was first released all the way back in early 2000, more than 11 years ago. Nik Software has released several upgrades and competitive products since then.

The Importance of Sharpening Digital Images

The need for sharpening arises from the digital capture process and the new set of expectations in the digital world. With the advent of digital photography, there is now the ability to create incredibly sharp and detailed images, thanks to the powerful image-editing software available, the evolution of the capture process, and the growth of incredibly high-resolution sensors coupled with new lens manufacturing technology. Figure 10-1 shows the difference between an unsharpened and sharpened image.

In the film days, the only way to get such incredible sharpness was to shoot with an 8 × 10 (or larger) view camera, now even digital SLRs have the resolution needed to connect high-resolution images with normal print sizes to create much more detailed images than we were used to in the film days. Furthermore, advances in lenses and the automatic inclusion of high levels of sharpness in some cameras have resulted in a larger amount of detail. Put another way, because we now can make images sharper, we all expect images to be sharper.

There are also elements unique to the digital cycle that makes sharpening images a necessary step in the workflow. Typically, three main factors account for a loss of image detail in the digital image life cycle: factors in the image capture process, factors in the image enhancement process, and factors in the digital output process.

Detail loss during capture

During the image capture process, several factors contribute to the loss of image detail.

The first is the lens. Lenses are now sharper and more detailed than ever before. Nanotechnology, new coatings, and computer-aided lens design all allow lenses to resolve more information than ever before. At the same time, photographers are demanding lighter and less-expensive lenses with ever-growing zoom ranges. Getting lenses cheaper, lighter, and with longer zoom ranges all push the boundaries of lens design, which in turn increases unwanted artifacts (such as flare, distortion, and chromatic aberrations) and reduces details.

Even when shooting with high-quality prime lenses (nonzoom lenses), there's softening of image details. This is due to simple physics: Bending light through a medium must result

FIGURE 10-1. This image shows the difference between the original (detail at upper left) and the sharpened version (detail at upper right) of the image.

in some spread of the light beams, resulting in an image that is not exactly the same nor with the same details as in the real world.

Coupling these factors along with the fact that most of the time we don't shoot in the lens's optimally sharp aperture range (roughly f/5.6 through f/11, depending on the lens) yet expect incredibly sharp images, there's need for sharpening to overcome the loss of detail inherent from a lens.

In addition to the loss of detail caused by the lens, nearly every digital camera has an anti-aliasing filter (sometimes called a *low-pass filter*) placed on top of the sensor. This physical filter (either glass or plastic) has a slight blurring effect specifically designed to prevent moiré patterns from being created when capturing subjects with fine details and converging lines. Most camera manufacturers found that the loss of detail caused by this anti-aliasing filter is preferable to the moiré pattern.

Sharpening can give the appearance of bringing back the loss of detail caused by the filter whereas moiré patterns cannot truly be removed once they're captured.

The nature of converting a subject or scene from the analog world to the digital world also contributes to the apparent loss of detail. When captured digitally, the image is represented by a fixed grid of addressable picture elements (pixels). As the analog world is not made up of a fixed grid, the translation from a nonfixed grid to a fixed grid means that some elements of the scene that do not fall exactly within the grid pattern are not recorded. This results in less detail being captured.

Finally, as most digital cameras capture only one color per pixel, the full-color object must be re-created based on the surrounding pixels. This interpolation of color detail further reduces image detail.

Detail loss during image processing

The most common cause of detail loss during image processing is due to resizing an image. When an image is resized, new pixels must be created based on the surrounding pixel details. Often, the bicubic interpolation algorithm is used, as it results in more photographic image detail than other available interpolation algorithms. But one of the unfortunate side effects of the bicubic interpolation algorithm is that it has a tendency to soften image details slightly, which brings in the need for sharpening.

Even if you're using tools designed to resize, like OnOne Software's amazing Perfect Resize (previously known as Genuine Fractals) — a tool we highly recommend if you're doing a lot of resizing and want to get the best quality — you can expect some detail loss.

Detail loss during output

The last place that can affect the sharpness of your photos is the output device. An output device is any method of displaying your image, such as a projector, monitor, or printer. Projectors and monitors don't necessarily introduce softness to an image, so we're really talking about printers. With printers, there are two factors that reduce the sharpness of your images: the transition from digital back to analog, and the paper.

Just as with the loss of detail during capture caused by converting an object from the unstructured analog world (visually speaking) to a very structured (pixelated) digital world, the reverse is also true (but to a lesser extent): When outputting an image, different technologies are used to give the impression that an image has a full range of tones and colors. These technologies all try to avoid the appearance of pixels or dots, and each has a softening effect on your photos. A printer using the continuous tone process (such as digital silver printers used by photo labs) usually has the least reduction on sharpness, whereas inkjet and halftone-based printers introduce the most softness to your images.

The other output process factor is the paper used. Different paper types affect the ink droplets. Using a glossy or coated paper ensures that the ink droplet stays in the proper place and with the proper (round) shape. Uncoated or textured papers can displace the ink droplet or cause the shape to distort, resulting in a loss of detail.

Removing the Guesswork from a Complicated Task

Now that we've described why you might want to sharpen and what contributes to sharpening, exactly how do you sharpen an image?

Some photographers may argue that the unsharp mask technique was originally used in the darkroom days. We can't remember the last time we did an unsharp mask in the darkroom, nor can we find anyone who did. Where we do remember seeing unsharp mask is on the drum scanners in the press houses. These drum scanners were originally used to scan negatives and positives and make them ready for printing. Before desktop publishing, drum scanners were used to make reproductions of negatives and positives to be placed directly into layout.

These early scanners used photomultiplier tubes (PMTs), which have amazing levels of detail and resolution. Normally, there were four PMTs: one each for red, green, blue, and a fourth, usually called the USM PMT, or unsharp mask PMT. This fourth tube was designed, in essence, to add detail to the scan on the fly, based on the resolution that the image was being scanned at. The goal of the USM PMT was to match the apparent level of detail of the original, and nothing more.

Fast-forward to desktop publishing days and the advent of Photoshop and the introduction of a software-based unsharp mask tool. Confusion has always abounded about why it's called an unsharp mask tool, with countless photographers calling it all types of different names (*unsharpen mask* being the most common misnomer). In essence, the image is blurred (the unsharp part of the name), and the blurred image is then subtracted from the original image. The difference between these two images is the outlines of the objects creating an edge mask (the mask part of the name).

To put this in context, think about the result of the blurred image. You still see the original image and the rough outlines of the objects, but the fine details are all gone. When you subtract the blurred details from the original image, the result is smooth areas with no detail, and the edges of the objects. Next in the unsharp mask process is the addition of the edge mask to the original image, accentuating the edges more, resulting in additional detail and contrast around edges, *et voilà!*, you have a sharpened image.

The tool set provided in a typical unsharp mask algorithm (see Figure 10-2 for the Photoshop Unsharp Mask interface) is often difficult to wrap one's head around. You are provided with a percent, radius, and threshold.

- Percent means the strength of the algorithm.
- Radius is how big of a blur to apply (the bigger the blur, the more detail that is smoothed out, but also the bigger the edges that are accentuated are created).

FIGURE 10-2. The typical unsharp mask, shown here in Photoshop

■ Threshold is a mechanism that limits what types of details are affected (the higher the threshold, the more of a difference in objects is needed before they're sharpened, essentially meaning that the higher this value, the more sharpening is only applied to well-defined edges, preventing smooth areas from being sharpened).

Now, to make matters worse, sharpening is very much output-specific. That is, the type of output (normally the type of printer) matters a great deal, as do the variables in the output process (such as paper and viewing distance). The biggest impact to the type of sharpening applied, though, is based on the types of printers. There are three main types of printers, each of which produces detail differently.

The first type is based on the inkjet printers that we all know and love. These printers use a random pattern of nearly the same-size dots (although more and more printers now have a slight variance of their print droplets to help blend those droplets and avoid looking like a set of discrete dots). This random pattern of different ink colors (four or more) strives to re-create a continuous range of tones and colors from a limited set of colors, without the human eye being able to discern the pattern or the droplets.

The second type is the continuous tone printer. The most typical continuous tone printer is the photographic printer found at labs that produce silver-based images. Other types are dye-sublimation and thermal wax-transfer printers. Continuous tone printers can create various colors in the same spot. That is, unlike other printer types, which use the same color of ink and different mixtures of inks to create different colors, a continuous tone printer can create varying shades of a color.

The third and most common type of printer is the halftone-based printer. Typically halftone printers are printing presses. A halftone process uses a fixed pattern of dots that change their size to change their apparent shade or value. That is, a very small dot appears as a light color while a large dot appears as a dark color. The interaction between the different colors (usually between four and six colors) creates the appearance of the full range of colors.

There are now printers that use a combination of halftone and inkjet image methods, but these are the exception rather than the rule.

In addition to the printer type, other elements of the printing also affect your sharpening needs. For example, the size of the print and how far away the viewer is from the print, the type of paper used, and even the photographer's subjective taste all affect the amount of sharpening to be applied.

Taking all the parameters into consideration when sharpening your image is a daunting task, to say the least. Add to the fact that your monitor uses a completely different

method to display details from your printer, and you have an incredibly difficult task on your hands.

For a long time, the only way to get a good sharpening result meant to use a starting point for unsharp mask that you've previously set as your personal starting point, applying it to your image, and then printing out some or all of the image and judging the sharpness based on that proof. This process is expensive, time-consuming, and frustrating. And that's why Sharpener Pro was created.

How Sharpener Pro 3.0 Works

When you open an image in Sharpener Pro, the software analyzes the image. The analysis reveals to Sharpener Pro what type of sharpening to apply to the image based on the image details, allowing it to vary sharpening based on the relative details found throughout the image (applying less sharpening to areas requiring less sharpening) and to identify potential problem areas (like those that would create artifacts such as moiré patterns if they were to be sharpened). Figure 10-3 shows the Sharpener Pro 3.0 Output Sharpening interface.

Sharpener Pro then lets you define the type of sharpening based on the output process

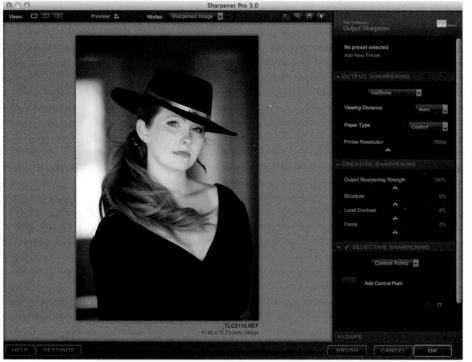

FIGURE 10-3. The Sharpener Pro 3.0 interface

and your personal preference. When applying sharpening to your images, Sharpener Pro automatically protects color details, making it possible to sharpen your images in RGB mode (the recommended color mode) without changing or introducing color shifts.

Sharpener Pro's algorithms have been tuned and improved over the 11-plus years that Sharpener Pro has been on the market. Professional photographers, graphic designers, and prepress professionals have all provided feedback based on actual output to tweak the results into a foolproof, guesswork-free sharpening process that creates easily reproducible and predictable results.

Applying Sharpener Pro to Your Images

Normally, sharpening is broken down into three types of sharpening: RAW presharpening (also sometimes called *capture sharpening*), creative sharpening, and output sharpening. Sharpener Pro 3.0 covers these three types of sharpening with two filters: the RAW Presharpener and the Output Sharpener.

Tip: If you're using Adobe Photoshop CS4 or later, we recommend that you first convert your image to a smart object, as this lets you apply Sharpener Pro as a smart filter. This way, if you ever need to disable sharpening or apply a different type of sharpening (such as sharpening first for an inkjet printer but later print at a color lab on a continuous tone printer), you can just double-click the filter in the Layers panel and change the settings. In Photoshop, to convert your image to a smart object, choose Filter ➪ Convert for Smart Filters.

RAW Presharpening

As described in Chapter 2, RAW presharpening is a controversial topic. Normally, some small amount of sharpening is applied either in the camera (when shooting in JPEG or TIFF modes) or in the RAW processor (such as Adobe Camera Raw, Lightroom, Aperture, Nikon Capture NX, or Canon DPP). Figure 10-4 shows Sharpener Pro's RAW Presharpener interface.

RAW sharpening is applied to make up for the loss of detail that occurs during the capture phase, and it ensures that the image displayed on screen appears sharp. Without this sharpening, RAW images would look a bit out of focus.

Normally, using the sharpening in your RAW conversion tool is sufficient for RAW sharpening. But some photographers turn off RAW sharpening altogether and apply only one sharpening pass with the Output Sharpener.

Some photographers (especially for truly special images in which you need complete

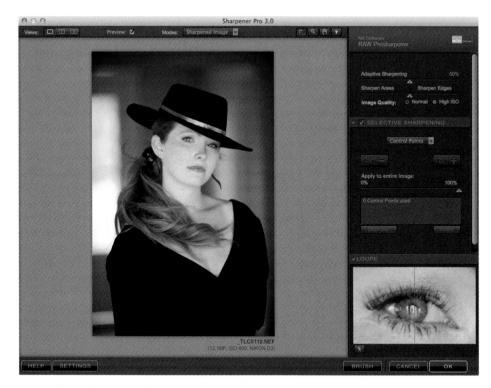

FIGURE 10-4. The RAW Presharpener interface

control), prefer the RAW Presharpener because you can control exactly how much sharpening is applied to your image throughout the entire image-editing workflow, by selectively applying the sharpening to the image.

To use the RAW Presharpener, make sure to turn off sharpening in your RAW processor and apply the RAW Presharpener as early in the image-editing process as possible (but not before noise reduction). Figure 10-5 shows sharpening being turned off in Adobe Camera Raw.

After opening the RAW Presharpener, you're provided with controls over the sharpening process.

The first slider, Adaptive Sharpening, lets you control the amount of sharpening applied to the image. The name comes from the fact that as you increase the sharpening slider's setting, the amount of sharpness and type of sharpening is automatically adjusted. That is, instead of applying the same amount and type of sharpening as the slider is increased, the actual sharpening applied changes. This type of sharpening is based on the Nik Software image research team's findings of the best type of sharpening to apply at different levels. In practice, this means you increase this slider until the onscreen image appears to be sharp, but not too sharp (see Figure 10-6).

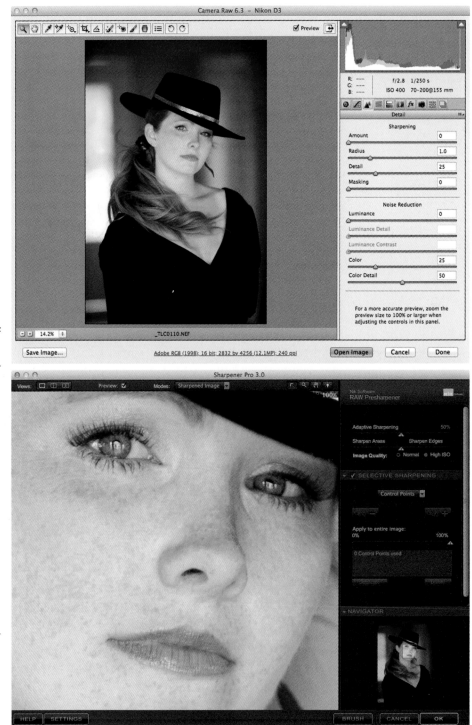

FIGURE 10-5. Sharpening is being turned off in Adobe Camera Raw

FIGURE 10-6. A value of 50%, the default value, creates the desired level of sharpening. Turning on and off the preview can help you determine if you've applied too much or too little sharpening.

The next slider, Sharpen Areas / Sharpen Edges, lets you control how the sharpening is applied to the image. This unique control lets you focus the sharpening algorithm more on one type of image details or another. When set to the Sharpen Areas side of the slider, the control's sharpening avoids edges and sharpens only the details in an object. This can be helpful if you want to avoid applying sharpening to an image whose edges are already sharp or contain artifacts (such as aliasing and chromatic aberrations).

Normally, this slider is set either to the middle or closer to the Sharpen Edges side, because our eyes determine sharpness based on the edges of an image. By focusing on the sharpness of the edges in an image, you can ensure that the image appears to be sharp and avoid oversharpening image details like skin or sky (which are considered to be areas instead of edges).

When using the RAW Presharpener, we recommend leaving this slider in the middle, unless you see a problem with the sharpness of areas in the image, and we recommend you use control points to remove sharpness from potential problem areas like skin and sky.

The next control, Image Quality, adjusts the sharpening algorithm to adapt to images with a lot of noise. Select High ISO if you are working on a high-ISO image. Typically, we don't recommend sharpening a high-ISO image, but if you have to, selecting Image Quality makes the process a bit easier.

The most significant benefit of the RAW Presharpener is the Selective Sharpening section. It is here that you get the most value out of the RAW Presharpener and can get more control than in the RAW sharpening tools found outside of Sharpener Pro. For nearly every situation, we recommend using the Control Points method (we describe the Color Ranges section later in this chapter).

Using control points makes it possible to apply the RAW Presharpener selectively to your image using U Point technology. With these tools, you can decide where to apply the RAW Presharpener, so you can prevent sharpening in certain areas. This need to not sharpen occurs most often with portrait photographers trying to achieve the softest skin tones possible; in that case, avoiding sharpening at both stages of sharpening yields the best possible results.

Control points in the RAW Presharpener work a lot like control points inside Color Efex Pro: You have a + (100%) and a – (0%) control point, and a global opacity slider (called Apply to Entire Image in the RAW Presharpener).

Clicking the + control point immediately sets the Opacity slider to 0%, just like in Color Efex Pro. Sharpener Pro does this opacity change so you see the result of the + control point. When you place the + control point, sharpening is applied *only* where the control point selects. Placing additional control points let you confirm and ensure that the

sharpening is applied exactly where you want it.

Both the + and the − control points have Opacity sliders. After dropping a control point on your image, you can adjust the opacity to apply a different level of sharpening other than 0% or 100%. Keep in mind that the + and − control point buttons both place the same control point, the only difference is the starting point of the Opacity slider: A + control point places a control point with the opacity slider at 100% whereas a − control point places a control point with the opacity slider at 0%.

You can then visually confirm where the sharpening is applied by using the Modes popup menu to choose Effect Mask. This shows you a black-and-white mask of your image, with white being the areas where sharpening is applied and black being the areas where it is not. The various shades of gray show the various levels of sharpening being applied. Figure 10-7 shows an image with the effect mask displayed.

Control points are the method we recommend to apply sharpening selectively to your images. The only situation in which the control points cannot work well is with batch processing. This is because control points are location-specific, and it's unlikely your subjects stay perfectly still throughout a series of images. Imagine having a control point on someone's eye adding sharpness just to the cornea, and in one shot the subject blinked

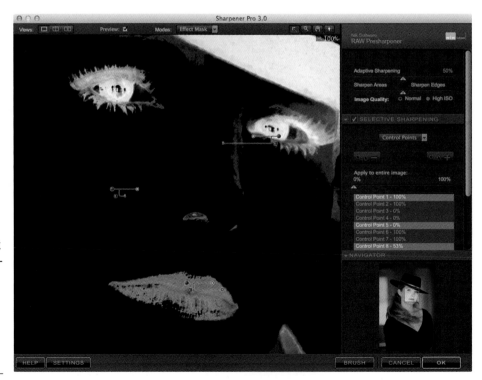

FIGURE 10-7. A mask of the selective sharpening result. We added a few − control points to the skin and a few + control points to the eyes and eyelashes to create this selection.

or turned his head. You have just sharpened his cheek or eyelid — not exactly what you wanted!

If you need to selectively apply sharpening to a batch of images, you need to use the Color Ranges option. This option makes it possible to select a color independent of location and then select the amount of sharpening to apply to that area.

By default, three color ranges are available when you first select the Color Ranges option. You can change the colors for each of these ranges either by clicking the Eyedropper tool and then selecting a color from the image or by clicking the color rectangle and selecting a color from the color picker. After selecting a color, use the Opacity slider to control how much sharpening to apply to that color. To add additional color ranges, click the + icon below the available ranges.

After selecting the appropriate amount of sharpening, click OK or Save to apply the sharpening to your image.

Output-based sharpening

Although normally considered the last part in the sharpening step of image editing, in Sharpener Pro 3.0 output sharpening is done at the same time as the creative sharpening, and it's the first thing selected in the Output Sharpener. This makes it possible to base any creative sharpening on the output sharpening. (Nik Software believes creative sharpening and output sharpening have an important relationship to one another, thus the "promotion" of output sharpening.)

In the Output Sharpener, you need to first tell Sharpener Pro which type of output process you will use. Each option provides different types of controls, each tailored to that output process, as Figure 10-8 shows.

Display output process

The Display output process is designed for images that will be viewed on a monitor or projector instead of printed. This is also a good option in case you need to sharpen your image but don't know exactly how it will be printed, such as when shooting for stock photography.

There is only one slider available in the Display method: Adaptive Sharpening. As in the RAW Presharpener, this slider lets you control the amount of sharpening applied to the image. Increase this slider's setting until the image appears to be sharp but not too sharp.

Inkjet output process

Use the Inkjet output sharpening process to sharpen images printed on an inkjet printer. The controls provided let you control the variables of an inkjet printer.

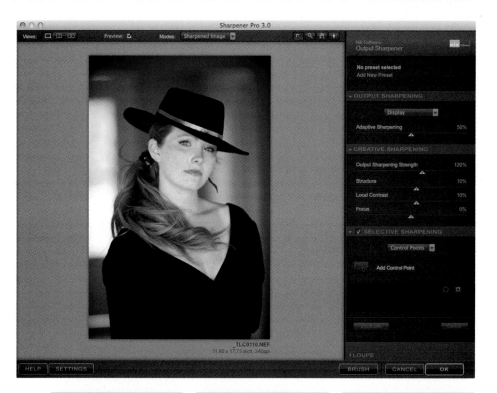

FIGURE 10-8. The settings for each sharpen output option. At top: Display. At bottom, from left to right: Inkjet, Continuous Tone, and Halftone.

The Viewing Distance control lets you adapt the sharpening based on how far away a viewer is from the printed image. The farther back a viewer is from an image, the less detail he or she is able to see. This control can help by changing how the image is sharpened and increases the amount and size of the sharpening results so that from a distance, the image still appears to have a large amount of detail. Normally, leaving Inkjet set to Auto is the best approach. The Auto value sets the viewing distance from the print to the diagonal of the print. We recommend adjusting this option only if you know that the viewer will either be farther from or closer to the image than the diagonal, such as when the print is displayed in a tight space where the viewer is closer to the image or in an installation that prevents the viewer from getting closer to the image.

The Paper Type control lets you adjust the amount of sharpening based on the type of paper used. Depending on the paper and your specific printer, detail can be affected by the paper in two ways. The first is called *dot spread* (also known as *dot gain* in the prepress industry), which is caused by the ink being absorbed by the paper, making what would have been a small dot a larger dot as it spreads into the paper fibers. The other way detail is affected is by the texture of the paper. A smooth, glossy surface ensures that the ink droplet lands exactly in the place where the printer sends the ink. With a highly textured paper, not only could the ink droplet be placed in a slightly different place from intended, but that droplet's size might also change. Selecting the paper type closest to the type of paper that you're using adjusts the sharpening as needed.

The final control, Printer Resolution, lets you select the resolution of the printer you are using. It is important to set this value according to the resolution you have selected in your printer driver, not based on the maximum value of your printer. This control adjusts the sharpening settings to ensure that the sharpening results are appropriate for that particular printing resolution. You can select one of the User Defined options and type in the resolution of your printer; the first value is the horizontal resolution (usually the bigger number) and the second value is the vertical resolution (usually the smaller number).

Continuous Tone output process

Use this option when sending an image to a photo lab (unless they advertise as producing giclée prints, which are most often inkjet-based — *giclée* is French for *squirted*).

The Viewing Distance control lets you adapt sharpening based on how far away a viewer is from the printed image. As described earlier in the inkjet section, the farther back a viewer is from an image, the less detail he or she can see. This setting lets you correct for interaction between the viewer and the image.

The Printer Resolution option allows you to select from common resolutions used by printers. If the resolution of your printer isn't available, enter your resolution in the User Defined option. When in doubt, select 300 dpi, as this is a common value for most printers.

Halftone output process

This option is available when printing on a halftone-based device. Most likely you will need to use the Halftone output process when printing on a printing press, such as for magazines or books.

The Viewing Distance slider controls the sharpening based on how far away a viewer is from the printed image. As described in the previous sections, use this control to adjust the sharpening based on either the Auto setting (recommended) or how far away the viewer is from the image.

The Paper Type control provides control over the sharpness required by the paper. Newsprint, the type of paper used for newspapers, is completely uncoated and has the most dot spread, causing ink drops to become much larger than intended and introducing blur to the images. High-gloss paper types have the least dot spread and can maintain the highest resolution, requiring the least amount of sharpening.

The last control, Printer Resolution, lets you select the resolution of the printer. Ask your prepress support team which value to use here, but a common value is 150 lpi (lines per inch).

Creative sharpening

Creative sharpening is often considered the second part in the sharpening stage of image editing. In Sharpener Pro, it is actually the last due to the connection to the output sharpening.

Once the output sharpening values are set, you can start adjusting the sharpening to your taste. Adapting sharpening according to your personal taste is really what creative sharpening is all about. Whereas the output sharpening settings strive to add sharpness to the image based on the measurement of image details and the predicted amount of detail loss by the output system, creative sharpening lets you determine exactly how much sharpening to apply — and where.

The most important thing to consider with creative sharpening is how to improve your image. Consider how to draw the user's attention to certain parts of your image to help emphasize your subject. In addition to being drawn to the brightest, highest-contrast, and

saturated objects, the eye is also drawn to the sharpest, most-detailed objects in the scene. Keep in mind that you can help draw your viewer's eye to crucial objects by applying more sharpness to that object than to other areas.

Sharpener Pro 3.0 has two kinds of sharpening tools in the creative sharpening process: Creative Sharpening, which affect the entire image, and Selective Sharpening, which enables you to adjust details selectively. The global tools apply the enhancements across the entire image whereas the selective tools apply the same tools only to the areas you specify.

When working with the Creative and Selective Sharpening sections, Sharpener Pro presents you with the following controls.

The Output Sharpening Strength slider controls how much sharpening is applied overall, based on the settings in the Output Sharpening section. The global slider is especially useful if you want to prevent sharpening from being applied to your image. You can lower the Output Sharpening slider to 0% and then use the control points or color ranges to add sharpening only to certain areas.

The Structure slider controls the incredibly powerful and popular Structure control, unique to Nik Software's tools. Structure can accentuate the texture of objects and areas

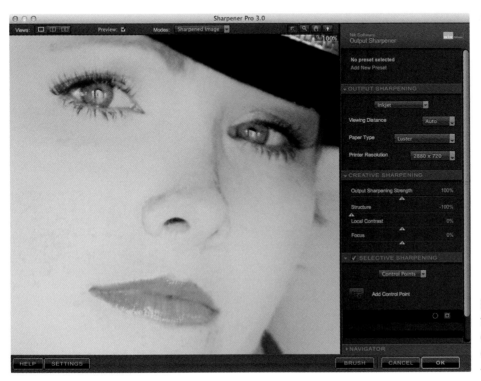

FIGURE 10-9. A negative Structure value softens details but retains edge structure.

in an image, without affecting the edges of those objects. This type of enhancement, sometimes referred to as *midtone contrast*, controls the details in your image further and helps give you complete control over the detail in your images.

You can also use Structure to reduce textures and details in your image by moving the slider to negative values (to the left). Working with a negative Structure value is especially powerful when using control points to selectively apply creative sharpening. Figures 10-9 and 10-10 show the two extremes of the Structure slider.

The Local Contrast slider applies a highpass-based midtone contrast enhancement to your images. Local Contrast can add shape and dimension to objects, but it can create halos around objects. It is important to not overapply Local Contrast and to watch high-contrast edges to ensure no halos are introduced. Notice Figure 10-11 and Figure 10-12 to see how the Local Contrast slider affects images.

The last slider, Focus, uses a unique algorithm to try to bring out-of-focus objects into focus. Of course, an object that is completely out of focus can never be brought into focus, but this tool works remarkably well on objects that are out of focus due to a shallow depth of field.

You can use the Focus slider with negative values to make objects that are in focus

FIGURE 10-10. A positive Structure value accentuates all the details in the image. It looks horrible on the skin but does interesting things to the textures in the hat.

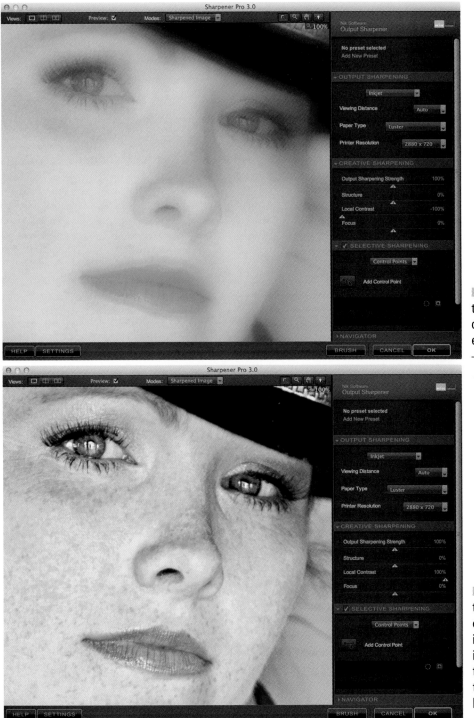

FIGURE 10-11. Negative Local Contrast introduces a haze across the entire image.

FIGURE 10-12. Positive Local Contrast adds contrast to the entire image but can also introduce halos. Look at the edge around the hat to see an example of a halo.

out of focus using control points. This technique lets you bring your subject into more attention by making areas that are not important to the scene appear slightly out of focus. Figures 10-13 and 10-14 examples of the Focus slider being applied to an image.

The Control Points option in the Selective Sharpening section uses U Point technology to isolate objects and adjust their Output Sharpening Strength, Structure, Local Contrast, and Focus values. The effect applied to a specific area is based on the global settings in the Creative Sharpening section and the result of the control points.

Control points override the values of global values, meaning that if, for example, you have Output Sharpening Strength set to 100% in the Creative Sharpening section but a control point on that area with the Output Sharpening Strength slider set to 0%, the amount of Output Sharpening applied to that object is 0%.

First set the global sharpening settings, and then adjust the selective settings using the control points, following the recommended workflow of global to granular. See Figure 10-15 for an example of how control points can selectively soften and sharpen parts of your image.

The Color Ranges option is useful only if you are applying the output sharpening to a batch of images. Only output sharpening can be adjusted with the Color Ranges option,

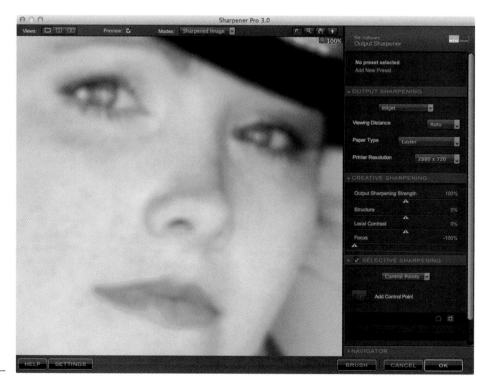

■ **FIGURE 10-13.** With the Focus slider moved to the left, the image is blurred completely.

so the values in the Creative Sharpening section are also applied globally to your images when using Color Ranges option. Figure 10-16 shows how the Color Ranges option can selectively sharpen an image.

Just as with RAW presharpening, use the Eyedropper tool to select a color or use the color patch to open the color picker. Then adjust the output sharpening strength for that selected color. To add another color range, click on the + button at the bottom of the section.

Important Controls in the Settings

Although many of the options in the settings are fairly straightforward (and therefore are not described in this book), there are two options in the settings control area that you might consider. The settings options are show in Figure 10-17.

Default Control Point Settings

There are two options, both of which control what the sliders are set to by default when you place a control point:

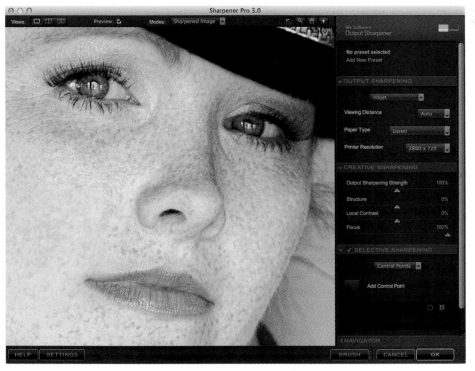

FIGURE 10-14. Moving the Focus slider to the right tries to bring everything into sharp focus.

FIGURE 10-15. Using a large control point with the Output Sharpening Strength set to 0% and slightly negative values for Structure and Local Contrast can help soften skin tones. Adding control points to the eyes and lips with increased sharpening values helps draw attention to those crucial parts of a portrait.

FIGURE 10-16. Adding a few color ranges lets you isolate the important tones in the model's face to selectively sharpen them, as well as to prevent sharpening from being applied.

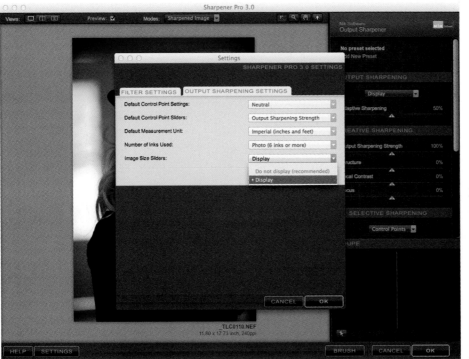

FIGURE 10-17. You can adjust the settings in Sharpener Pro 3.0 to adapt to your workflow.

- ■ **Neutral.** The sliders for control points added to the image when Neutral is selected will all be added with neutral, or 0%, values.
- ■ **Retain Creative Sharpening Setting.** The sliders for any added control points will mirror the slider values in the Creative Sharpening section. This is helpful if you want to make sure that control points don't change the values of the image by default.

Image Size sliders

If you are working in Lightroom or Aperture, you should turn Image Size to Display. Because Lightroom and Aperture do allow you to resize the image, Sharpener Pro sharpens the image as if the image will be printed at 72 dpi, usually resulting in far-oversharpened images. By setting this option to Display, two new size sliders are available to tell Sharpener Pro what size the image will be and thus get the appropriate sharpening results.

Chapter 11

Portraits
Start to Finish

Now that you have a good understanding of each of the tools in the Nik Software product line from the preceding ten chapters, let's go through a few images start to finish to see how they can all work in a single workflow.

Example 1: Candace

The lighting of the portrait in Figure 11-1, right out of the camera, is nice. There is a

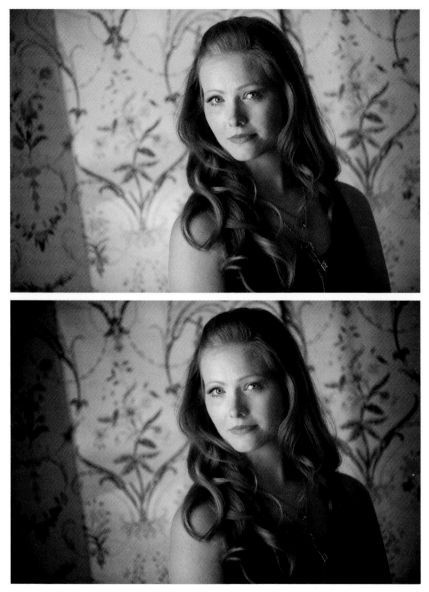

FIGURE 11-1. The original image (top) and the image after being edited (bottom)

good balance between the subject and the background, and the contrast of light between the two sides of the model's face is also nice. But the image can be improved (as most images can be); in this case, we wanted to draw even more attention to the model's beautiful eyes. We used Viveza 2, Color Efex Pro 4, and Sharpener Pro 3.0 to do so.

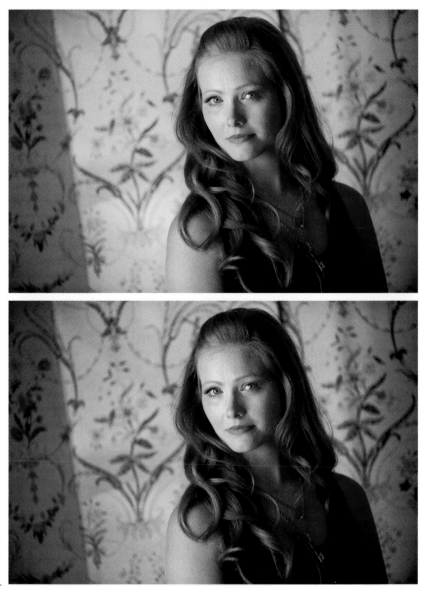

FIGURE 11-2. The original image (top) and the image after editing in Viveza 2 (bottom)

What we did in Viveza 2

Viveza 2's ability to precisely shape color and light makes it a great tool to start any image-editing session. Figure 11-2 shows what we could accomplish with Viveza 2, which was a basic adjustment of the light from the original capture, drawing more attention to the face and eyes.

To start, we added a control point to the background behind the model's head. Reducing the Brightness slider's setting and increasing the Contrast and Structure sliders' settings helped darken the background. We also added in a slight amount of structure in the background to define the pattern on the wall, as shown in Figure 11-3.

Figure 11-4 shows that we duplicated the control point by pressing and holding Option or Alt and dragging a new control point to the opposite side of the background to give a consistent and natural look.

Next, we slightly brightened the skin on her face and added in a bit of softening. To accomplish this, we increased the settings of the Brightness and Contrast sliders, then lessened the texture in her face by slightly lowering the value of the Structure slider. We duplicated and moved this control point to the shadow side as well, as shown in Figure 11-5.

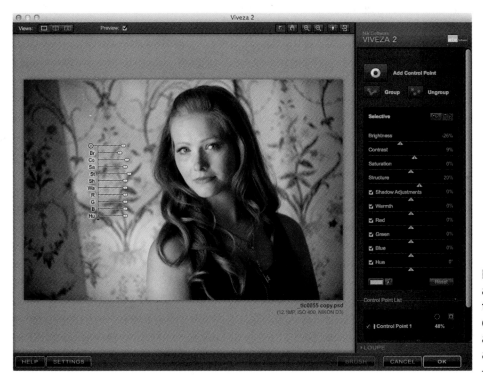

FIGURE 11-3. We first added a control point to the background to darken the background and increase contrast and structure.

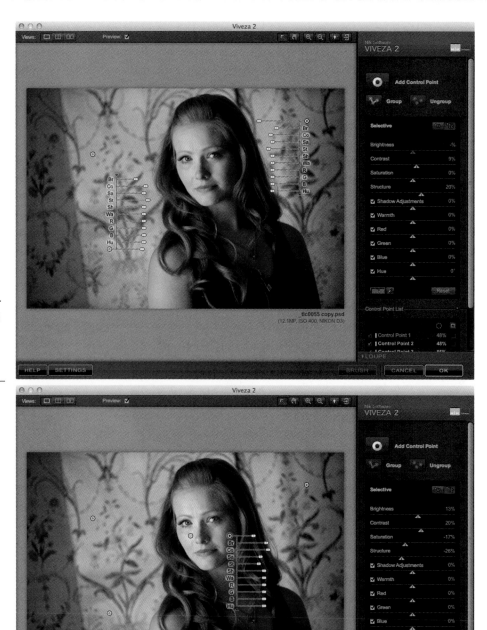

FIGURE 11-4. We duplicated the first control point placed on the background and added it to other areas of the background.

FIGURE 11-5. We added two control points to the face, brightening and softening the skin.

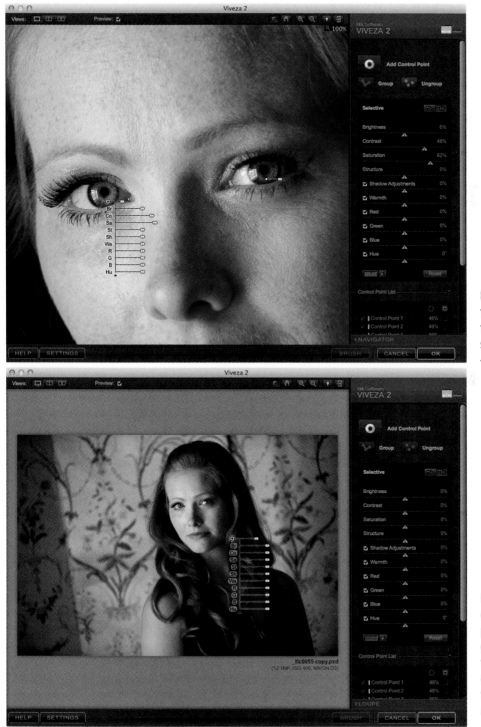

FIGURE 11-6. We then used control points to add contrast and saturation to the eyes.

FIGURE 11-7. The effect from the control points on the background spilled over onto the hair, so we added a control point to the hair to prevent it from being affected.

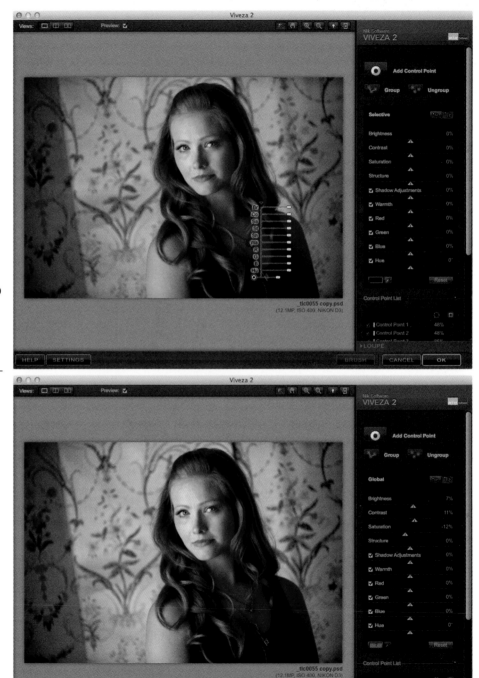

■ **FIGURE 11-8**. To keep detail in the blouse, we added a neutral control point to maintain tonality.

■ **FIGURE 11-9**. Once we made all the selective adjustments, we reviewed the entire image and adjusted the global sliders slightly to brighten and reduce saturation.

One of the great things about control points is they let you work fairly easily on the subject's eyes, without the pain of making a mask. As Figure 11-6 shows, we added contrast and color saturation in the eyes to make a more compelling image.

Occasionally, an edit affects an area you do not want changed. In this case, when we adjusted the background control point, some of the information was also the same in her hair, so the hair was slightly affected. To prevent this change from adding contrast, structure, or saturation in her hair, we just placed a control point in the hair, removing any unwanted affect, as Figure 11-7 shows.

To make sure the clothing remained unaffected, we also placed a neutral control point on the fabric (as shown in Figure 11-8), again removing any affect or change caused by any of the other control points in the image.

After all the control points were in position, the image seemed to be a bit dark overall. Because Viveza also allows global adjustments, we felt there was a bit too much overall color saturation, so we reduced the Brightness slider's setting to increase the look slightly, as Figure 11-9 shows.

What we did in Color Efex Pro 4

As Figure 11-10 shows, Color Efex Pro 4 lets you enhance so many different areas of your work, plus it provides plenty of creative and correction options. When you open an image in Color Efex Pro, note that you have the same selective options with control points, so you can add any filter effect selectively.

One of our most-used filters in Color Efex Pro 4 is Darken / Lighten Center. Using this filter can direct the viewer's attention to the subject by darkening the corners and edges slightly, creating a soft vignette look. In this portrait, we used Darken / Lighten Center to move the attention away from the edges, as shown in Figure 11-11.

What we did in Sharpener Pro 3.0

Working with a professional color lab means a continuous tone printer will be used for the final output. As Figure 11-12 shows, to optimally sharpen this image for such output, we set the DPI setting to match the instruction from the lab and slightly reduced the default sharpening amount to 70% from 100%. As described in previous chapters, the final sharpness is designed for the output and is very difficult to see on your screen.

Because sharpening is generally a global adjustment, we wanted to remove any sharpening from the model's skin. In this case, we added a couple control points to remove both the amount of sharpening and introduce a very slight look of softness by

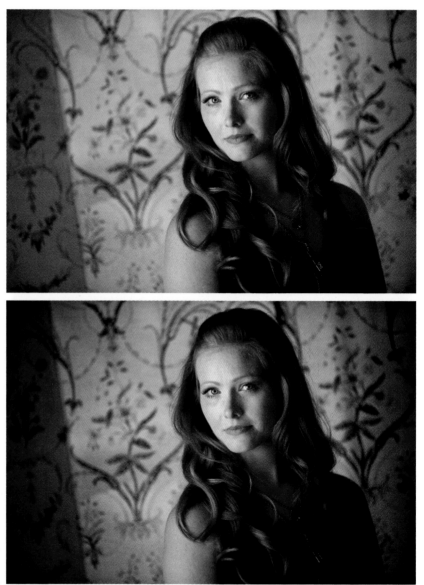

■ **FIGURE 11-10.** The image from Viveza 2 (top) and after using Color Efex Pro 4 (bottom)

reducing the values of the Structure and Local Contrast sliders, as shown in Figure 11-13.

We placed another control point on her lips to make sure there is good sharpness on the lips, as they are often a focal point in portrait photography, drawing the viewer's eyes and supporting the overall sharpness of the image, as shown in Figure 11-14.

Because the eyes are generally the first indicators of sharpness and a great point of reference, it is vital that the eyes appear sharp and clear. In this case, we slightly increased

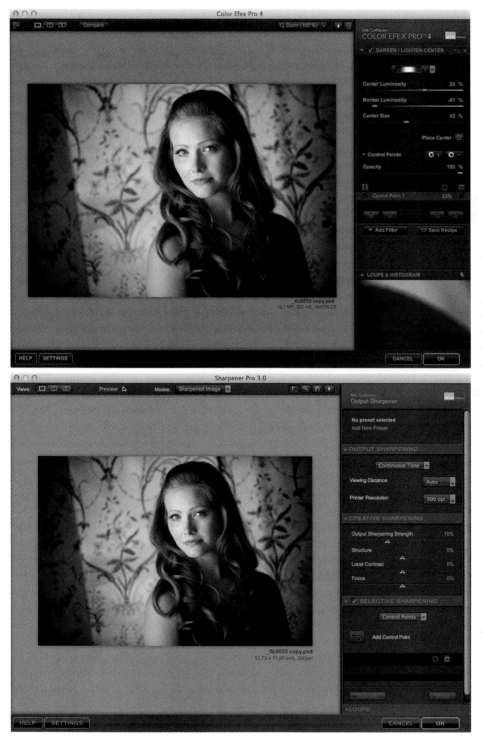

FIGURE 11-11. We used the Darken / Lighten Center filter to draw the viewer's eye to the center of the photograph and away from the edges.

FIGURE 11-12. Using the Continuous Tone output sharpening method is appropriate for this image, as it will be printed at a photo lab.

FIGURE 11-13. We added two control points to the skin to identify its dark and light portions. We then removed sharpening and introduced some softening by reducing the values of the Structure and Local Contrast sliders.

FIGURE 11-14. The lips are the second-most-important area of a portrait, so we added a control point there to ensure sharpening is applied.

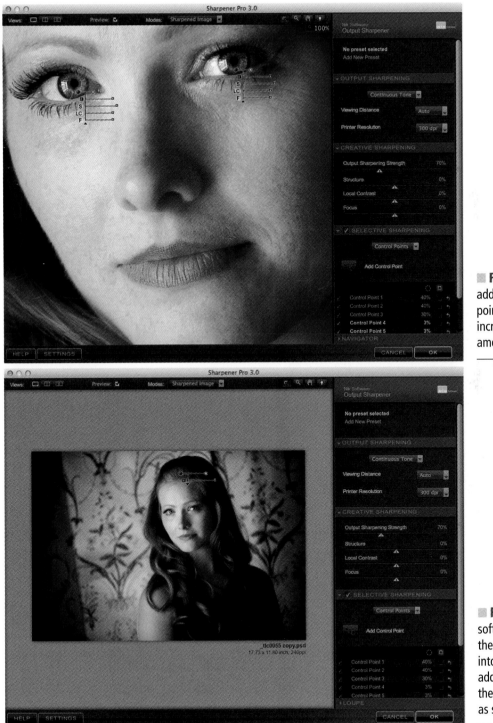

FIGURE 11-15. We added two control points to the eyes and increased the Structure amount.

FIGURE 11-16. The softening effect from the skin was spilling into the hair, so we added a control point to the hair to keep the hair as sharp as possible.

the Structure setting to help the eyes hold the viewer's attention by giving the appearance of sharpness and texture, as shown in Figure 11-15.

On final review, we noticed that the slight softening from the skin adjustment was also softening the hair. We used a neutral control point to remove this effect, keeping the hair crisp and sharp, as Figure 11-16 shows.

Example 2: Lori

In the example shown in Figure 11-17, we took a nice portrait and moved it up notch. This traditional headshot is greatly enhanced by a few simple edits that do not require a great deal of time. Using multiple Nik Software products can help to optimize a photograph.

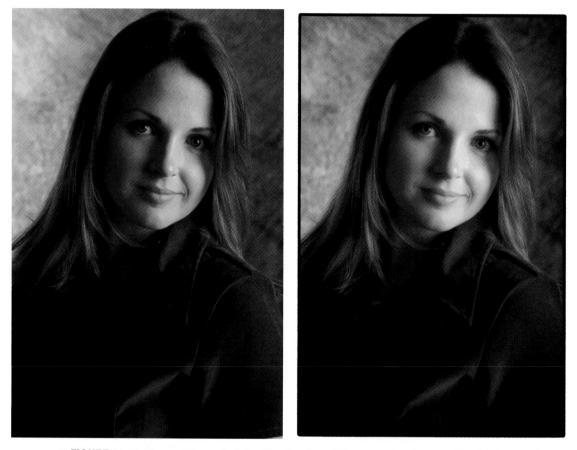

FIGURE 11-17. We used Viveza 2, Color Efex Pro 4, and Sharpener Pro 3.0 to stylize this image. The original is at left, and the final result is at right.

What we did in Viveza 2

The first thing to do in an image of this type is direct the viewer's attention and make sure there are no distractions from the primary subject. Here, we used Viveza to fine-tune the image, as Figure 11-18 shows.

Our first edit was to add a control point to darken the background slightly, as Figure 11-19 shows. It is also a good idea to increase contrast and saturation a bit when working on a textured and colorful background.

Directional lighting, even when soft, generally leads to unevenness of skin. Figure 11-20 reveals how we were able to reduce the contrast slightly, giving a smoother transition from dark to light. The reduction in contrast is more in keeping with her look and the studio environment in which she was placed.

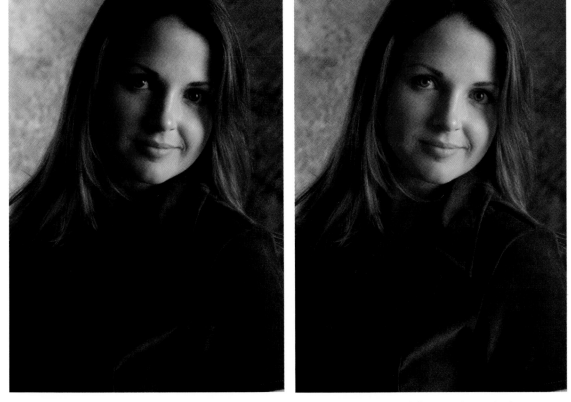

▓ **FIGURE 11-18.** We used Viveza 2 to darken the background and lighten the model's eyes. The original is at left and the final result of using Viveza is at right.

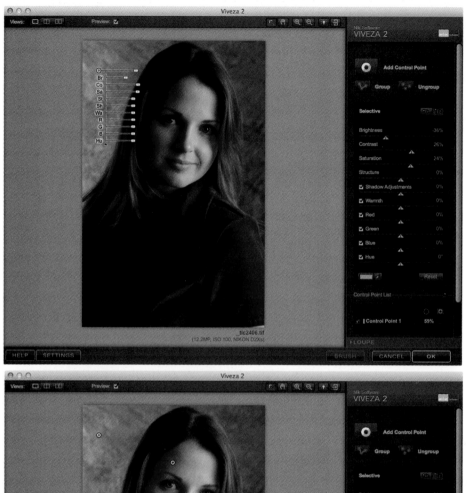

FIGURE 11-19. We added a control point to the background to darken it slightly.

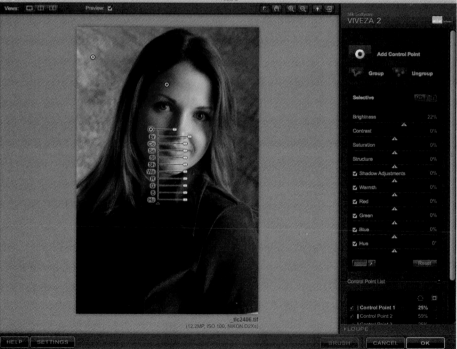

FIGURE 11-20. We added two control points to the skin to balance the contrast between the two sides of the face.

As with any directional light, it is easy to lose detail in darker areas. This is where Viveza shines. We used it to place a control point on her jacket and slightly increased the exposure resulting in more detail, as Figure 11-21 shows.

A slight increase from the Shadow Adjustment slider gives more detail and texture in her hair. These types of small edits and adjustments are ideal for creating depth and dimension throughout your image (see Figure 11-22).

Once again, we added sparkle or life to the eyes by increasing contrast, saturation, and structure, as Figure 11-23 shows. These adjustment controls are some of the most powerful available not only for adding snap or sparkle in small areas like the eyes but also for larger, more global edits that you might apply in images such as landscapes or scenic images.

We polished the image by slightly increasing brightness, contrast, and structure globally, as Figure 11-24 shows. Again, the global adjustment aspects of Viveza save time in the workflow, so we strongly recommend using Viveza for all your overall global adjustments.

What we did in Color Efex Pro 4

The effects in Color Efex Pro 4 offer the look of traditional glass filters, creative options,

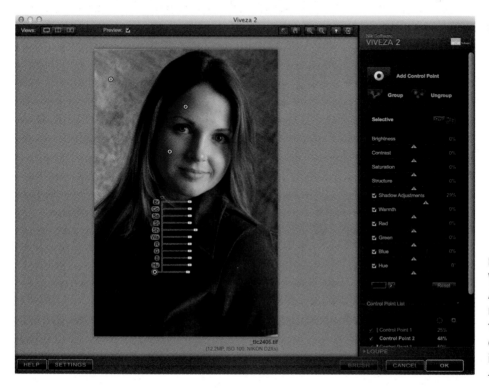

FIGURE 11-21.
We used the Shadow Adjustments slider on a new control point added to the jacket to bring out some of the details in the jacket.

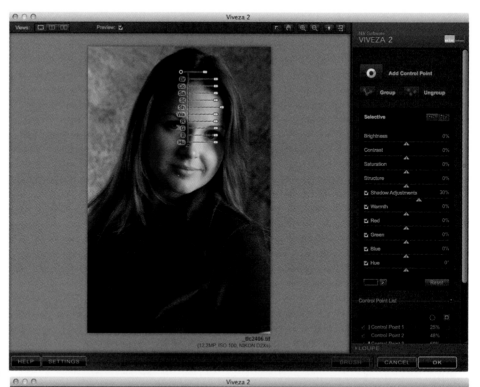

FIGURE 11-22.
Another control point is added to the hair and the Shadow Adjustments slider is used again to bring out some of the details in the darker part of the hair.

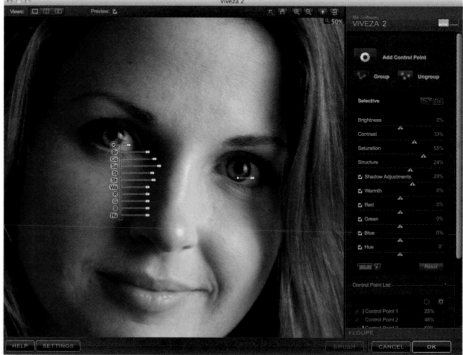

FIGURE 11-23. We used control points to bring out the detail and color of the eyes.

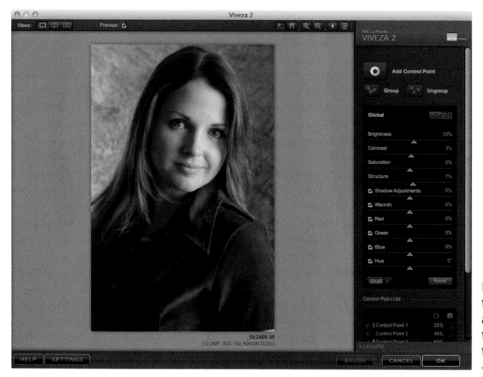

FIGURE 11-24. We then used the global adjustments to finish the tonality adjustments of the image.

color-correction filters, and the opportunity to easily add drama to your work. In the portrait in Figure 11-25, Color Efex Pro helped us create a complimentary photograph in a few easy steps. We worked to make a headshot for this lovely woman of which she can be very proud.

One of the go-to filters for us whenever we're editing photographs of people is Glamour Glow. This unique filter is a blend of softness and drama and when adjusted properly adds a look of sizzle to the image (as Figure 11-26 shows). Here, the default setting does a nice job but did slightly reduce color saturation.

As we all know, the human eye will be drawn to the brightest area in a photograph and usually drawn away from the darkest. This is usually true in the case of a medium or darker-key photograph. In this portrait, we chose to keep the viewer's attention on our subject by using the Vignette Lens filter and adjusting it to lower the brightness values around the edges of the frame (see Figure 11-27).

Finishing off any photograph is always a personal touch, and one that different photographers often won't agree on — nor need to. After all, expressing our own individual personality is why we got into photography in the first place. In this case, we wanted a slight border around the image, and Color Efex Pro 4 offers a simple solution with an almost

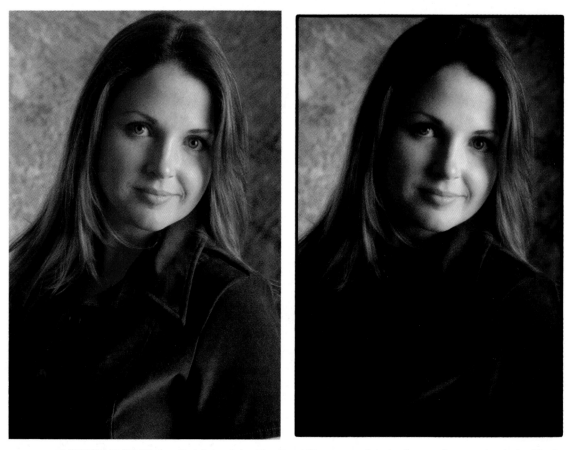

■ **FIGURE 11-25.** We applied three Color Efex Pro 4 filters to stylize the face and create the desired look in the image (at right). The image we brought in from Viveza is at left.

endless supply of adjustable options. By using its image borders, we put a frame around the photograph, as shown in Figure 11-28.

What we did in Sharpener Pro 3.0

Sharpening for people-styled photography is a little more difficult than sharpening a landscape or even fine-art image. Here, we have reduced the sharpening amount from the default setting of 100% down to 70% that seems to be appropriate in most portraits for overall sharpening. See Figure 11-29.

One of the things we often see in the world of portraiture is that people tend to oversharpen their images. Pores that are sharpened in the skin, especially in women, do not create very complimentary images. In this case, we controlled sharpness by adding a

FIGURE 11-28. Adding a border is a great finishing touch for any photograph.

FIGURE 11-29. The first step in sharpening any image is selecting the appropriate output settings and adjusting the global sharpening settings. In this image, we selected an Output Sharpening Strength of 70% to provide an appropriate amount of sharpening for a portrait.

 FIGURE 11-30. It is always a good idea to remove sharpening from the skin of a portrait. Reducing the value of the Structure slider can also soften the skin details and provide a pleasant effect.

 FIGURE 11-31. After reducing the sharpening on the skin, we added a control point to the lips to ensure that sharpening was still applied to the lips.

■ **FIGURE 11-32.** We added a control point to the shirt and adjusted the shirt's Structure setting to enhance the texture.

■ **FIGURE 11-33.** We used the Focus and Structure sliders to improve the focus and details of the eyes.

control point in the face and reducing the Structure slider's value, thereby keeping the skin smooth and silky, as shown in Figure 11-30.

Once again, we wanted to make sure the lips were not affected by the softening of the skin with the reduction in structure. So we placed a neutral control point on the lips to remove the influence of the lower structure, as shown in Figure 11-31.

A quick increase of texture in the shirt (using control points to contain the adjustments to the shirt), as shown in Figure 11-32, took only a few seconds. Having the option for this type of fast correction is so helpful in today's digital photography.

Finally, working on the eyes is such an important part of the final stage in your editing. Eyes are so expressive and add so much to the picture that you want to make certain there is good light, good color, and good sharpness. Thus, selectively sharpening eyes is of key importance, and not easily done by any other method. Figure 11-33 shows the sharpening we applied to the image.

Chapter 12

Landscapes
Start to Finish

Landscape photography was probably the first type of work being captured. Stationary subjects worked well with the unbearably slow speeds of capture in the early days of photography. Coupled with a never-ending supply of subject matter, the landscape was a natural and almost perfect subject. Nothing has changed much, except our ability to capture much lower-light levels, to use more postproduction capabilities for enhancements, and to travel more easily to various locations. Based on research from technology companies and photo-industry manufacturers, landscape photography makes up the highest percentage of photography being done today. And that is no wonder, given the beautiful subjects, an audience of enthusiastic viewers from all walks of life, and the opportunities for getting great pictures.

Example 1: Trees of Peterhof

Most photographers have a good understanding of how a scene will look when captured. Today's digital cameras give a preview, which for the most part reveals exposure, composition, and any problems you might encounter. However, visualizing in black-and-white is not easy for everyone. Understanding the role of color filtration and how different tones of gray translate from color into black-and-white takes a lot of testing and experimenting. The color image in Figure 12-1 is a powerful image compositionally, but when converted to black-and-white it really comes to life.

What we did in Dfine 2.0

Long-exposure photographs often require noise reduction even if they are shot with a very low ISO. This color image was shot at ISO 100 on a Nikon D3 (known for its low-noise characteristics) and had discernible noise when the image was converted to black-and-white and resized. We applied noise reduction early in the process to get the best result. Applying the noise reduction globally was sufficient and enabled us to quickly get to the next step.

Dfine 2.0 can quickly apply noise reduction globally, and it is great at maintaining sharpness and detail while minimizing noise. We applied the correction manually but could just as easily used the automatic feature. Generally speaking, noise reduction comprises two steps: measuring the noise and then reducing the noise, as Figure 12-2 shows.

What we did in Silver Efex Pro 2

Working with Silver Efex Pro 2 is a dream for us. We both have considerable darkroom

experience and now have so many more controls than was ever possible in the wet lab (the darkroom) of silver-halide photography. Among those controls is the ability to apply color filters to the image to create various effects and make enhancements. In Figure 12-3, we used a red filter in Silver Efex Pro 2 to maximize the separation of the clouds from the blue sky.

We further enhanced and darkened the sky by going to the Sensitivity section under the Film Types and moving the Red filter slider all the way to the right. This change really

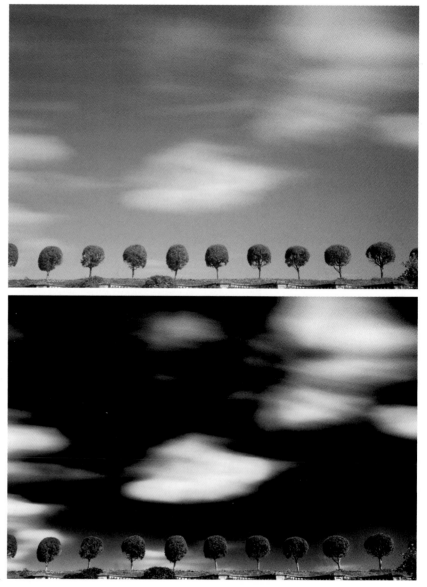

FIGURE 12-1. The original image (top) and the image after being edited (bottom)

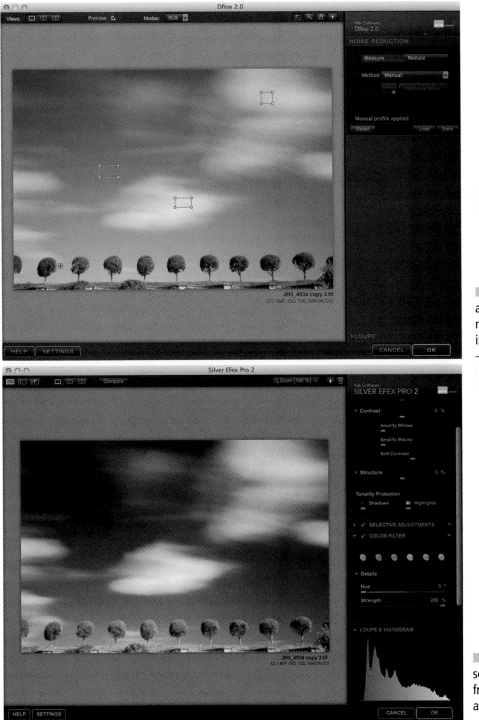

FIGURE 12-2. We applied Dfine 2.0's noise reduction to the entire image.

FIGURE 12-3. To start separating the clouds from the sky, we applied a red filter to the image.

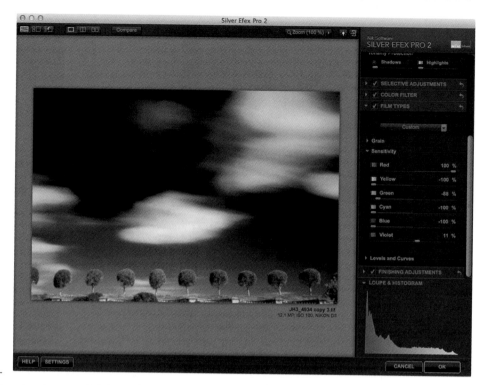

made the sky deep and rich, and what is really great is that this enhancement can be accomplished without fear of any banding or artifacts. We moved the other color sliders to the far left to minimize their effect on the image, as Figure 12-4 shows.

We could make subtle enhancement to the sky by adding the Amplify Blacks filter, which is in the Contrast control section, as Figure 12-5 shows. This feature allows you to move the level of black without fear of losing detail or blocking up shadow areas, so we often use it in our black-and-white work.

The Amplify Whites filter in the Contrast area is best used to clean up highlight and lighter areas in your pictures without affecting other areas. As Figure 12-6 shows, we placed a control point directly on the clouds and adjusted Amplify Whites to further separate the sky from the clouds. You can also see there was a very slight reduction in contrast in the clouds, resulting in a smoother look.

Adding a control point to the sky just under the clouds let us drop the value of the sky slightly more, resulting in a much more uniform level of brightness, as shown in Figure 12-7.

Once again, adding a little Amplify Black filtering and also raising the Structure setting gave more definition and contrast to the trees, as Figure 12-9 shows This helped balance

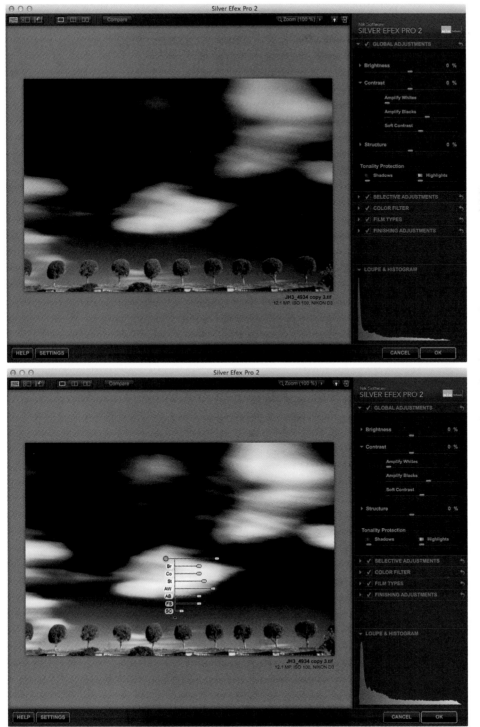

FIGURE 12-5. To get the deep, rich sky, we used the Amplify Blacks slider.

FIGURE 12-6. We then added a control point to the clouds to brighten them and introduce a higher level of contrast to the image.

■ FIGURE 12-7. Adding a control point below the clouds helped darken the sky close to the horizon for a uniform tonality.

■ FIGURE 12-8. We added control points to the trees to balance their tonality and increase their separation from the background.

FIGURE 12-9.
Because the image will be printed on an inkjet printer, we used the inkjet settings and selected the appropriate paper type and resolution.

the overall look to the photograph.

What we did in Sharpener Pro 3.0

Sharpening for the output is a new concept for many photographers. In this example, the end result is an inkjet print, so we chose Inkjet in the Output popup menu. Figure 12-9 shows the settings. The inkjet setting optimizes the sharpening amount and type based on the paper and printer resolution. The final sharpness varies based on these selections, plus it does not look the same on your screen from size to size or paper to paper.

As shown in Figure 12-10, control points prove to be invaluable as they let us easily remove the influence of sharpening in the sky by placing a control point with 0% strength. Sharpening the sky at any level could result in the introduction of noise or other problems.

Because the trees are the focal point of the image, we increased the sharpness and structure to provide more texture. Here, we placed control points on each tree to selectively increase their sharpness and structure, as Figure 12-11 shows. You can easily duplicate control points by clicking on the control point and then clicking and dragging the control point while pressing and holding Option or Alt to create a new control point with the same adjustment.

FIGURE 12-10. To prevent sharpening of the sky (which could bring out noise), we added a control point with the Output Sharpening Strength slider set to 0%.

FIGURE 12-11. We added control points to the trees to get more sharpness and structure.

Example 2: Cliff Jump

This slice of Americana is a nice image illustrating the fun lifestyle of the coast. We used three Nik Software tools to enhance it.

What we did in Dfine 2.0

To begin this edit, we applied Dfine 2.0's noise reduction to the entire image, using the automatic measurement. (You set measurement to be automatic in the Settings dialog box by clicking the Settings button in the lower-left corner.) This noise reduction once again helped give us an image with the optimal quality, as shown in Figure 12-13.

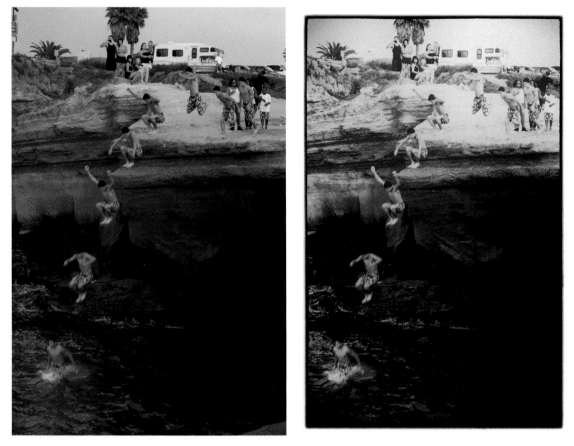

FIGURE 12-12. We merged multiple images to create the image at left. We then used Dfine 2.0, Viveza 2, Color Efex Pro 4 to enhance and stylize the image, with the final result shown at right.

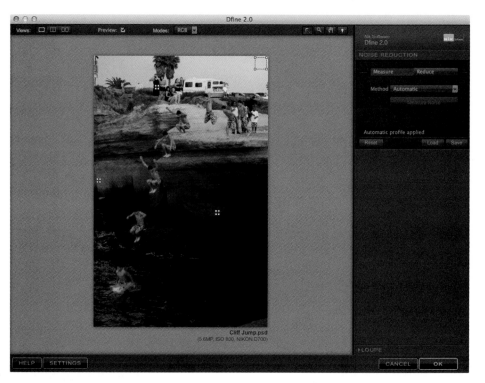

■ **FIGURE 12-13.** Applying Dfine's Automatic method often is all you need to get great-quality noise reduction.

What we did in Viveza 2

Selectively editing various elements of an image can be one of the most important parts of working on your images. We often use Viveza to do in a few seconds the kind of work that we could not previously do without a lot of time, energy, and effort. As Figure 12-14 shows, we used Viveza to help create balance in the photograph before going to the next stage.

By nature, shadows are difficult to control. Of course, they are also required to produce depth in an image. But the fact is some shadows are darker and some lighter, and if you want to even out the brightness you often must make selective adjustments. In Figure 12-15, we placed a control point and used shadow adjustment to open up the area just enough to reveal plenty of detail but not be a visual trap taking the eye away from the subject.

The dirt looked a little flat, so we added three control points for controlled contrast and structure to increase the overall snap or texture of the floor and wall, as Figure 12-17 shows. We also added warmth to give the appearance of the time of day to be late afternoon.

Multiple control points are often needed in editing. But when the same subject is in

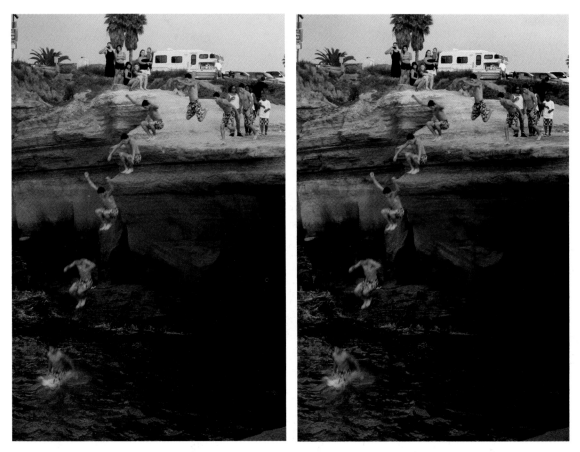

■ FIGURE 12-14. Viveza 2 helped balance the color and tonality of an image. At left is the image after noise reduction in Dfine; at right is the image after we were done in Viveza.

different positions in an image (such as in this example composite) and you need to edit just that subject, it can be a daunting task at best to get each control point placed. Still, the effort is worthwhile, In this case, control points really saved the day by removing some of the color and saturation, as Figure 12-17 shows. Of course, you can always try to make numerous layer masks to perform this edit, but that takes more time than most people have.

What we did in Color Efex Pro 4

Nostalgia is alive and well, and in our profession we are seeing record numbers of photographers restoring old photos, creating photos that look like old photos, and even creating albums that have the look of the 1950s and '60s. In this image, we created the

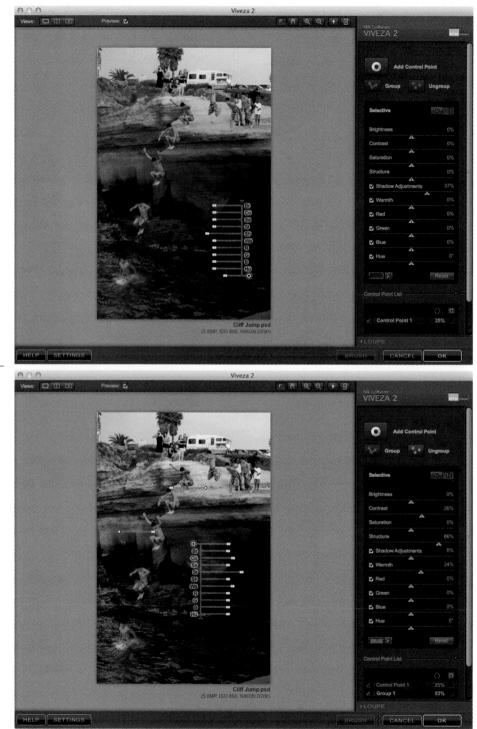

FIGURE 12-15. Adding a control point and increasing the Shadow Adjustments slider helped open up the shadows in the bottom-right corner of the image.

FIGURE 12-16. Adding three control points to the cliff helped bring out the cliff's color and details.

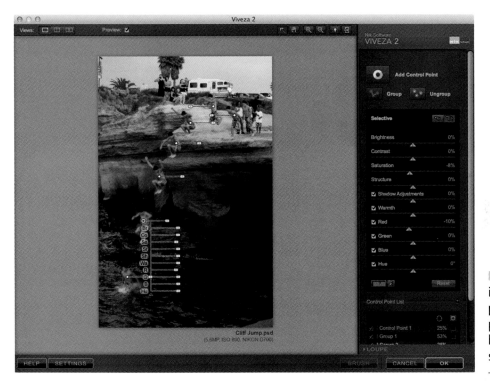

FIGURE 12-17. Creating a group of control points on the jumper prevented his skin from becoming too warm and saturated.

same look of yesteryear by using several filters in Color Efex Pro 4, as Figure 12-19 shows. We began with the Film Efex filter called Faded to establish the desired look.

Keeping the viewer's attention inside the frame of the picture is the best way to direct his or her attention. Adding the Vignette Lens filter effect is relatively easy, and it's a natural way to help achieve this task, as Figure 12-20 shows. Also, as we remembered from childhood and looking at old family photos, there is usually a darkening or vignette effect that could easily be seen in the corners of the photo.

Another subtle yet important element is to accentuate contrast. Especially effective in a photograph of this type, contrast adds interest and a little drama. As Figure 12-21 shows, the Contrast Only filter did a good job of not affecting or changing color balance while enhancing the contrast.

Working with image borders was the final step in creating the illusion and giving the nostalgic look of time. Figure 12-22 reveals the border we chose to match what was available in the past. Adding it was as easy as moving a couple of sliders to control size, edge, and smoothness. Once you have established the type or style of border, click the Vary Border button to see the automatic variations while keeping the overall border type you selected. Keep in mind that you can always make a new recipe that includes your favorite variations.

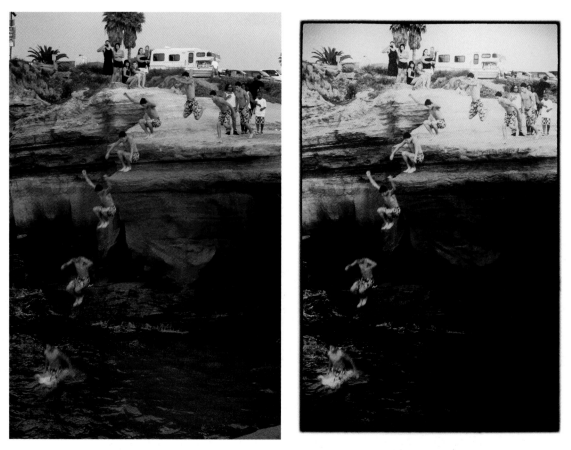

FIGURE 12-18. In this photo, we wanted to create a faded film look, so we used four filters in Color Efex Pro to accomplish the effect. The image taken from Viveza is shown at left; the image we adjusted in Color Efex Pro is shown at right.

Example 3: Black-and-White HDR

For all the great benefit received from capturing digital photography, perhaps the one big drawback, or at least something that needs help: the dynamic range of contrast. As we described in Chapter 7, it's important to increase the range of contrast in scenes with great brightness and darkness. In Figure 12-23, you can see the middle exposure of the original five-image bracket used to capture the relevant details, from highlights to shadows, and a black-and-white HDR Efex Pro version of the same image illustrating great detail throughout.

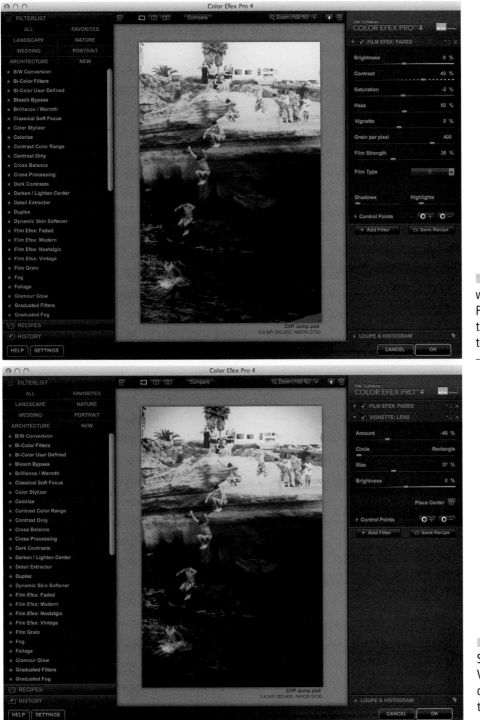

■ FIGURE 12-19. First, we applied Film Efex Faded filter to create the look of an old photograph.

■ FIGURE 12-20. Second, we used the Vignette Lens filter to draw the viewer's eye to the center of the image.

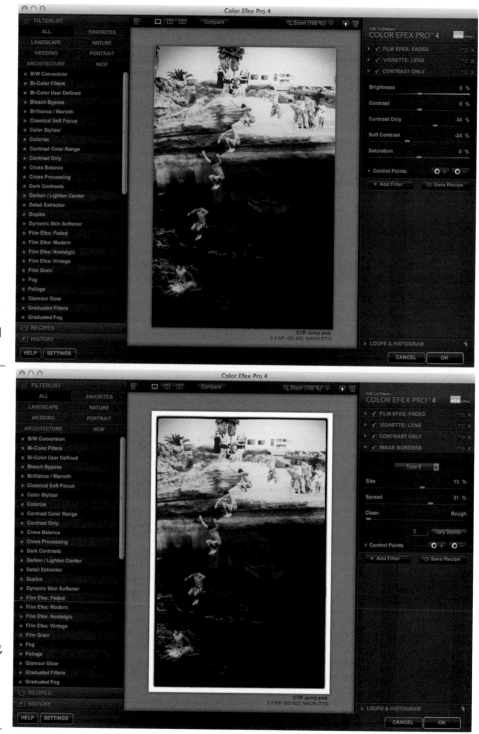

FIGURE 12-21. Third, we used the Contrast Only filter to adjust and refine the contrast.

FIGURE 12-22. Finally, we used the Image Borders filter to create a frame around the image.

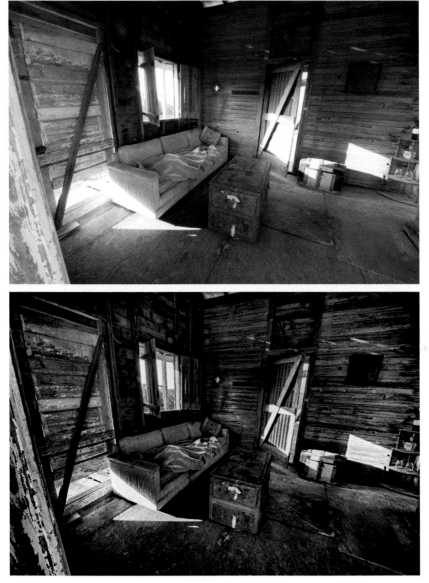

█ **FIGURE 12-23**. The combination of HDR Efex Pro and Silver Efex Pro 2 can yield images never before possible. At top is the original image, and at bottom is our final enhanced image.

What we did in HDR Efex Pro

There is a great amount of detail in the shadows inside the room in the image in Figure 12-24. However, we lost the detail outside the window. By bracketing and making a darker exposure for the detail outside, we were able to create an overall series of images that contain all the detail.

As Figure 12-25 shows, we slightly adjusted Exposure down and Tone Mapping up slightly. When you know you plan to go to black-and-white, you need to be very careful

FIGURE 12-24. HDR Efex Pro helped ensure there is detail in areas that cannot be captured with a single shot. At top is the original image, and at bottom is what we completed in HDR Efex Pro.

about not overprocessing your combined image — or else you risk introducing problems with image quality.

What we did in Silver Efex Pro 2

Figure 12-26 shows the adjusted color image and the final black-and-white image converted using Silver Efex Pro 2. Notice how the image tends to jump off the page with

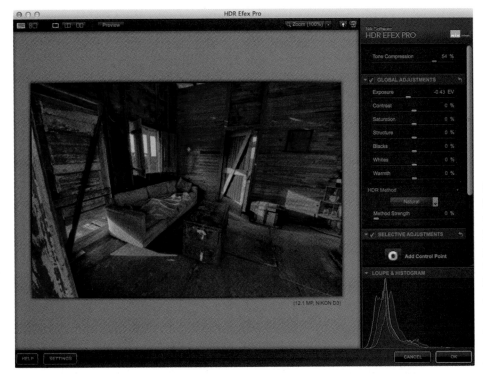

FIGURE 12-25. We recommend performing very limited processing in HDR Efex Pro when making a black-and-white HDR. All you need is a full range of tonality, as you can use Silver Efex Pro 2 to create the contrast needed in the image.

depth, shape, form, and dimension. The contrast and tonality help add interest in this funky little room and make it an image people enjoy viewing.

The settings and controls are preset to a position that is rarely what you want; otherwise, why would you use the tool to change them? But this starting place (such as shown in Figure 12-27) does give you a reference as your editing progresses.

The first enhancement we made was to adjust contrast. We used the Amplify White and Amplify Black sliders to find a contrast ideal for this scene. Maintaining detail is critical, and these two controls are great for adding just the right amount of contrast. Note the difference in the histogram between the images in Figures 12-27 and 12-28.

As Figure 12-29 shows, we moved the green, blue, and cyan sliders to negative positions to control the brightness out the window and in some of the interior.

As with most images, light comes from above, which generally results in flat surfaces picking up or revealing a lot of light. Here, the floor acts like a light trap, so we used a control point to reduce that luminance. Figure 12-30 shows that adding a control point on the floor and moving the Brightness slider to the negative side really helps keep the viewer's attention from wandering.

As so much of this interior is the same tone, we placed a neutral control point on the

FIGURE 12-26. The controls in Silver Efex Pro 2 can take a plain-looking HDR image and create a truly expressive image. At top is the image produced in HDR Efex Pro, and at bottom is the image refined in Silver Efex Pro.

sofa cushion to remove the adjustment made for the floor, as Figure 12-31 shows. This control point helps prevent the sofa's seating area from being too dark or dull-looking.

Working in a traditional darkroom usually meant a lot of burning and dodging of areas of the image. Here, we used control points to achieve the same thing. Placing numerous controls on the walls and making adjustments in contrast and structure is one of the best ways to truly edit a digital image to look as if it were created in a darkroom, as Figure 12-32 shows.

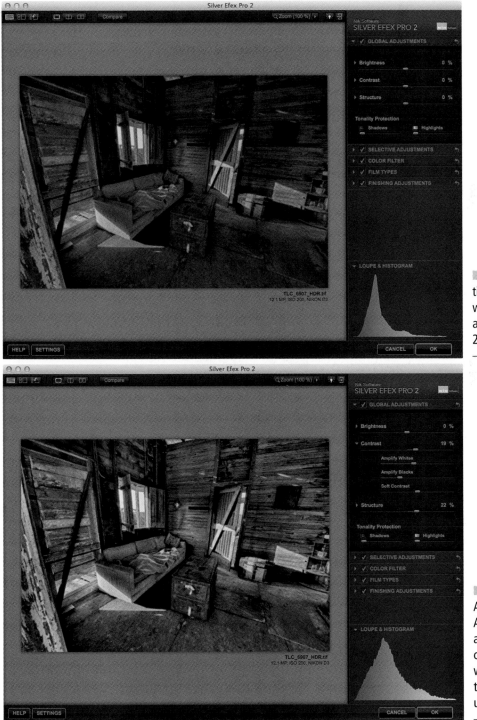

FIGURE 12-27. The initial conversion displayed when you first open up an HDR in Silver Efex Pro 2 is usually very flat.

FIGURE 12-28. The Amplify Whites and Amplify Blacks sliders are incredibly helpful controls with black-and-white HDR images, as they can boost contrast unlike any other control.

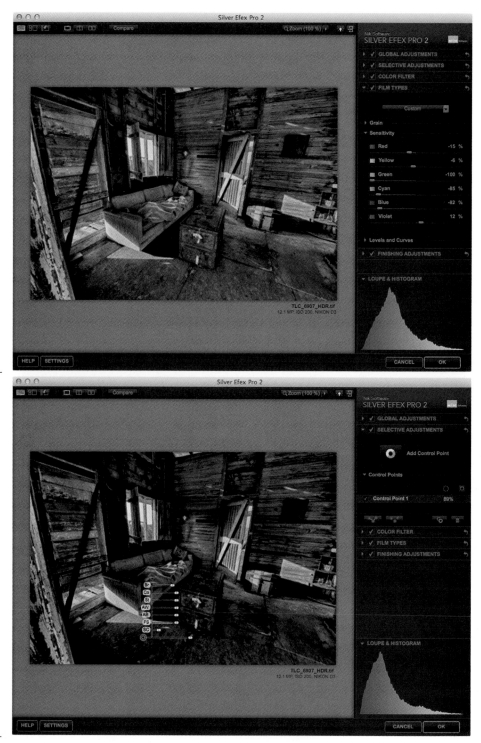

FIGURE 12-29. The Sensitivity sliders in the Film Types section provide powerful but fine-tuned control.

FIGURE 12-30. We added a control point to the floor to prevent it from calling too much attention to the viewer.

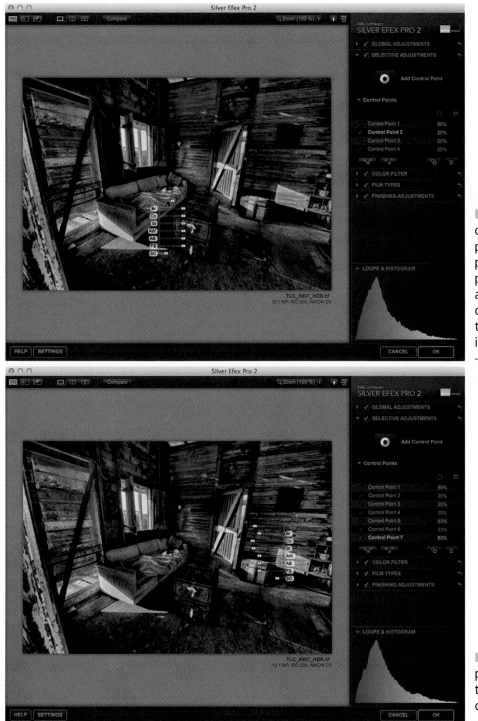

FIGURE 12-31. The couch is an important part of the scene, so we placed a neutral control point on it to prevent any overspray from the control point we added to the floor, maintaining its original tonality.

FIGURE 12-32. We placed control points on the walls to adjust the contrast and structure.

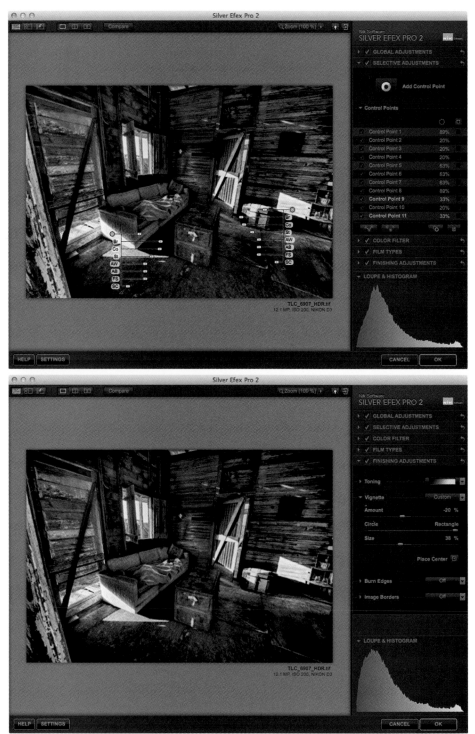

FIGURE 12-33. Finally, we added control points to the highlights of the image to make sure that the highlights were bright but still retained detail.

FIGURE 12-34. To finish the image, we added a darkening effect around the edges.

Once again we used control points to adjust brightness throughout the small areas of brightness, bringing out details and maintaining a great level of useful contrast, meaning contrast used to help create depth without losing detail, as Figure 12-33 shows.

Finishing an image is one of the things that separates the amateur from the pro: The pros generally go the extra step to ensure the image is finished.

We finished, or polished, the image by adding a slight darkening around the four borders (the edges). In another image the right finishing might be one final hit of contrast by adjusting the Amplify Blacks slider. Whatever it takes, we highly recommend you take the time to finish the image and give it the professional polish it needs to make the viewer look at the image and shake their head with amazement.

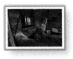

Appendix A

The Rise of Digital Photography and the History of Nik

The ability to capture and enhance a photograph digitally has been an exciting evolution of photography. The reduced cost of shooting digitally and the increased quality and control has resulted in a more approachable and rewarding experience, with more people than ever before able to enjoy photography.

The Rise of Digital Photography

Since the early days of digital photography, there have been the expected comparisons with the glory days of photography and the strong feelings photographers have had toward analog photography based on silver halide.

For nearly 150 years, silver halide was photography and photography was silver halide. Silver halide brought with it certain benefits and certain limitations, but also certain expectations over the look and how to interact with it.

As soon as digital photography reached a quality level at which professional photographers could start using it for commercial work, the argument over which is better — analog or digital — reached a fever pitch. Whichever side of the debate you tend to be on, the fact is that silver halide requires a lot less postprocessing and certainly a lot less computer savvy. In the analog world, you select your camera, lens, film, and sometimes the lighting and filtration — and that's it. Sure, you could argue that the lab you use would provide different quality and capabilities. And sure, you could get crazy and ask for some pretty special processing at the lab, but most of the time you take the film out of the camera, drop it off somewhere, and later return to receive the processed photos.

In digital photography, there is no lab where you drop off the images. *We* are the lab, the lab technician, the processor, the retoucher, and the printer. Suddenly, we need to know what to do, how to do it, and most important, how to do it quickly and with high-enough quality to be profitable and maintain our reputations.

Adobe Photoshop was the de facto tool at the dawn of this transition from silver halide to digital. Photoshop contained a bevy of tools and controls never before seen by the traditional photographer, with the type of control not available in the analog world. Now, photographers can apply enhancements to their images after the image is captured, as opposed to doing nearly everything before the image is captured.

Photoshop offers vast control and power not before available to photographers. However, it is not designed for photographers. Tools such as Levels, Curves, and Hue / Saturation took a completely different approach to image processing from what photographers are familiar with. Where someone would normally use a piece of glass in front of the lens to warm up their image, digital photographers have to figure out which

■ **FIGURE A-1.** The current Nik Software logo (left) and the original Nik Multimedia logo (right)

of these tools (or combination of tools) will create a similar effect, all while learning about the limitations of working in a digital environment.

It is this divide between analog photography and digital editing tools that Nik Software saw as an opportunity to create new products that would bridge the divide.

The History of Nik Software

In 1995, Nils Kokemohr (whose name is the basis for the name Nik) started Nik Software, originally Nik Multimedia, as a company focused on graphic design and digital photography. The original logo is shown in Figure A-1. The first products were combinations of Photoshop actions and textures called Nil's Efex! and Nil's Type Efex! Over the course of the following year, Nils set up distribution in Europe, the United States, and Japan, and people around the world started to use and love his tools and see the graphical and imaging vision that he had.

Nils rekindled his relationship with Dirk Schöttke in Hamburg, Germany, whom he had once worked for as a young computer technician, and began the journey of establishing

a new imaging company. Eventually, Nils started working with two promising young engineering students (Manuel Wille and Kai Labusch) out of the prestigious image processing school in Lübeck, Germany, and embarked on creating their first software-based (not action-based) products.

At the same time, Nils, Dirk, Manuel, and Kai started working with a pair of savvy American businessmen, Michael Slater and Edward Sanchez, and formed an American branch. These six individuals formed the core of the company, and apart from Kai (who left to continue graduate studies) everyone is still with the company to this day.

The first software and photography specific products, Nik Color Efex!, was released in 1999. Nik Sharpener! and Nik Sharpener Pro! quickly followed in early 2000, with Nik Color Efex Pro! released in the middle of 2000.

Nik Color Efex! and Color Efex Pro! were designed to give digital photographers familiar tools with familiar controls. Filters such as the Skylight filter and the Polarization filter provided tools photographers had used for years as glass filters in a digital format, with the ability to easily predict the end result, something not easily done with the existing functionality in Photoshop. Both Nik Sharpener! and Nik Sharpener Pro! provided easy-to-use sharpening with the ability to create optimal sharpness without the normal guesswork involved in sharpening images.

It was these two product lines that set the foundation for what Nik Software would eventually become and that helped usher in a new era of digital photography.

In 2002, Nik Multimedia released Dfine 1.0, a revolutionary approach to noise reduction. In 2004, Nik Color Efex Pro 2.0 was released, supporting both Photoshop and Nikon Capture 4, starting the relationship between Nik Multimedia and Nikon.

With the introduction of Nik Sharpener Pro 2.0 in 2005, even more control was provided over the sharpening process.

In addition to making Nik Color Efex Pro 2.0 for Nikon Capture 4, Nik Multimedia

Nik **Color Efex Pro™ 2.0**
75 Professional Digital
Photographic Filters
Complete Edition

Nik **Sharpener Pro™ 2.0**
The Professional's Choice
for Image Sharpening
Complete Edition

Nik Software
Viveza®
Color Control Revolutionized
for Photoshop®, Lightroom®, and Aperture™

started working with Nikon to bring, at the time unreleased, U Point technology to the market.

U Point technology was something that Nils had been working on for years, all with the goal of providing an easy, understandable, and powerful new way to make selection adjustments to a photograph. Nils believed that photographers wanted a way to simply point to a part of their image and make a selection directly. He believed that photographers saw images as a series of areas or objects, unlike traditional image-editing tools that saw images as a series of unconnected pixels. In those tools, users had to identify and isolate objects by manually describing the area with a brush or lasso (or use unsophisticated methods of selecting an object solely off the similarity between pixels. But Nils envisioned a product that could create complex selections in seconds. After creating several prototypes, it was time to find a partner.

Based on the success of Nik Color Efex Pro 2.0 for Nikon Capture 4, both Nik Multimedia and Nikon believed that there was synergy between the two companies and their direction in the digital photography market. Nikon made a capital investment in Nik Multimedia, which enabled the company to grow and add additional engineers to start working on a new project: Capture NX.

Nik Multimedia started working on Capture NX and, in 2006, the first version was released. Capture NX took the previous Capture 4 product and added U Point-based selection tools, a brush engine, photographic filters and enhancement tools, a browser, and an advanced editing mechanism. Capture NX made it possible for photographers to get the highest-possible-quality RAW processing based on Nikon's algorithms with a photographic-specific editing workflow. Capture NX received worldwide acclaim and its U Point technology received an European Imaging and Sound Association (EISA) award for best photographic technology.

Along with the release of Capture NX, Nik Multimedia changed its name to Nik Software and added the tag line "Photography First."

Dfine 2.0 was released in 2007, the first plug-in to incorporate U Point technology.

Color Efex Pro 3.0 quickly followed in late 2007, adding new filters, an improved interface, and U Point technology.

Throughout 2008, three new products — Viveza, Silver Efex Pro, and Sharpener Pro 3.0 — were introduced, as was compatibility for all Nik products with Apple Aperture. Viveza took the incredibly popular color control points in Capture NX and made it possible to use color control points in Photoshop. Silver Efex Pro provided a black-and-white-specific editing tool set, designed to create natural-looking black-and-white images with the utmost control.

In 2011, Nik Software released three new products: Silver Efex Pro 2, Snapseed (a mobile image-editing tool for iPhones and iPads), and Color Efex Pro 4.

Each of the six product lines offered by Nik Software is designed to offer three main benefits:

- Use unique algorithms and controls not in any other image-processing tool.
- Provide greatly increased productivity and efficiency for a photographer's workflow.
- Make it possible for photographers not intimately familiar with the more advanced workings of Photoshop to accomplish their vision.

Appendix B

Index